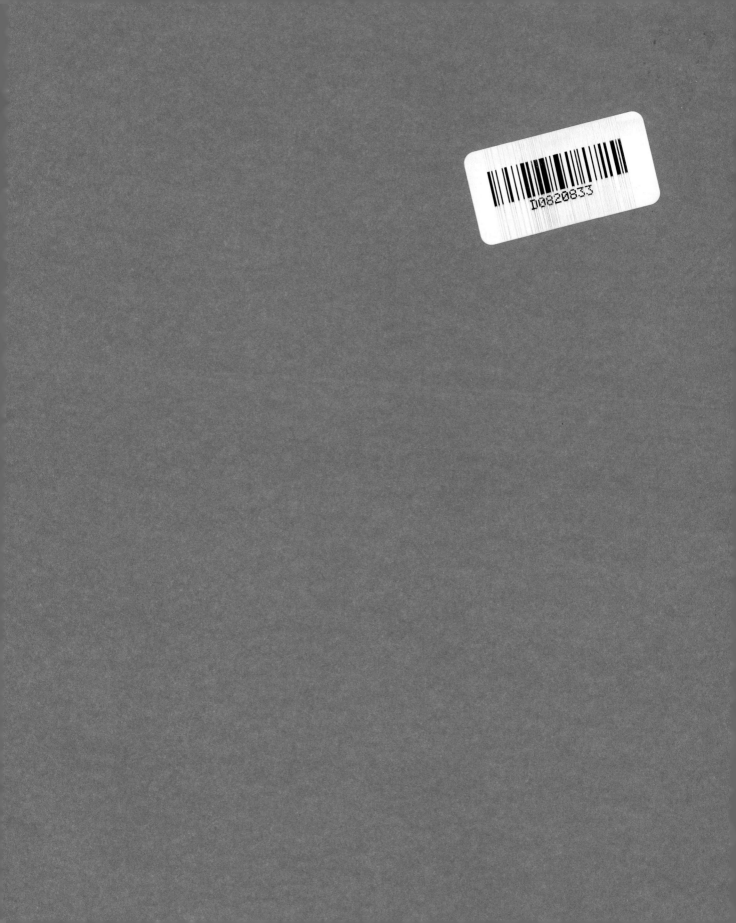

HIROSHIGE FAN PRINTS

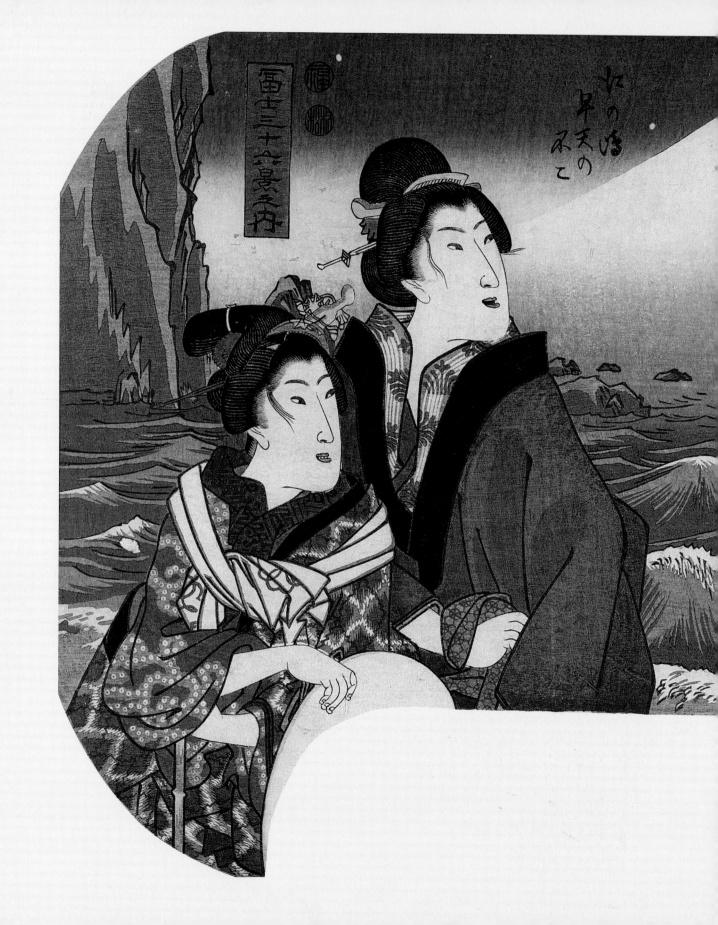

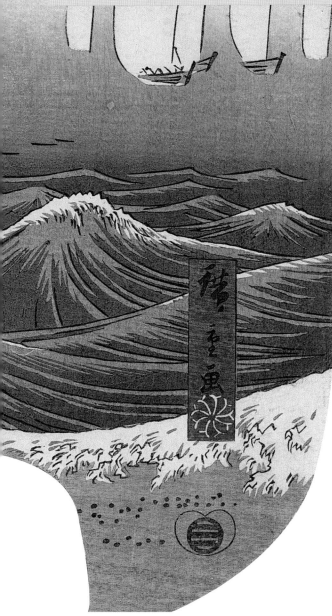

VICTORIA & ALBERT MUSEUM • FAR EASTERN SERIES

HIROSHIGE FAN PRINTS

RUPERT FAULKNER

First published by V&A Publications, 2001

V&A Publications
160 Brompton Road
London SW3 1HW

Rupert Faulkner asserts his moral right
to be identified as the author of this book

Series design by Harry Green
Page design by Yvonne Dedman
Photography by Sara Hodges, V&A Photographic Studio

ISBN 1 85177 332 0

A catalogue record for this book is available
from the British Library

Originated in Milan by Colorlito
Printed and bound
in Singapore by C.S. Graphics

Illustrations

JACKET FRONT: *Yoshino River in Yamato Province* (see plate 106)

JACKET BACK: *Shichiri Beach at Kamakura in Sagami Province* (see plate 89)

HALF-TITLE: *All Rivers Converge and Flow into the Sea* (see plate 56)

FRONTISPIECE: *Mount Fuji at Dawn from the Island of Enoshima* (see plate 77)

CONTENTS: *Catching Fireflies by a Pond* (see plate XI)

V&A Publications
160 Brompton Road
London SW3 1HW
www.vam.ac.uk

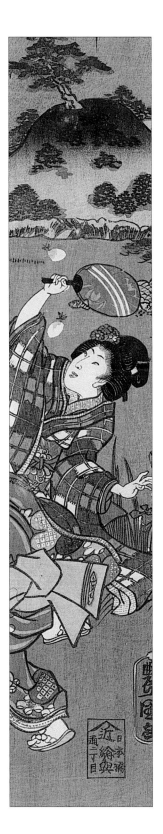

Contents

Acknowledgements

Few publications, even a modest catalogue like this, are created in isolation. I am deeply indebted to many friends and colleagues in Europe, Japan and the United States for the support and advice they have given me during the time it has taken to research and write this book. When I joined the staff of the Victoria & Albert Museum (hereafter the V&A) in 1984, one of the first things to which my attention was drawn was the collection of Hiroshige fan prints. I remember the sense of wonder and astonishment I felt as I opened box after box of these extraordinary designs, many of them as bright and fresh as they would have been on the day they emerged from the printer's studio. The enthusiasm shown by members of the Ukiyo-e Society of America when they visited the V&A in 1997 confirmed my long-held belief that the collection deserved to be published in full. This led me to approach Mary Butler of V&A Publications who, the forever supportive and resolute enabler that she is, agreed to my proposal. I am much indebted to her, her team and to Yvonne Dedman, whose skills as a designer have added so much to the quality of the finished book. I would also like to thank Sara Hodges of the V&A's Photographic Studio for the photographs she took of the complete collection of 126 prints, and Pauline Webber and her colleagues in the V&A's Conservation Department for preparing the prints for photography. I am similarly grateful to my colleagues in the V&A's Far Eastern Department for their support, and in particular to Andrew Bolton and Liz Wilkinson for their help with the photographic programme.

Outside the V&A thanks are due to Timothy Clark and his colleagues in the Department of Japanese Antiquities at the British Museum, Matthi Forrer of the Japanese Department of the Museum for Ethnology in Leiden, Roger Keyes of the Center for the Study of Japanese Woodblock Prints in Rhode Island, Carolyn Staley of Carolyn Staley Fine Japanese Prints in Seattle and Chris Uhlenbeck of Hotei Japanese Prints in Leiden. The research I undertook in Japan during two periods in December 1998 and December 1999 was facilitated by a large number of people. I am especially grateful to the Tokyo National Museum for providing me with the travel grant that made the first of these trips possible, to Suzuki Jūzō for spending two long afternoons answering my many ill-informed questions and to Sakai Gankō for making the collection and resources of the Japan Ukiyo-e Museum available to me. I am similarly indebted to Asano Shūgō of the Chiba City Museum of Art, Hashimoto Kenichirō of the Kanagawa Prefectural Museum of Cultural History, Hata Urara and her colleagues at the Edo-Tokyo Museum, Iwata Hideyuki of Atomi Women's University, Kobayashi Tadashi of Gakushuin University, Nagata Seiji of the Ōta Memorial Museum of Art and Satō Mitsunobu of the Hiraki Ukiyo-e Museum. My knowledge of the Asakusa and

Mukōjima districts of Tokyo was considerably furthered by an evening tour provided by Hibiya Taketoshi and Uchida Yasuhiro, friends of Satō Satoru of Jissen Women's University. I am grateful to Professor Satō not just for this introduction but also for the extensive advice and guidance he gave me during the weekly visits he made to work on the V&A's Japanese print collection during his 1999–2000 sabbatical year in London. I owe a similar debt of gratitude to Paul Griffith of Saitama University for the help he provided in creating preliminary catalogue entries while working as a volunteer in the V&A in August to September 1997.

My final words of thanks are reserved for my wife and two daughters, and the patience and good humour they have shown in the face of my monopoly of the family computer and the inevitable intrusions of work into evenings and weekends.

Chronology of Periods in Japanese History

Nara period	710–94
Heian period	794–1185
Kamakura period	1185–1336
Muromachi period	1336–1573
Momoyama period	1573–1615
Edo period	1615–1868
Meiji period	1868–1912

NOTES ON JAPANESE NAMES AND PRONUNCIATION

Japanese names are given in Japanese order, that is family name followed by given name.

Consonants in Japanese words are pronounced much as they are in English, vowels as they are in Italian. There is a difference, however, between the short and the long u/ū and o/ō, the macron over the vowel signifying the longer form. The shorter u is pronounced as in the Italian 'Umbria', the longer ū as in 'hoot'. The shorter o is pronounced as in 'not', the longer ō as in 'ought'. Macrons are used throughout the text except on the frequently occurring place names Tokyo, Kyoto and Osaka (strictly Tōkyō, Kyōto and Ōsaka).

NOTES ON DATING CONVENTIONS

The combinations of censor, censorship and date seals found on many designs produced from the end of 1846 onwards allow them to be dated to the level of year and month. Dates established on the basis of these seals are represented by the formula [year]/[month], e.g. 1856/1, or [year]/[month]–[year]/[month], e.g. 1847/1–1848/10. The month indicated corresponds to the lunar calendar used in Japan until 1872. Date seals such as appear from 1852/2 onwards take the form of a zodiacal sign for the year followed by a numeral for the month, e.g. *Snake 1* (1857/1).

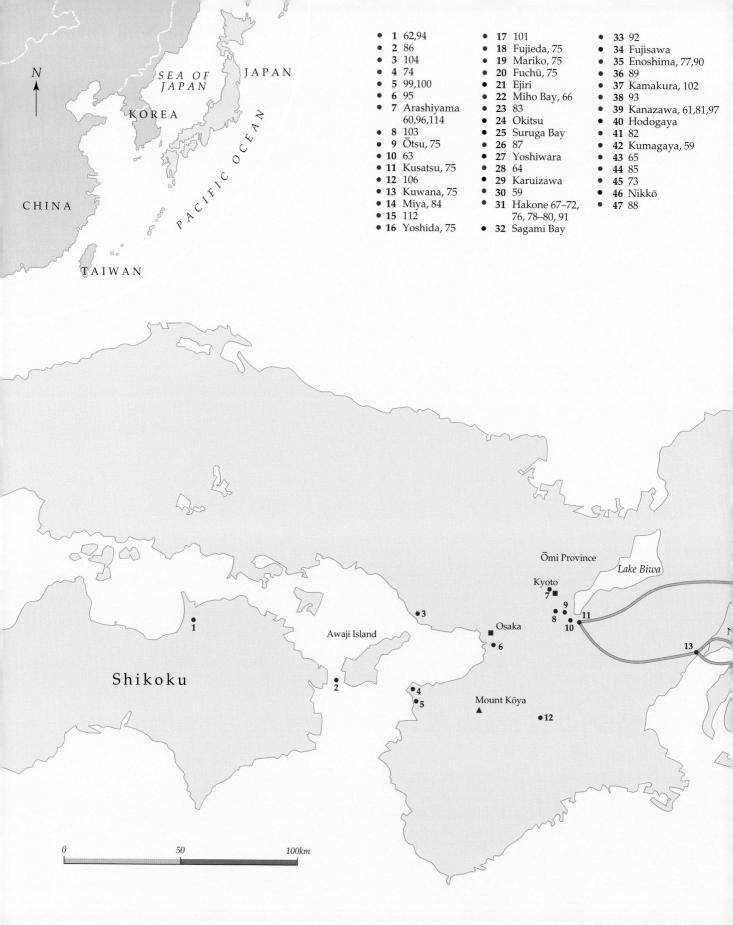

N

SEA OF
JAPAN

JAPAN

KOREA

PACIFIC OCEAN

CHINA

TAIWAN

●	**1**	62,94		●	**17**	101		●	**33**	92
●	**2**	86		●	**18**	Fujieda, 75		●	**34**	Fujisawa
●	**3**	104		●	**19**	Mariko, 75		●	**35**	Enoshima, 77,90
●	**4**	74		●	**20**	Fuchū, 75		●	**36**	89
●	**5**	99,100		●	**21**	Ejiri		●	**37**	Kamakura, 102
●	**6**	95		●	**22**	Miho Bay, 66		●	**38**	93
●	**7**	Arashiyama 60,96,114		●	**23**	83		●	**39**	Kanazawa, 61,81,97
●	**8**	103		●	**24**	Okitsu		●	**40**	Hodogaya
●	**9**	Ōtsu, 75		●	**25**	Suruga Bay		●	**41**	82
●	**10**	63		●	**26**	87		●	**42**	Kumagaya, 59
●	**11**	Kusatsu, 75		●	**27**	Yoshiwara		●	**43**	65
●	**12**	106		●	**28**	64		●	**44**	85
●	**13**	Kuwana, 75		●	**29**	Karuizawa		●	**45**	73
●	**14**	Miya, 84		●	**30**	59		●	**46**	Nikkō
●	**15**	112		●	**31**	Hakone 67–72, 76, 78–80, 91		●	**47**	88
●	**16**	Yoshida, 75		●	**32**	Sagami Bay				

Ōmi Province

Lake Biwa

Kyoto
7

9
8 **11**
10

Osaka
6

13

Awaji Island

Shikoku

1

3

2

4
5

Mount Kōya ▲

12

0 50 100km

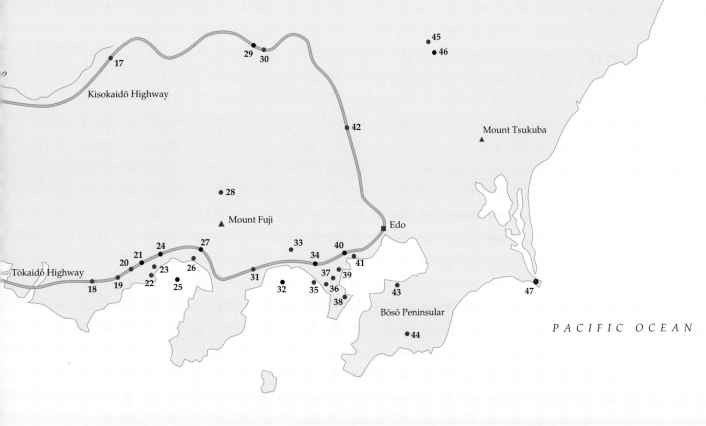

Locations of scenes in fan prints

Other locations mentioned in text

Mountains

Major cities

Major highways

Coastline, rivers, lakes

N

Honshū

45
46

Kisokaidō Highway

17

29 30

42

Mount Tsukuba

28

Mount Fuji

Edo

33
40
34
24 27
20 21
23 26
22
25
31
32
37 39
35 36
38
41
43

Tōkaidō Highway

18 19

47

Bōsō Peninsular

44

PACIFIC OCEAN

Introduction

The *ukiyo-e* woodblock prints of Utagawa Hiroshige I (1797–1858) are among the best known and most frequently reproduced of all Japanese works of art. Hiroshige was a native of Edo, present-day Tokyo, the large and bustling political and economic centre of pre-modern Japan. Born into a low-ranking samurai family, he was a prolific artist estimated to have created between 4000 and 4500 designs during a career that lasted the best part of 50 years (Forrer 1997, p.25). This was complemented by his work as a painter and book illustrator. Hiroshige worked across the full range of *ukiyo-e* subject matter, designing prints of beautiful women, Kabuki actors and famous historical and mythological figures. Bird and flower studies were a particular forte, but his greatest contribution lay in the field of landscape prints. Starting in the 1830s, about three-quarters of his designs belong to this genre. They divide largely into three categories: views of Edo, views of the provinces and views of the Tōkaidō, the highway with its 53 post-stations that linked Edo with the imperial capital of Kyoto. Like the numerous and similarly well-known images left by Hiroshige's counterpart Katsushika Hokusai (1760–1849), these serve as compelling lenses through which to view the urban and rural topography of early to mid-nineteenth-century Japan.

Hiroshige was in his own time a designer of popular images for a mass market. The artistic status he enjoys today was initially accorded to him by collectors and curators in the West. Large numbers of prints by Hiroshige and other artists found their way abroad following the opening of Japan and the establishment of commercial and diplomatic ties with the USA, Britain and other Western nations during the 1850s. They were avidly sought out by artists and designers swept up in the ensuing wave of adulation and borrowing of Japanese artistic concepts and forms known as Japonisme. *Ukiyo-e* prints were regularly depicted as props in the backgrounds of exoticising late nineteenth-century paintings. More profoundly, their compositional devices, their use of flat expanses of colour and their subject matter directly influenced the work of many Impressionist and Post-Impressionist painters. It was against this background and in the context of the development in the West of critical approaches to Japanese art that attempts were first made systematically to analyse and evaluate the work of *ukiyo-e* print-makers.

In the case of Hiroshige, the catalogue of an exhibition of Japanese paintings and prints held in New York in 1896 saw the American connoisseur and critic Ernest Fennollosa describe him as a landscape artist *par excellence*, characterising him in the way that he is still viewed today (Forrer 1997, p.26). In the ensuing years pioneering studies were undertaken by John Stewart Happer (1909), Will H. Edmunds (1922) and Edward F. Strange, from 1900 to 1914 Keeper of the Department of Engraving,

Illustration and Design at the V&A. Strange's research culminated in the publication in 1925 of *The Colour Prints of Hiroshige*, which is still the only major monograph on Hiroshige in a Western language. The more notable of recent non-Japanese publications devoted to Hiroshige include *Hiroshige: One Hundred Famous Views of Edo* (1986) by Henry Smith and Amy Poster, *Hiroshige: Birds and Flowers* (1988) by Cynthia Bogel and Israel Goldman, and Matthi Forrer's *Hiroshige: Prints and Drawings*, the catalogue of the 1997 exhibition held at the Royal Academy of Arts in London to commemorate the bi-centenary of the artist's birth.

Early Japanese initiatives include the appearance in 1894 of Iijima Kyōshin's manuscript of a series of biographical articles about Hiroshige and other artists of the Utagawa School, which was subsequently published in 1941. In 1917 Watanabe Shōzaburō organised a major exhibition to commemorate the sixtieth anniversary of Hiroshige's death, the catalogue of which was published by the Japanese Society for the Study of Ukiyo-e the following year. The great Japanese monographs, both simply entitled *Hiroshige*, were published by Uchida Minoru and Suzuki Jūzō in 1932 and 1970 respectively. Japan's exhibition and publishing boom of recent years has resulted in large numbers of often lavishly illustrated books and catalogues devoted to or including the work of Hiroshige. These are too numerous to cite individually but can be sourced via those titles listed in the bibliography.

Hiroshige Fan Prints in the V&A

Japanese fans, with the exception of certain varieties with specialist military or ceremonial functions, are of two main kinds: the *ōgi* or folding fan; and the *uchiwa* or rigid fan. Adding the character 'e', meaning picture or illustration, gives the terms *ōgi-e*, folding fan design, and *uchiwa-e*, rigid fan design. As is evident from the illustrations in this book, Hiroshige was particularly talented in the field of woodblock printed *uchiwa-e*. It is difficult to assess how many designs he produced, surviving examples being scattered across scores of public and private collections in Japan, Europe and North America, but the number is quite considerable. Sakai Gankō (1981) has listed over 330 titles in 142 groups or series, while Forrer (1997, p.25) has suggested a probable total of around 350. In view of the fact that fewer than half of the designs in the V&A correspond to those in Sakai's list, the figure can reasonably be put at nearer 400. This is the number of surviving designs – given the ephemeral nature of fans, the original number is likely to have been substantially higher.

The V&A's collection of 126 Hiroshige *uchiwa-e* was assembled between 1886 and 1919. As far as it has been possible to ascertain, this is the single largest holding of its kind in the world. The importance of the *uchiwa-e* within Hiroshige's oeuvre was recognised by Strange, who devoted a chapter to the subject in his 1925 monograph. Strange's book was published a year after the appearance in 1924 of Matsuki Kihachirō's fully illustrated catalogue of an exhibition of 128 Hiroshige *uchiwa-e* held in Tokyo. Matsuki is acknowledged in the preface to Strange's book as having been an important source of assistance, although no mention is made of the 1924 exhibition as such. Strange's observations remain pertinent today and are worth quoting at length:

These prints are rare; for it is obvious that most of them, being made for use, must have been easily worn out and destroyed. Yet they are to be picked up, here and

there, and well repay the patience of the collector who is content to wait for his opportunities. Often they bear the mark of the ribs, having been removed from their mounts and cherished by someone who appreciated the artistic value of them; but, now and again, examples free from the marks of usage can be found. That indefatigable collector, Mr. Happer, could include but 9 ōgi and 16 uchiwa in the great collection sold in 1909. Only 10 were exhibited in the [1918] Memorial Exhibition. Sir R. Leicester Harmsworth has managed to secure about 18 or 20; but it is pleasant to be able to record that no fewer than 130 [sic] have been acquired by the Victoria and Albert Museum, so that visitors to London have there, at all events, an opportunity of studying a representative collection of a phase of Hiroshige's work which merits far more attention than it has yet received. For that reason, we have thought it advisable to devote to this subject a larger proportion of the illustrations to this volume than might otherwise have been the case, at the expense of some of the better-known prints which have frequently been reproduced elsewhere.

For to this class Hiroshige devoted some of the best of his talent. The forms alone offer a problem to the designer, which is attractive and calls for a particular effort. But he never fails. The composition is, though restricted in its opportunities by the rigid boundaries of the object, inevitably right and perfectly adapted to its purpose. It implies a concentration of design on a central base, with radiating lines outwards and upwards; and he either follows or contrasts with these, with a sure instinct that defies criticism. They cover the ground from his best period to the time of his death; and display an extraordinary variety of treatment – pure landscape in the exquisite, restrained and poetic style of the three great *Hakkei* [*Eight Views in Ōmi Province* (*Ōmi Hakkei no Uchi*), 1834–5; *Eight Views in Kanazawa* (*Kanazawa Hakkei*), 1835–6; *Eight Views in the Environs of Edo* (*Edo Kinkō Hakkei no Uchi*), 1837–8], the more vigorous method of the First Tōkaidō [*The Fifty-three Stations of the Tōkaidō Highway* (*Tōkaidō Gojūsan Tsugi no Uchi*), published by Hōeidō, 1831–4] and its added human interest, birds, flowers, tortoises, and other natural objects: and a whole series of brilliantly coloured landscapes with the graceful female figures in which he shows, more than in any other of his work, a hint of his inheritance from his master Toyohiro [Utagawa Toyohiro (d. 1828)]. And a word must be given to the blue prints (*aizuri*), and particularly the brilliant 'Fuji' from Schichi-ri [sic] Bay reproduced herein and dated 1855 [plate 89] – the powers of the man who made this superb design were hardly failing then!

The *aizuri* rendering of Mount Fuji referred to by Strange was one of 28 Hiroshige *uchiwa-e* purchased by the V&A in 1886 (inventory numbers E.12065-1886 to E.12092-1886). They were part of a group of over 15,000 *ukiyo-e* prints contained in 300 albums bought for £300 from a general dealer in the East End of London. Some of these were sent to the Royal Scottish Museum in Edinburgh, but the majority were retained by the V&A. Little more is known about the circumstances of the acquisition except that the prints were placed in the care of the National Art Library, which Strange joined on his arrival at the V&A in 1889. His initial work on this enormous collection, in which he was assisted by L. W. Micheletti, resulted in the publication in 1897 of his *Japanese Illustration*. A revised version of this book, entitled *Japanese Colour Prints*, was published in six editions between 1904 and 1931.

During his time in the National Art Library and then in the Department of Engraving, Illustration and Design, Strange added judiciously to the V&A's holdings of Japanese prints. Over the years he built up an extensive network of contacts, one of whom was the 'indefatigable collector' John Stewart Happer. Happer was an American businessman based in Yokohama, where he worked for the American Trading Company, agents for the Indian Refining Company of New York, Inc. (V&A Nominal File, Happer J.S.). A pioneer, as noted above, of Hiroshige studies, Happer was the first person to attempt a serious chronology of Hiroshige's work (Forrer 1997, p.27).

Happer's extensive collection of Japanese prints and paintings was auctioned in London by Sotheby's in April and June 1909 (Happer 1909). The second part of over 700 lots consisted entirely of works by Hiroshige. The copy of the sale catalogue in the possession of the V&A's Far Eastern Department is carefully annotated with the price and buyer of each lot. The nine *ōgi-e* and sixteen *uchiwa-e* in lots 327–35 and 336–51 were sold to a variety of British and Japanese collectors and dealers. None of these, nor indeed any of the other prints in the sale, was bought by the V&A. Though there is no specific evidence to substantiate this, this may be explained by the fact that Strange had already spent £250 at the first part of the Happer sale in April (V&A Nominal File, Sotheby Wilkinson & Hodge 1893–1913). The prices paid for the *uchiwa-e* in the June sale ranged from 16 shillings for a view of Arashiyama in Kyoto (lot 337) to nine pounds 15 shillings for an *aizuri* rendering of Mount Fuji seen from Miho Beach (lot 346), most lots having sold for between £1 and £3.

If the V&A failed to acquire any of the Hiroshige prints from the 1909 sale, direct negotiations between Strange and Happer led to the subsequent purchase of a group of *uchiwa-e* including 22 by Hiroshige (inventory numbers E.527-1911 to E.548-1911). A letter from Happer dated 23 March 1911 begins, 'My dear Strange, I have got you a lot of beauties, including one set of Hakkei' (plates 23–30) (V&A Nominal File, Happer J.S.). The prints bought from Happer include some of the best-preserved Hiroshige *uchiwa-e* in the V&A's collection. At ten shillings each they were far more reasonably priced than any of the examples sold at Sotheby's two years before. Strange's memorandum in support of the purchase begins, 'Director, These were sent to me privately but they are so good a lot that I think the Museum ought to have them' (V&A Nominal File, Happer J.S.). Not unwistfully perhaps, but Strange had secured for the V&A a very considerable bargain.

Two years later, in 1913, a further 29 Hiroshige *uchiwa-e* were acquired, two from Inada Hogitarō (inventory numbers E.574-1913 and E.575-1913) and 27 from R. Leicester Harmsworth (inventory numbers E.2907-1913 to E.2933-1913). Inada was an art dealer from Kyoto who moved to London in October 1909 and set himself up at premises in Guilford Street, Russell Square, near the British Museum. Before leaving Japan Inada wrote to Strange to thank him for his kindness during the visit he had made to London earlier in the year and to say that he had succeeded in securing for the V&A a group of woodblocks and woodblock printing tools in accordance with Strange's request (V&A Nominal File, Inada Hogitarō). These were the first of numerous purchases from Inada, which, according to the V&A's files, continued until July 1914. The Hiroshige *uchiwa-e* were bought in February 1913 at three pounds 10 shillings for the two. The acquisition papers note that Inada provided translations of the

captions. If Inada was an important source of Japanese graphic art, he also supplied the V&A with various other kinds of material. At a personal level his closest dealings seem to have been with Albert J. Koop of the V&A's Department of Metalwork, with whom he published in 1923 the remarkable and still valuable manual for 'art collectors and students' entitled *Japanese Names and How to Read Them*.

R. Leicester Harmsworth, the donor of the other 27 Hiroshige *uchiwa-e* acquired in 1913, was Member of Parliament for Caithness (1900–18) and Caithness-Sutherland (1918–22). He lived at Moray Lodge, Campden Hill, London W8. Moray Lodge backed on to the garden of Aubrey House, the home of William Alexander, one of the foremost collectors of Japanese art of the time. Much of Alexander's collection, including over 6000 *ukiyo-e* prints, was given to the V&A by his daughters following his death in April 1916. The extent to which the younger Harmsworth (1870–1937) was guided or inspired by Alexander (1841–1916) is not clear, but he was undoubtedly an important collector of Japanese prints. Strange referred to him, as in the passage above, in his 1925 monograph and had previously negotiated with him the loan of over 300 prints for an exhibition at the V&A from November 1913 to March 1914 (Strange 1913). The 27 Hiroshige *uchiwa-e* donated by Harmsworth in 1913 were bought at Sotheby's at a sale of Japanese prints on 2–4 June. Strange noted in a memorandum shortly before the sale that he had met Harmsworth and his agent Edgar Wilson at Sotheby's, and that Harmsworth had 'most generously given Mr. Wilson instructions to secure all the lots [of fan prints] … with the intention of presenting such as are purchased to the Museum' (V&A Nominal File, Sotheby Wilkinson & Hodge 1893–1913).

The final episode in this sequence of acquisitions was the Webb Bequest of 1919. According to the letter from his solicitors advising the V&A of the terms of his bequest, Bernard Hugh Webb was an 'Architect and former Gold Medallist of the Royal Academy' (V&A Nominal File, Webb B.H.). The instruction in his will requested:

> I direct my Executors to offer to the Trustees of the Victoria and Albert Museum, South Kensington London for their permanent or loan collections such Architectural drawings made by me and such photographs and books and engravings water colours and other drawings prints pictures, china, stuffs, furniture and curios as the Trustees of the Victoria and Albert Museum may select.

Webb had made numerous gifts to the V&A over the years, and his bequest resulted in the acquisition of several hundred further works of art. Included among his Japanese possessions was an album consisting primarily of woodblock printed *uchiwa-e*. The album is recorded as having been entitled the *Uchiwa Gajō* (Album of Fans), but its cover was lost when it was subsequently broken up into individual sheets. Of the 162 sheets originally in the album, 47 were by Hiroshige (inventory numbers between E.4825-1919 and E.4985-1919).

With the arrival of the Webb Bequest, the V&A's collection of Hiroshige *uchiwa-e* reached its current scope. It includes 58 views of Edo, two of which are duplicate impressions (plates 18–19), made up of 48 designs in 23 series and nine one-off designs. There are 39 views of the provinces comprising 31 designs in 12 series and eight one-off designs. There are 21 prints, including two duplicate impressions (plates 99–100), dealing with themes from literature, legend, history and theatre. These are made up of 18

designs in 11 series and two one-off designs. Finally, there are eight prints depicting animals, flowers and still-lifes. These consist of six designs in two series and two one-off designs. This gives a total of 126 impressions of 124 designs. Strictly speaking only 122 of the designs are by Hiroshige, plates 117–18 being by Utagawa Kunisada I (1786–1864) and Utagawa Kuniyoshi (1797–1868), who contributed with Hiroshige (plate 116) to the same series of *Parodies of the Sanbasō Dance*.

Of the 48 series into which 103 of the 124 designs fall, only four are complete (plates 23–30, 47–9, 67–72 and 116–18), with a substantial number comprising only a single design. A further 48 designs belonging to 19 of the 44 incomplete series have been identified in other collections and publications. References are included under the relevant catalogue entries. More extensive research than it has been possible to undertake would undoubtedly result in the discovery of further matches. A number of promising but as yet unsubstantiated leads are to be found, for example, in unpublished lists compiled by the late Dutch collector R. de Bruijn and Sakai Gankō, Director of the Japan Ukiyo-e Museum.

As is apparent from the illustrations in this book, the collection contains a large number of fine impressions in excellent and sometimes pristine condition. The way in which the collection was assembled has resulted, however, in some inconsistencies of quality. There are 10 later printings (*atozuri*), which is to say prints taken from worn blocks in years following the initial publication of a design, and several impressions that do not quite qualify as *atozuri* but were taken from less than perfect blocks. There are also a substantial number bearing ribmarks from having once been mounted up as fans. In some cases the marks are barely discernible, but in others they are quite pronounced. The majority of prints with ribmarks come from the Webb Bequest of 1919, leading to speculation that the album in which they were formerly bound was assembled by a Japanese dealer who went about collecting old fans and unmounting them. If the ribmarks are in some cases so prominent as to be disfiguring, they do give an insight not afforded by better-preserved examples into Hiroshige's remarkable facility with the *uchiwa* format. As Strange observed in the passage earlier, the 'rigid boundaries of the object … implies a concentration of design on a central base, with radiating lines outwards and upwards; and he either follows or contrasts with these, with a sure instinct that defies criticism.'

If the Webb Bequest was the source of the great majority of later printings (*atozuri*) and ribmarked prints, it also included the evening view of Eitai Bridge in plate 1, the earliest and one of the most successful designs in the V&A's collection. This dates from the first half of the 1830s, the period when Hiroshige was engaged in producing many of his finest landscape series. It is followed by a small group of works from the second half of the 1830s. These include the fine pair of evening views in plates 4 and 5, the view of the Usui Pass and the Kumagaya Embankment in plate 59, and the colourful depiction of a cockerel and hen in plate 119. A subsequent highlight from the early 1840s is the exquisite rendering of a group of courtesans on an early morning outing in plate 10.

The period 1843–7, to which over 30 designs can be attributed on the basis of their single censor's seals, was particularly successful. There are many richly coloured depictions of sites in Edo (plates 14–30), some masterful views of the provinces (plates 62–5)

and a fine pair of still-lifes (plates 125–6). Hiroshige also applied his talents to the production of a number of extremely successful compositions illustrating themes from literature, legend, history and theatre (plates 98–110). This interest in what for him was a new genre was prompted at least in part by the Tenpō Reforms of 1841–3 and the ban that was imposed on the publication of depictions of actors and courtesans.

The period 1847–53, to which over 20 designs can be attributed on the basis of their dual censors' seals, was more mixed. With the exception of plate 35, most of the views of Edo are a little tired and pedestrian. This is in contrast to the views of the provinces, which are generally rather successful. The latter include some splendid depictions of the hot-spring resort of Hakone (plates 67–72 and 78–80), a wonderful view of Mount Fuji (plate 77) and some fine renderings of famous locations in the Kanazawa and Bōsō Peninsular areas (plates 81–2 and 85). Plates 112–13 are evidence of Hiroshige's continuing talent for illustrating literary and theatrical themes.

This more variable pattern continued up until Hiroshige's death in 1858. The V&A's collection includes more than 30 *uchiwa-e* designs from the last five years of his life, a period when prints can be dated extremely precisely on the basis of the cyclical year and month seal that appears in combination with the *aratame* censorship seal. Plates 47–9 are intriguing for the way in which the distance between the viewer and subject diminishes progressively with each design. In plates 54–6 the women are shown with their backs turned to the viewer, giving rise to a wonderful sense of peace and calm. This use of unusual compositional devices parallels what we find in Hiroshige's final and contemporaneous series of vertical format prints, the *Famous Views in the Sixty-odd Provinces*, the *One Hundred Famous Views of Edo* and the *Thirty-six Views of Mount Fuji*. Plates 86–8 and, more particularly, plates 89–93 include some of his most successful *uchiwa-e* renderings of views of the provinces. Hiroshige's 'hardly failing' powers, as Strange described them, are also reflected in his final works on literary and theatrical themes (plates 114 and 116). Like his late views of the provinces, these benefited from the employment by the publishers to whom Hiroshige supplied his designs of extremely skilled block-cutters and printers.

The Production and Consumption of Fan Prints

Their different format aside, woodblock printed *uchiwa-e* were made in exactly the same way as other kinds of *ukiyo-e* print. Their production was organised by publishers who would commission artists to create designs that, once they had been approved by a board of censors as being of a politically neutral and non-licentious nature, would be passed to block-cutters to prepare blocks from which printers would produce the final images. These were then sold and distributed by the publishers. Since artists, block-cutters and printers worked as independent entities, the success of a particular edition of prints depended very much on the ability of the publisher to coordinate their different skills. Furthermore, since *ukiyo-e* prints were made for popular consumption, publishers had to be sensitive to market demands and be able to anticipate the fickle tastes of their customers.

The first step in the production process was the preparation by an appointed artist of a preliminary sketch like the one in plate Ia or Ib. This is known as a *shita-e*. If the publisher approved this, it was then worked up by one of the artist's pupils or a copyist in

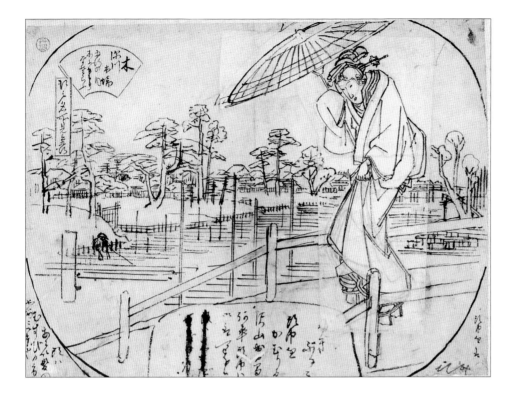

1a Preliminary sketch
(*shita-e*) for *Wood* from the
series *The Pride of Edo
Compared to the Five
Elements*; ink on paper; by
Utagawa Hiroshige I;
1843–7
By courtesy of the Kanagawa
Prefectural Museum of Cultural
History

1b Preliminary sketch
(*shita-e*) for *Earth* from the
series *The Pride of Edo
Compared to the Five
Elements*; ink on paper; by
Utagawa Hiroshige I;
1843–7
Purchased for the Museum by
The Donor Friends of the V&A;
photograph by courtesy of
Carolyn Staley Fine Japanese
Prints
V&A: FE.2-2001

II *Artisans* from the series
*Fashionable Likenesses of the Four
Classes of Citizen*; woodblock
print; by Utagawa Kunisada I;
1857
V&A: E.9984-1886

the employ of the publisher into what is known as a *hanshita-e*. This more elaborate and
finely detailed drawing had all the outlines, signatures and other text that would
appear in the finished print. The *hanshita-e* would be submitted by the publisher to the
censors. If approval was granted, censorship seals would be added to the drawing (see
Forrer 1997, no.136, for an example), which was then passed to the block-cutter.

The block-cutter would take the *hanshita-e* and paste it face down on to a block of
cherry wood cut in the direction of the grain. The upper layers of the paper would be
removed and oil rubbed in to make the remaining paper transparent and the drawing
more visible. The block-cutter would then carve away the wood between the areas and
lines of black. This is the process being undertaken by the woman in the right-hand
sheet of the triptych in plate II. Unused blocks can be seen on the floor behind and in
front of her. Given the sensitivity and evenness of line that was required, the cutting of
this keyblock or line-block demanded the highest of block-cutting skills. Registration
marks or *kentō* were added to a corner and an adjacent side of the block and a sequence
of proofs using black ink was taken. These are known as *kyōgōzuri*. In plate III part of
a registration mark can be seen in the bottom left-hand corner. The other mark, which
in this instance has been lost through trimming, would originally have been on the
right-hand side of the lower edge (see Forrer 1997, no.137, for an example with both
registration marks). The proofs were given to the artist to mark up with instructions
about which colours were to be used for which areas of the image. It was usual to use a
separate proof for each colour. These marked-up proofs were used by the block-cutter
to produce a sequence of colour blocks. This is what the woman at the back of the
middle sheet of plate II is doing. Because colour blocks consisted of flat areas rather

than fine outlines, they were easier to produce than keyblocks and could be entrusted to less experienced block-cutters. The registration marks on the proofs were transferred on to the colour blocks, thereby allowing the accurate registering of outline and colours during the subsequent process of printing.

Once the blocks were ready they were passed to the printer with instructions about colours and any special techniques to be used. The typical layout of a printer's studio is shown in the left-hand sheet of plate II. The order of printing depended on the combination of colours to be used, but usually the keyblock was printed in black first. As the woman at the front of the middle sheet of plate II is doing, the sheets of paper to be used for the edition were sized and dampened in advance. Smaller and lighter areas of colour were printed next, and larger and darker areas last. For each colour a water-based pigment was scrubbed on to the block with a thick, short-bristled brush. The sheet of paper was placed on to the block with the appropriate corner and edge carefully aligned, as they would have been when printing the keyblock, with the registration marks. A flat disc-shaped tool known as a *baren* was then used to rub the back of the paper, forcing the pigment deep into its fabric. The paper used for *ukiyo-e* prints was made from the long-fibred inner bark of the paper mulberry tree (*kōzo*) and was strong enough to withstand the considerable pressure exerted by the printer. Printing proceeded block by block, with the paper being kept in stacks between printings. This ensured that the moisture content of the paper remained constant and prevented problems of inaccurate registering that would have occurred had the paper been allowed to dry out and shrink.

III Keyblock proof (*kyōgōzuri*) of a design of chickens; woodblock print; by Katsushika Hokusai; 1832
V&A: E.1361-1916

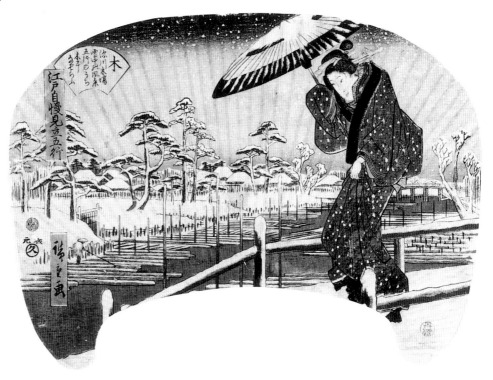

IV *Wood* from the series *The Pride of Edo Compared to the Five Elements*; woodblock print; by Utagawa Hiroshige I; 1843–7
By courtesy of the Kanagawa Prefectural Museum of Cultural History

There were a number of techniques that printers used to enrich the quality of their products. The most prevalent one was *bokashi* or tonal grading. This involved the partial wiping away of the pigment so that there was a gradation of colour across the block. Tonal grading was commonly used in the depiction of water and sky, and features regularly in the sorts of print, mainly landscapes or designs with landscape elements, illustrated in this book. *Mokumetsubushi* was a technique whereby the pattern of the grain of the woodblock was intentionally made to show through on the finished print. This can be seen in the sky behind the fireworks in plate 5, in the river in plate 36 and on the wall to the right of the hanging scroll in plate 125. *Barensuji* was a related technique that deliberately exploited the effects of the marks left by the *baren*. This can be seen in the grey background of plate 98. *Nunomezuri*, literally 'textile printing', was an elaborate technique whereby the imprint of a piece of textile glued to a block was transferred on to a print. This was usually followed by burnishing. This combination of techniques was used to provide the detail on the insect cage in plate 116.

An interesting aspect of the V&A's collection is the way in which all but a couple of the prints acquired in 1886 (inventory numbers E.12065-1886 to E.12092-1886) have traces of mica scattered across their surfaces. This is particularly apparent, for example, in plates 86–93. Since none of the other prints shares this feature, the likelihood is that the mica was applied for decorative purposes when the prints were mounted up, as they once were, in an album.

Plate IV is the final outcome of the lengthy and complicated process that began with the preparation of the sketch in plate Ia. The ribmarks radiating from its centre show that it was once mounted up as a fan like that in plates V and VI. A notable aspect of this and the few other Edo period woodblock printed fans that survive in Japanese museums is that they all have polychrome designs on the front and monochrome

designs on the reverse. The V&A's collection contains a number of simply coloured compositions like that in plate 75, but nothing quite as plain as the design in plate VI. *Aizuri* or monochrome blue *uchiwa-e* were, it should be observed, a special category. With the exception of plate 11, all the examples in the V&A are at least as, if not more, sophisticated than their polychrome counterparts. The relative prevalence of *aizuri* fan prints can be explained by the association of coolness with the colour blue. The prints in plates 64–5 and 78–80 differ from the others in not having a section cut away or blanked out from the bottom. They were intended to be mounted, as in the case of plates 64–5 they once were, on a framework of radiating splints with a handle that clipped over the centre of the lower edge (see plate XI).

In the fan shop illustrated in plate VII the man behind the sliding door can be seen mounting a print on to a bamboo frame. Finished fans with all manner of designs hang in rows along the back of the shop. Two women compare the merits of different designs, while the mistress of the house is engaged in conversation with a male customer. By Hiroshige's time it was common to buy fans from shops like this, but in the eighteenth century it was more usual to buy them from itinerant merchants like the one depicted in plate VIII. According to an early nineteenth-century source, the busiest time for the sale of fans was early summer, and it was no doubt with this in mind that fan-print publishers organised their production cycle (Fujisawa 1999, p.3).

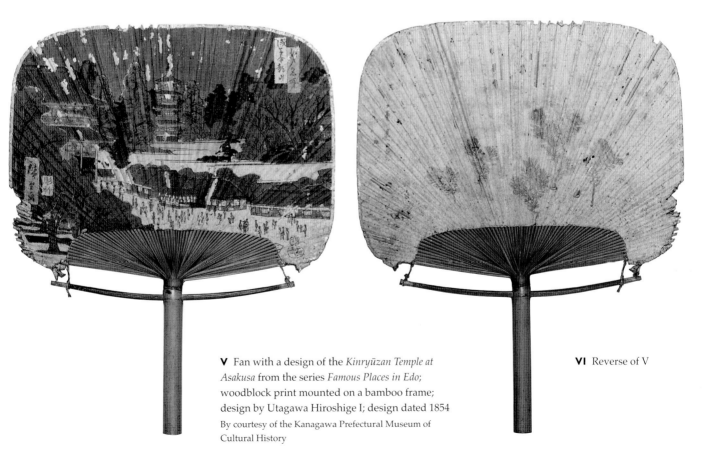

V Fan with a design of the *Kinryūzan Temple at Asakusa* from the series *Famous Places in Edo*; woodblock print mounted on a bamboo frame; design by Utagawa Hiroshige I; design dated 1854
By courtesy of the Kanagawa Prefectural Museum of Cultural History

VI Reverse of V

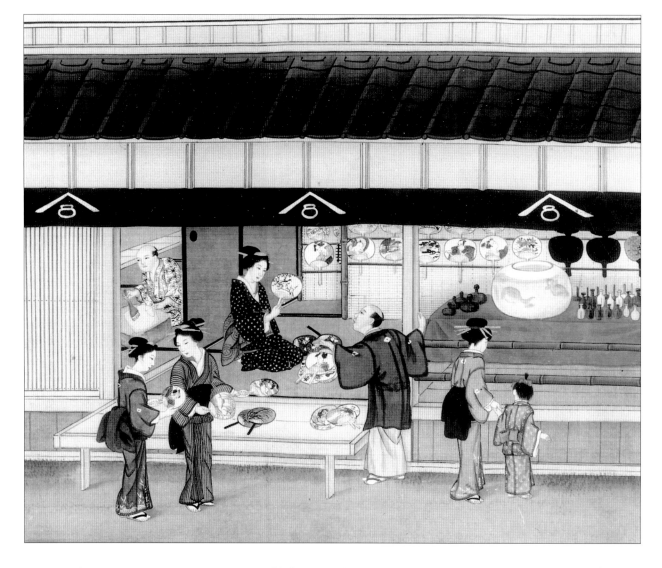

VII A Fan Shop; colours on silk; anonymous; early 1800s
By courtesy of the Bibliothèque nationale de France

Fan-print publishers or *uchiwa toiya* operated separately from *jimoto toiya*, the publishers of illustrated books and standard-format prints. They belonged to their own merchant association, one of numerous monopoly organisations established during the Kyōhō era (1716–36). These arrangements were suspended in 1842 as part of the Tenpō Reforms. As a result several *jimoto toiya* began to publish fan prints, and a number of the larger *uchiwa toiya* branched out into the publication of standard-format prints. When the system of merchant associations was reinstated in 1851, several former *jimoto toiya* registered as *uchiwa toiya* (Fujisawa 1999, pp.4–5). This and the care invested in the production of the sorts of designs illustrated in this book suggest that the making and selling of woodblock-printed *uchiwa* was a potentially lucrative business.

Of the 124 designs in the V&A's collection, nine were published anonymously and a further five have unidentified publishers' marks. The remaining 110 designs were published by a total of 13 publishers. The most important by far was Ibaya Senzaburō,

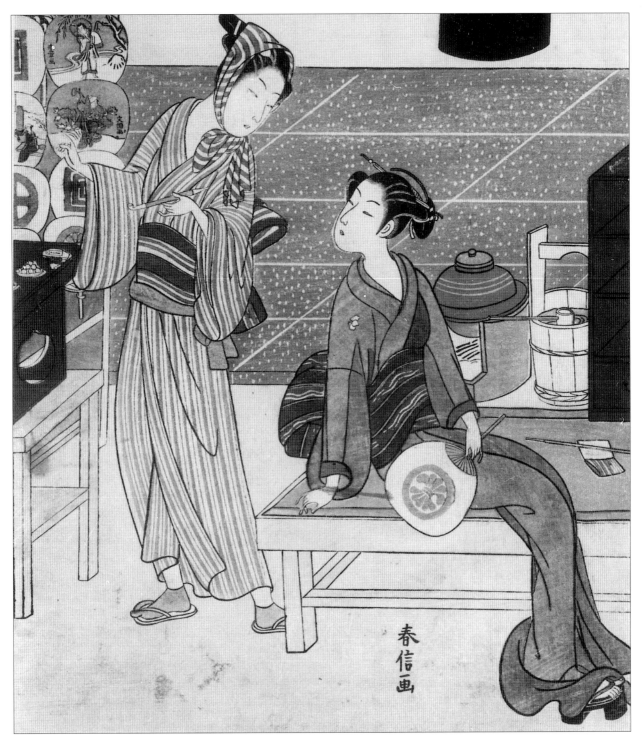

who published 41, the majority of them to the very highest of standards. Next in importance, responsible for in the region of 10 designs each, were Ibaya Kyūbei, Enshūya Matabei, Iseya Sōemon and Tsujiya Yasubei. Like Ibaya Senzaburō, these were all specialist fan publishers. The only *jimoto toiya* to have produced any designs of note was Sanoya Kihei.

VIII Osen and the Fan Seller; woodblock print; by Suzuki Harunobu (1724–70); late 1760s
By courtesy of the Tokyo National Museum

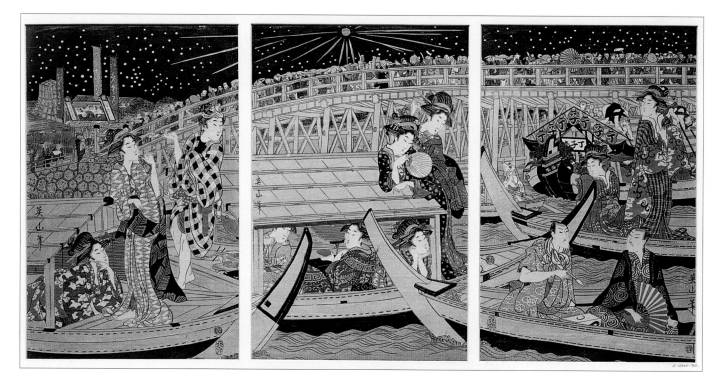

IX Fireworks at Ryōgoku
Bridge; woodblock print; by
Kikugawa Eizan (1787–1867);
1807
V&A: E.13305-1886

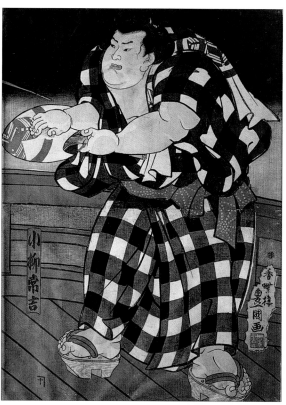

X Koyanagi Tsunekichi on
Ryōgoku Bridge (detail from a
double triptych); woodblock
print; by Utagawa Kunisada I;
1843-7
V&A: E.1133-1912

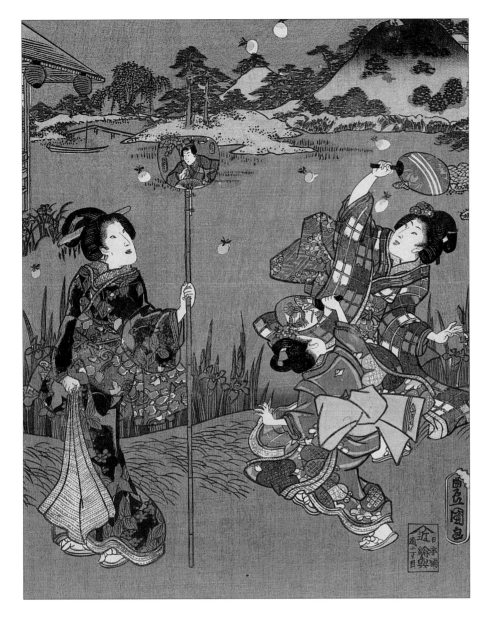

XI Catching Fireflies by a Pond
(detail from a triptych);
woodblock print; by Utagawa
Kunisada I; 1847–52
V&A: E.8211-1886

Plates IX–XII illustrate fans in use during the heat of the Japanese summer. Plate IX shows revellers taking in the evening cool on the waters of the Sumida river. Crowds throng the Ryōgoku Bridge behind them as fireworks light up the night sky above. The fan held by the courtesan leaning languorously on the roof of the boat in the middle sheet is simply decorated with a pattern of radiating lines. This is probably the reverse of the fan, the side we can not see being decorated with a more elaborate design. The fan held by the man in the foreground of the right-hand sheet is an *ōgi* or folding fan, the other main type of fan used in Japan. Plate X takes us up on to Ryōgoku Bridge itself. The massive figure holding a commensurately enormous fan is Koyanagi Tsunekichi, a famous sumo wrestler of his time. Plate XI shows fans being used in the popular pastime of firefly catching. Like the examples that appear in plates IX–X, the fan attached to the bamboo pole held by the woman on the left has the open structure with a cut-away section of the sort for which the majority of the Hiroshige examples in

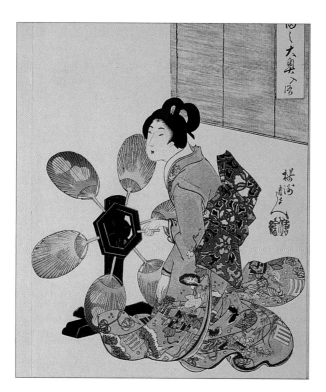

XII Ōoku of Chiyoda (detail from a triptych); woodblock print; by Toyohara Chikanobu (1838–1912); mid-1890s
By courtesy of the Edo-Tokyo Museum

this book were designed. This is different from the fans held by the woman and child on the right, which are of the type with a handle that clips over the lower edge. Plate XII shows an interesting use of fans in a hand-powered version of what in the twentieth century developed into the electric fan.

The images in this book can be enjoyed at a number of levels. As the catalogue entries make apparent, they tell us much about the customs and preoccupations of the society and age in which Hiroshige lived. Also, as suggested earlier, the landscape designs that constitute the bulk of his oeuvre are compelling lenses through which to view the rural and urban topography of mid-nineteenth-century Japan. It must, however, be borne in mind – as Henry Smith has observed – that Hiroshige was in the business of 'selling images of places, not documentary photographs' (Forrer 1997, p.39). If his views of Edo were based on direct observation, he felt no compunction about rearranging the scenery in order to emphasise the characteristics of a particular locality or in the interests of compositional effect. In the case of his views of the provinces, only a few areas of which he is recorded as having actually visited in person, Hiroshige frequently based his designs on illustrations in published gazetteers. This was also true of some of his views of Edo. The similarities between many of the images in this book and Hiroshige's standard-format prints suggest that he had a stock of designs that he repeatedly reworked in his studio. He went out to sketch, certainly, but direct observation as a means towards the accurate representation of place was not of primary concern. His aim was to produce images that would appeal to consumers for whom travel was an increasingly important part of their lives, both in terms of business and leisure. This led to a selectivity of subject matter – a focusing on *meisho* or famous places – and an aesthetic emphasis, often quite abstract, on composition and colour.

In its concentration on *uchiwa-e*, this book deals with a relatively uncharted aspect of Hiroshige's work. The 124 designs represent between a third and a quarter of his work in the field, which in turn constitutes about a tenth of his total output of *ukiyo-e* designs. Compared with other artists, this is a relatively high figure. Hiroshige was clearly much in demand for, and took pleasure in, rising to the challenge of working in this exacting but potentially gratifying format. The attention given here to this facet of Hiroshige's work will result, it is hoped, in a fuller and more rounded understanding of the achievements of one of Japan's most respected artists.

The Catalogue

Introductory Note

The catalogue entries that follow consist of basic captions followed by passages of explanatory text. The captions give information on picture and series titles, artist signatures and seals, publishers, censor and date seals, and dates. Engravers' seals are also recorded in the few instances that they appear. Picture and series titles written in italic are translations followed in brackets by transcriptions of the titles that physically appear on the designs. Those in normal text are ascribed titles. Italic is also used for transcriptions of signatures and seals, which are mainly artist signatures and artist, censor and date seals. Publishers are recorded in accordance with the listing in *GUDJ* (vol.3, pp.134–48). The prints in each of the four sections of the catalogue are arranged chronologically. These are:

 1 Views of Edo (plates 1–58)
 2 Views of the Provinces (plates 59–97)
 3 Literature, Legend, History and Theatre (plates 98–118)
 4 Animals, Flowers and Still-lifes (plates 119–26).

Censor and date seals, which are recorded in accordance with the tables in *GUDJ* (vol.3, pp.126–32), are the basis for the dating of the majority of the prints. The *GUDJ* chronology has been followed except in the case of the dual censor-seal period 1846/12–1852/2, for which the more detailed system of dating proposed in Satō (1998) has been used. Designs that do not have censor or date seals, or can not be dated solely according to their censor seals, have been dated on the basis of the style of the artist signature. Chronologies of the changing style of Hiroshige's signature are published in a number of sources, the most detailed and authoritative being Kobijutsu (1983), Suzuki (1970), Tanba (1965) and Uchida (1932).

The explanatory information that follows the hard captions has been drawn from three major sources. Firstly from standard dictionaries and encyclopedias, as well as, secondly, from more specialist dictionaries and handbooks such as *GUDJ*, Halford (1956), Hamada (1973), Nishiyama (1984) and Waley (1984), and, finally, from publications devoted specifically to Hiroshige, most notably Hori (1996 and 1997), Smith and Poster (1986) and Suzuki and Ōkubo (1996). Use has also been made of numerous insights provided by Satō Satoru and the information in a set of preliminary catalogue entries compiled in 1997 by Paul Griffith of Saitama University.

The locations of the views of Edo in plates 1–58 are shown on the map of the city (see page 29). Grid references to the maps published in Shiraishi (1993) have been given wherever possible (in square brackets). In the case of plates 42 and 44 the references are to maps in Hori (1996). The locations of the views of the provinces in plates 59–97 are

shown on the map of Japan (see pages 8–9). Those that feature in the designs dealing with literary or legendary themes in plates 98–118 are also indicated on both maps. The naming of districts in Edo is based on the titles of the mid-nineteenth-century maps reproduced in Shiraishi (1993) and Hori (1996). Elsewhere the principle has been followed of using modern prefectural as opposed to historical provincial names.

For designs identified in other collections and publications belonging to incomplete V&A series, only a single reference is given even though the design may appear in more than one publication and/or be represented in more than one collection. References to designs in other collections are made only when published illustrations do not exist. For designs that have been published, the source is quoted in the following order of precedence: Matsuki (1924), Sakai (1996), Ōta Memorial Museum (1998). Only if the design is not published in any of these three sources is an alternative reference given. References to duplicates of, and to already existing, illustrations of designs in the V&A's collection are not included. Prior to this book, the most comprehensive coverage of the V&A's collection of Hiroshige *uchiwa-e* was provided by Strange (1925), though this has relatively few illustrations, and *Hizō Ukiyo-e Taikan* (vol.5), which has 26 colour plates with extended commentaries and a further 15 black-and-white plates with short captions.

In Hiroshige's time woodblock *uchiwa-e* were printed on paper of a standard size known as the *aiban*. Measuring approximately 235×330mm (giving an image size in the region of 220×290mm), this was smaller than the 265×390mm *ōban* used for standard-format prints. With only a few exceptions, all the designs in this book are of *aiban* size. Due to different degrees of trimming, especially among examples that have been salvaged from made-up fans, there are minor variations, but not so great as to warrant individual recording of sizes. Dimensions have been omitted, therefore, except in the case of the three non-standard-size works in plates 2 and 64–5.

It should also be noted that in the interests of visual consistency all the designs have been illustrated as cut-outs, that is without the surrounding borders of the rectangular sheets of paper on which they were originally printed. These no longer exist in the case of prints salvaged fron made-up fans but are preserved, with various degrees of trimming, on the majority of the examples that survived being mounted up.

Locations of scenes shown in fan prints, in and around Edo

I | Views of Edo

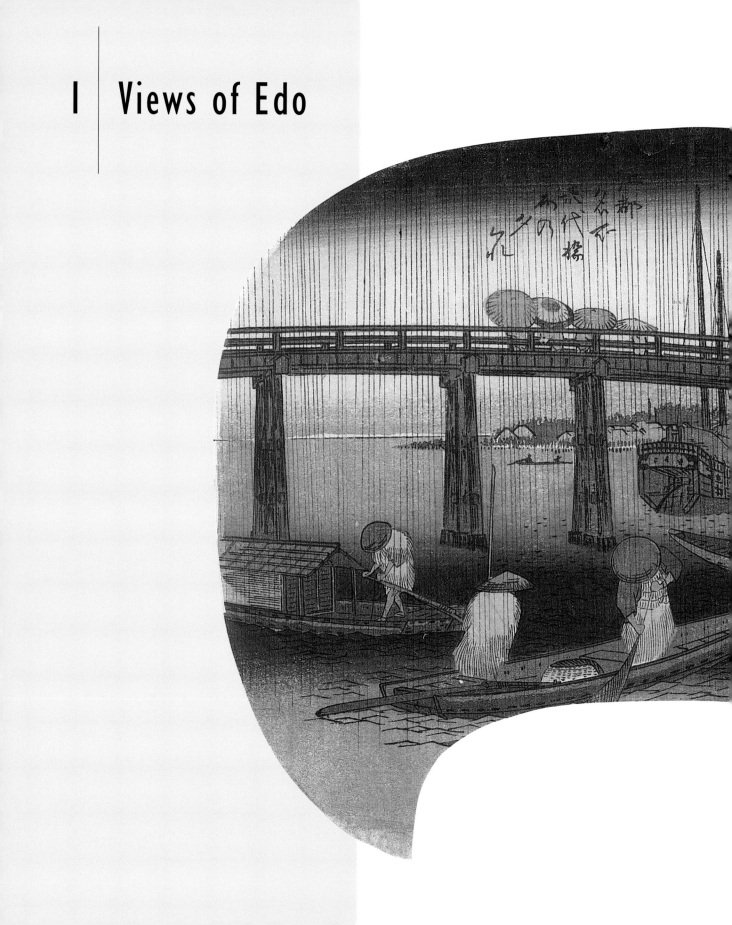

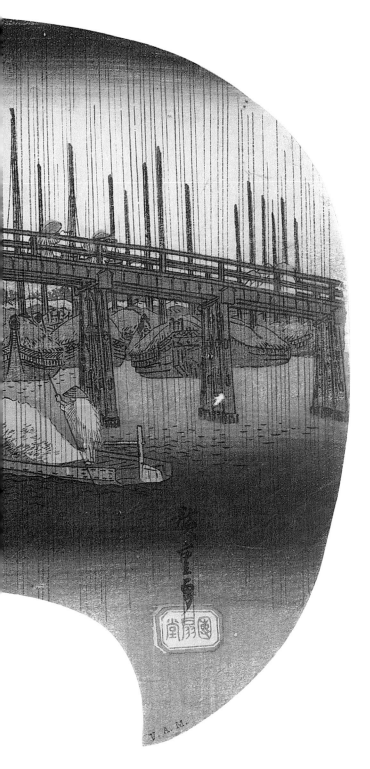

Plate 1

Eitai Bridge in the Evening Rain (*Eitaibashi Ame no Yūgure*), from the series *Famous Places in Edo* (*Edo Meisho*)
Signed *Hiroshige ga*
Published by Ibaya Senzaburō
About 1830–5
V&A: E.4938-1919

Spanning the Sumida river just before it widened into Edo Bay, the Eitai Bridge was completed in 1698 as a link between the Southern Nihonbashi district and the increasingly populous Honjo Fukagawa district to the east [Shiraishi 1993, 7I10/21J4]. The view in this print is from the north looking towards the island of Tsukudajima, a small area of land reclaimed from Edo Bay in 1645–6 as the port for a group of fishermen in the employ of the Tokugawa shogunate [Shiraishi 1993, 5J3; see plate 29]. The large boats beyond the bridge are cargo ships laden with goods from western Japan. The shallowness of Edo Bay meant that they had to anchor offshore and transfer their cargo on to smaller boats, like the one on the near right, for shipment to the quays and warehouses that lined the canals of the city. The vessel on the near left is a roof-boat (*yanebune*), a commonly encountered form of pleasure craft, while that in the immediate foreground is a fishing boat.

Dating from the early 1830s, this is not only one of Hiroshige's earliest-known *uchiwa-e* designs but also one of his most successful. The slanted umbrellas on the bridge and the stooping forms of the boatmen in their straw capes struggle against the intensity of the evening rain, which pours down in heavy, vertical streaks. The darkness of the lowering sky is echoed in the blue of the water above the bridge, where the three boats, each pointing in a different direction, seem momentarily transfixed.

The red seal below the artist's signature reads *Dansendō*, the shop name (*yagō*) of the publisher Ibaya Senzaburō. No other designs from the series are known.

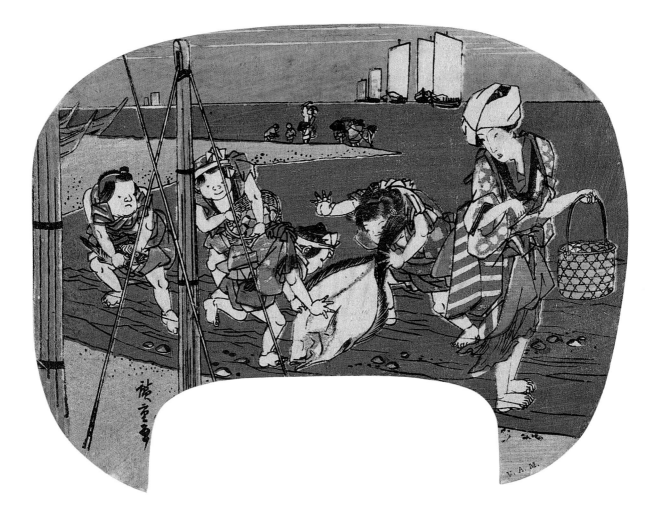

Plate 2

Woman and Children by the Sea

Signed *Hiroshige ga*

Published anonymously

About 1835

225 × 169mm

V&A: E.4906-1919

The location in this view is somewhere along the Takanawa shoreline in the southern part of Edo. The boats sailing in the distance across Edo Bay are the same sorts of cargo ships seen anchored to the south of Eitai Bridge in plate 1. The woman and children are gathering shellfish and catching fish, the two boys in the centre grappling with a large flounder they have just landed. The style of the design, particularly the depiction of the woman, is reminiscent of the work of Keisai Eisen (1790–1848). This corroborates the mid-1830s dating suggested by the style of the artist's signature. The broken black lines and inaccurate registering of the colours indicate, however, that this particular impression is a later printing (*atozuri*). An unusual aspect of the design is its small size.

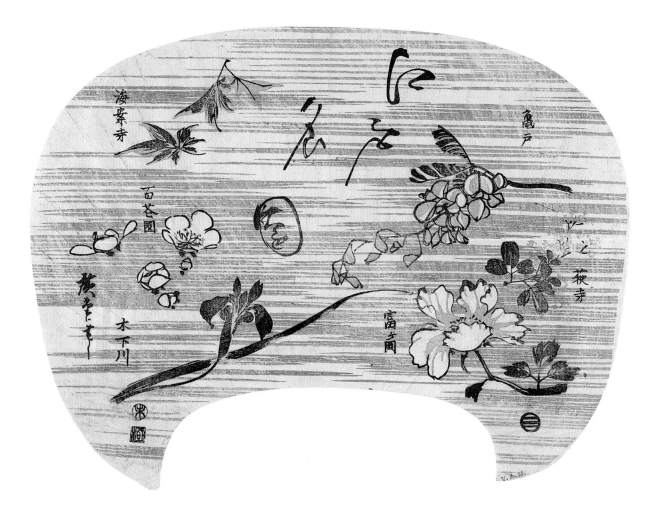

Plate 3
Famous Gardens in Edo (*Edo Meien*)
Signed *Hiroshige hitsu*
Published by Ibaya Senzaburō
Censorship seal *kiwame*; date seal *Sheep* (1835)
1835
V&A: E.4939-1919

A later printing (*atozuri*) like the work in plate 2, this casually executed and simply coloured early design gives the names of six gardens in Edo alongside depictions of the plants for which they were famous. These are, clockwise from top right, wisteria at Kameido, bushclover at Hagidera, peonies at Tomigaoka, irises at Kinegawa, plum blossoms at Hyakkaen and maples at Kaianji. Kameido is the Kameido Tenjin Shrine, located

in the northeastern part of the Honjo district [Shiraishi 1993, 20A6; see plates 12 and 34]. Hagidera is an alternative name for the Ryūganji Temple, located just north of the Kameido Tenjin Shrine [Shiraishi 1993, 20B7]. Tomigaoka is the Tomigaoka Hachiman Shrine, also known as the Fukagawa Hachiman Shrine, located in the southwestern part of the Honjo Fukagawa district [Shiraishi 1993, 21G2]. Kinegawa was in the central eastern part of the Mukōjima district [Shiraishi 1993, 19C4; see plate 20], while Hyakkaen was a celebrated plum garden in Terashima-mura in the central western part of Mukōjima, near the bank of the Sumida river [Shiraishi 1993,19I6]. Kaianji, famous for the colour of its autumn foliage, was located in the vicinity of the Tōkaiji Temple at the southern (Shinagawa) end of the Takanawa district [Shiraishi 1993, 23A8].

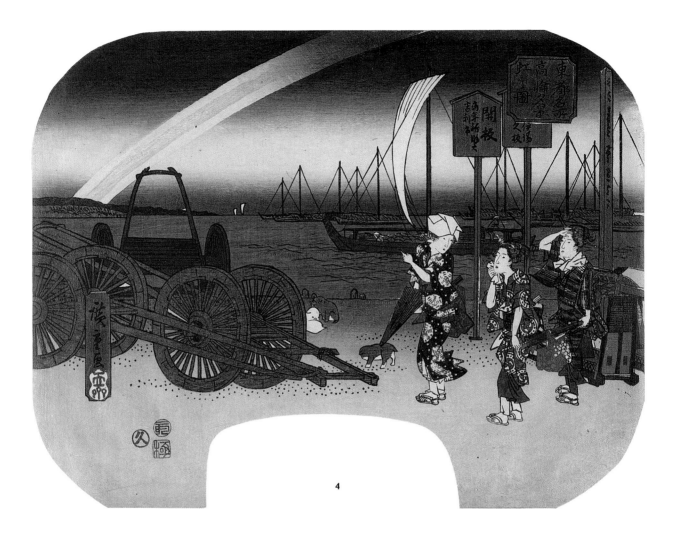

4

Plate 4

Evening View with a Rainbow at Takanawa
(*Takanawa Yūkei Niji no Zu*)

Plate 5

Distant View of Fireworks at Ryōgoku
(*Ryōgoku Hanabi Enbō no Zu*)

Two designs from the series *Famous Places in the Eastern
Capital (Tōto Meisho)*
Signed *Hiroshige ga*, with seal *Ichiryūsai*
Published by Ibaya Kyūbei
Censorship seal *kiwame*; date seal *Boar* (1839)
1839
V&A: E.546-1911, E.2930-1913

These two duskily evocative designs explore different
qualities of light in the evening sky. The oxcarts beneath
the rainbow on the left of plate 4 suggest that we are in
Kuruma-chō, an area on the Takanawa shoreline where
oxen were kept to help with urban construction projects
[Shiraishi 1993, 23F5]. The text on the billboard behind
the red cartouche reads *Ibakyū han*, meaning 'published
by Ibakyū', and that on the billboard to the left *tōnen
shinchō daikichi rishi*, meaning 'in the hope that this print,
newly designed [literally 'carved'] this year, will sell
profitably'.

The fireworks over Ryōgoku Bridge depicted in plate 5
were a regular feature of Edo life during the hot months
of summer [Shiraishi 1993, 8J2/20J1]. They could be
enjoyed from the bridge itself, from pleasure boats and

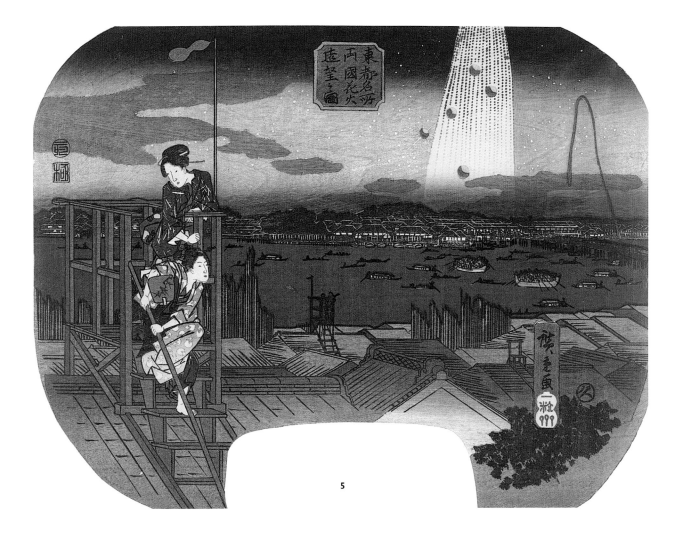

5

restaurants on and along the banks of the Sumida river,
or, as here, from the rooftops of distant houses. The way
in which the river curves away to both left and right
suggests that the view is taken from the Asakusa district
to the northwest. The summer season at Ryōgoku
officially opened on the twenty-eighth day of the fifth
month with the staging of the *Kawabiraki* or 'Opening the
River' ceremony. From then until the early autumn it
was thronged by visitors intent on taking in the cool of
the evening, a custom known as *yūsuzumi*.

One other design from the series is known. This is a
view of the moon rising above the sterns of cargo ships
moored off the island of Tsukudajima (Sakai 1996,
no.1400).

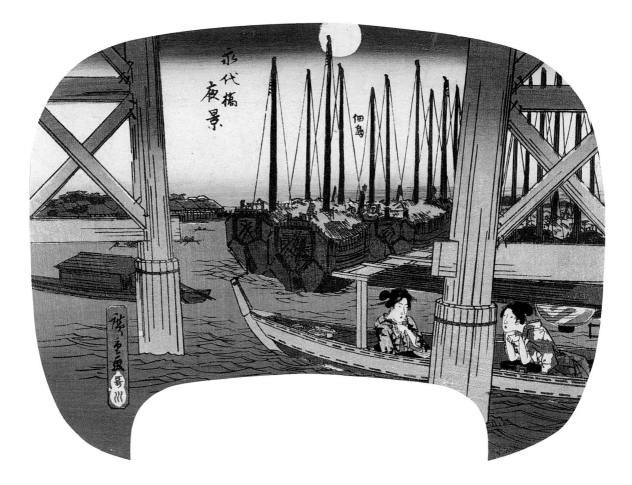

Plate 6

Night View at Eitai Bridge (*Eitaibashi Yakei*)
Signed *Hiroshige ga*, with seal *Utagawa*
Published by Sanoya Kihei
About 1840–2

V&A: E.4870-1919

This moonlit view is taken from the Sumida river almost immediately below the Eitai Bridge, which we have seen depicted from a more northerly vantage point in plate 1 [Shiraishi 1993, 7I10/21J4]. It is as if the viewer has moved downstream to the western side of the bridge and is looking south and southeastwards over Edo Bay. The buildings on the left mark the southwestern extremity of the Honjo Fukagawa district, while the presence of the island of Tsukudajima behind the anchored cargo ships is indicated by the two characters below and slightly to the right of the moon [Shiraishi 1993, 5J3]. The paper lantern partially visible in the boat to the right is marked with the katakana characters for *hi* and *ro*, the first two syllables of Hiroshige's name.

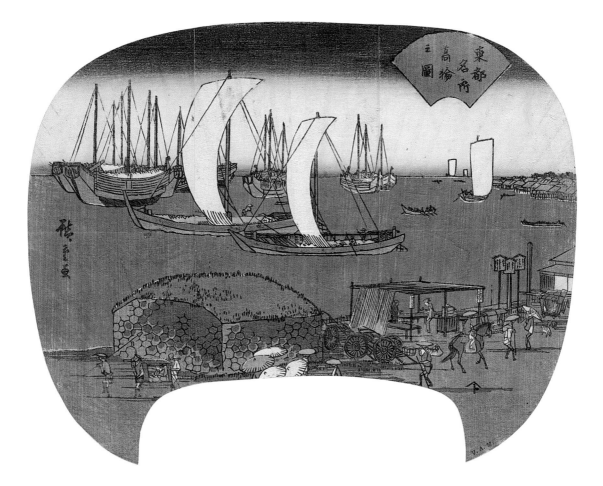

Plate 7

View of Takanawa (*Takanawa no Zu*), from the series
Famous Places in the Eastern Capital (*Tōto Meisho*)
Signed *Hiroshige ga*
Published by Enshūya Matabei
About 1840–2
V&A: E.4920-1919

The rainy scene in this later printing (*atozuri*) of an early 1840s design is set on the Takanawa shoreline at the northern end of Kuruma-chō, which we have seen depicted in plate 4 [Shiraishi 1993, 23F5]. The more distant vantage point brings a wider sweep of the coast into view, and the atmosphere is one of bustling daytime activity rather than the tranquillity of evening. The oxcarts in the middle foreground are the same as those in plate 4, and there is a similar arrangement of billboards to the right. The area between these is occupied by a temporary tea stall, and to the left there is a large grass-covered construction. This is part of the remains of the Ōkido, the gate that marked the official southern boundary of Edo.

The ribmarks visible towards the top of the print are evidence that it was salvaged from a made-up fan. No other designs from the series are known.

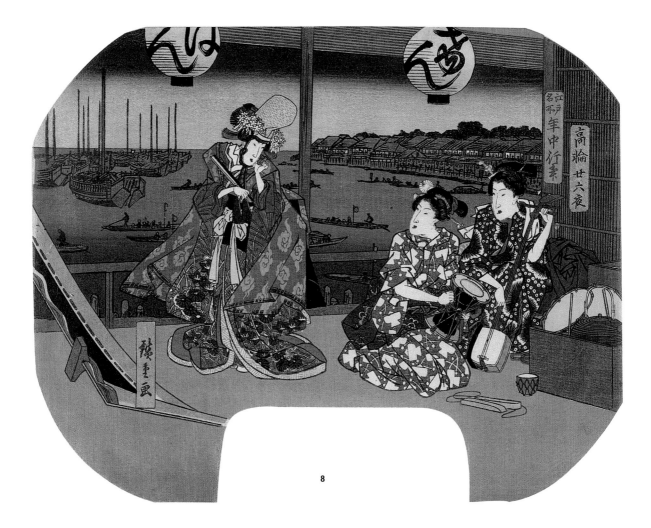

8

Plate 8

The Twenty-sixth Night at Takanawa
(*Takanawa Nijūrokuya*)

Plate 9

Low Tide at Susaki (*Susaki Shiohi*)

Two designs from the series *Annual Events at Famous
Places in Edo* (*Edo Meisho Nenjū Gyōji*)
Signed *Hiroshige ga*
Published anonymously
About 1840–2
V&A: E.542-1911, E.574-1913

With plate 8 we move to the northern part of the
Takanawa district, where buildings lined both sides of
the Tōkaidō Highway. The characters on the paper
lanterns read *kenban*, indicating that this is a geisha
administrative office being used by the three courtesans
for a practice session. The woman in the centre is dressed
as a *shirabyōshi* or itinerant female dancer, while those on
the right prepare to accompany her with a shoulder
drum and *shamisen*. On the left is a stage prop in the form
of a cut-out boat, and on the floor to the right is a pair of
wooden clappers of the sort used in the Kabuki theatre.
These, the dancer's costume and the configuration of
musical instruments suggest that the performance will
be a *nagauta*-accompanied rendering of the *Asazumabune*
dance. The twenty-sixth night of the title is that of the

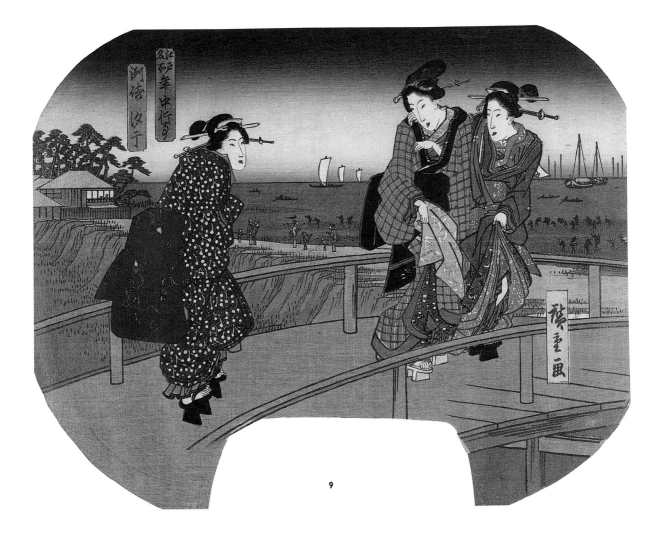

9

seventh month, on which it was customary, as in the first month, to celebrate the rising of the moon. Takanawa was a favoured location for viewing the moon and was particularly busy at this time of the year.

Plate 9 takes us to the southern (Shinagawa) end of the Takanawa district to the spit of land (*susaki*) that extended out from the mouth of the Meguro river, channelling it northwards into Edo Bay [Shiraishi 1993, 23B8]. Susaki was a popular place for viewing the sunrise on New Year's Day (see plate 47), but here the focus of activity is the gathering of shellfish in the shallow waters visible behind the courtesans on the bridge. The building to the left is a restaurant next to the entrance of the Susaki Shrine. Dedicated to Benten, the goddess of water, this nestled among a grove of pine

trees, here partially visible behind the restaurant, at the very northern end of the spit.

Five other designs from the series are known. They depict a visit to the Ōji Shrine (Sakai 1996, no.1389), a visit to the Umewaka Mound in the grounds of the Mokuboji Temple (Sakai 1996, no.1391), the Tanabata Festival at Yushima (Sakai 1996, no.1393), the Daikoku Dance in the Yoshiwara (Sakai 1996, no.1394) and the 'Opening the River' ceremony at Ryōgoku (Matsuki 1924, no.79).

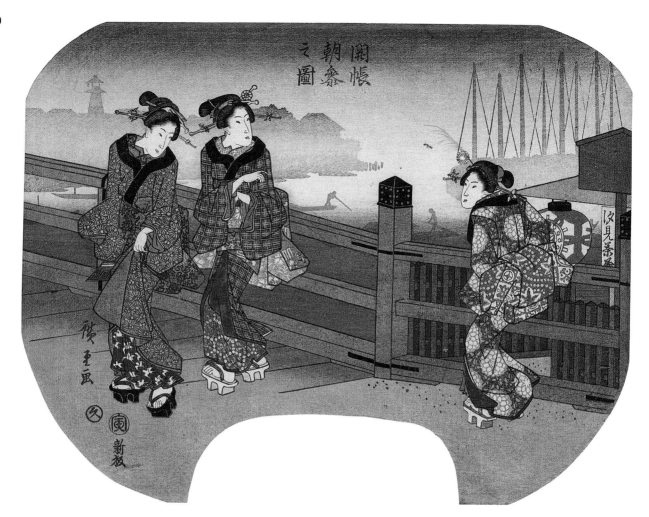

Plate 10

Visiting a Temple at Dawn (*Kaichō Asamairi no Zu*)
Signed *Hiroshige ga*
Published by Ibaya Kyūbei
Date seal *Tiger* (1842)
1842
V&A: E.538-1911

This quietly atmospheric depiction of three courtesans on an early morning outing is one of the most successful of Hiroshige's *uchiwa-e* designs. Shades of grey softened by tonal grading (*bokashi*) provide a misty background to the strong geometric lines of the bridge and the solid forms of the three women. The colours of the sky and river are echoed in the blues and greys of the women's outer garments, subdued foils for the accents of red at hem, sleeve and collar, and for the bright-red sash worn by the younger woman on the right. The breadth of the

river and the masted cargo boats moored in the background suggest that we are standing at the western end of the Eitai Bridge looking towards Edo Bay and the Honjo Fukagawa district [Shiraishi 1993, 7I10/21J4]. The teahouse on the right with its large paper lantern is called the Shiomi Chaya, literally 'Tide-viewing Teahouse', an appropriate name for an establishment near the mouth of the Sumida river. The *kaichō*, literally 'curtain-opening', of the title of the print refers to the practice of shrines and temples revealing to the public on certain days of the year religious icons that were normally hidden from view or treasures borrowed from other religious establishments. In this case the three women are on their way to the Tomigaoka Hachiman Shrine, which lay a short distance across the river to the east (see plate 3). The characters below the date seal on the lower left read *shinpan*, meaning 'newly published'.

Plate 11

The ***Okina Inari Shrine at Nihonbashi*** (*Nihonbashi Okina Inari*), the ***Myōken Hall at Yanagashima*** (*Yanagashima Myōken*) and the ***Ryōdaishi Hall at Ueno*** (*Ueno Ryōdaishi*)
Signed *Hiroshige ga*
Published by Ibaya Kyūbei
About 1843–4
V&A: E.4925-1919

This *aizuri* or monochrome blue *uchiwa-e* is interesting for the way it is made up of three smaller fan designs. It has been salvaged, as the ribmarks indicate, from a made-up fan and was printed, judging from the broken outlines, from relatively worn blocks. The three views are of popular religious sites in Edo.

The Okina Inari Shrine (right) was a small shrine situated to the immediate southeast of Nihonbashi, the bridge that was the geographical and symbolic centre of both Edo and Japan as a whole [Shiraishi 1993, 7J3]. One of scores of shrines in Edo and the Kantō hinterland dedicated to the harvest god Inari, it enjoyed a spell of

intense popularity in the late 1830s for the good luck it was believed to bring to those who visited and gave offerings.

The Myōken Hall (centre) was situated in the northeastern part of the Honjo district next to where the Yanagishima Bridge, seen here from the north, crossed the Yokojukkengawa Canal at its meeting point with the Kitajukkengawa Canal [Shiraishi 1993, 20B8]. Part of the Honshōji Temple complex, it was named after the image of the Bodhisattva Myōken that it housed. This was the focus of a religious cult subscribed to by large numbers of Edo residents, including the *ukiyo-e* artist Katsushika Hokusai (1760–1849).

The Ryōdaishi Hall (left), set in the expansive wooded surroundings that we see, was located next to the Gohonbō or Chief Priest's Residence of the Kan'eiji Temple in the northeastern corner of the Shitaya district [Shiraishi 1993, 16I7]. It was the memorial hall of Tenkai, also known as Jigen Daishi, who founded the temple in 1625 as the Edo equivalent of the Enryakuji temple complex on Mount Hiei to the northeast of Kyoto.

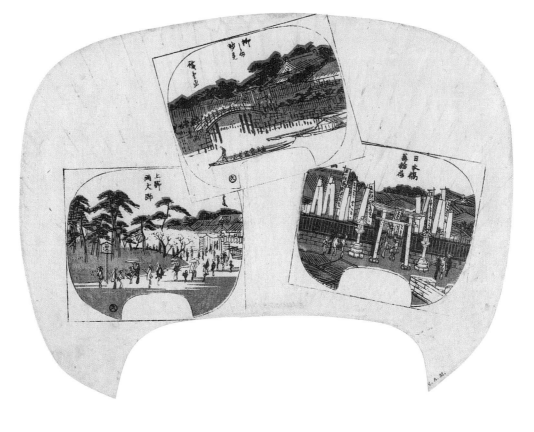

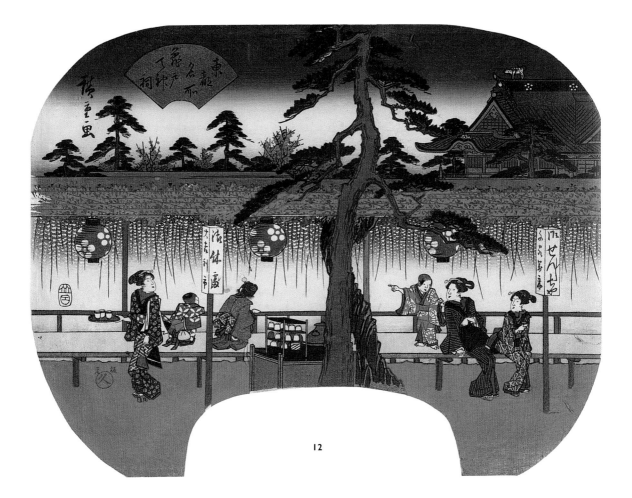

12

Plate 12
The Kameido Tenjin Shrine (*Kameido Tenjin Yashiro*)

Plate 13
Viewing Lotus Flowers at the Shinobazu Pond at Ueno
(*Ueno Shinobazu(no)ike Hasu no Hanami*)

Two designs from the series *Famous Places in the Eastern Capital* (*Tōto Meisho*)
Signed *Hiroshige ga*
Published by Ibaya Kyūbei
Censor's seal *Fu*
1843–7
V&A: E.537-1911, E.4924-1919

The Kameido Tenjin Shrine, visible to the upper right of plate 12, lay in the northeastern part of the Honjo district across the Yokojukkengawa Canal from the Myōken Hall and Honshōji Temple complex of plate 11 [Shiraishi 1993, 20A6]. It was built in the early 1660s as part of the development of the area to the east of the Sumida river, begun after the devastation of the central part of Edo by the Meireki fire of 1657. It was and still is famous for its purple-flowering wisteria and its *taikobashi* or drum bridge (see plate 34). The view here is of wisteria trellises along the eastern shore of the pond in the centre of the shrine grounds. The signs on the trellis supports read (from right to left) *osenjicha / senkyaku banrai*, meaning 'tea / that many clients should come', and *oyasumidokoro / daikichi rishi*, meaning 'resting place / that business should flourish'.

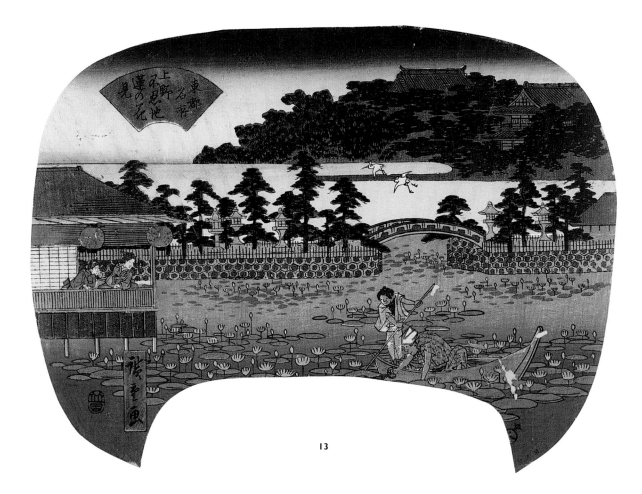

13

The flowering lotuses in plate 13 can still, like the wisteria in plate 12, be enjoyed today. The location is the Shinobazu Pond on the southeastern edge of the Hongō district [Shiraishi 1993, 9E10]. The building to the left is a restaurant or tea house on the southeastern corner of the island in the middle of the pond, home to a much visited shrine dedicated to Benten, the goddess of water. In the background, behind the bridge linking the island to the mainland, are buildings forming part of the Kan'eiji Temple complex (see plate 11). The ribmarks visible towards the top of the print indicate that it was salvaged from a made-up fan. The broken outlines and less than perfect registering of the colours – both evident in the fan-shaped cartouche, for example, and in contrast to the sharpness of execution of the design in plate 12 – suggest that the print was taken from partially worn blocks.

At least three other designs from the series are known. They are depictions of the Onmayagashi ferry crossing in the rain (Matsuki 1924, no.21), the seashore at Takanawa (Matsuki 1924, no.22) and a view towards Edo Bay from the summit of Mount Atago (Matsuki 1924, no.30). A further design executed in shades of red and grey only but otherwise bearing the characteristics of the series depicts the Shōten Shrine at Matsuchiyama with the Asakusa Kannon Temple in the background (collection of the Japan Ukiyo-e Museum).

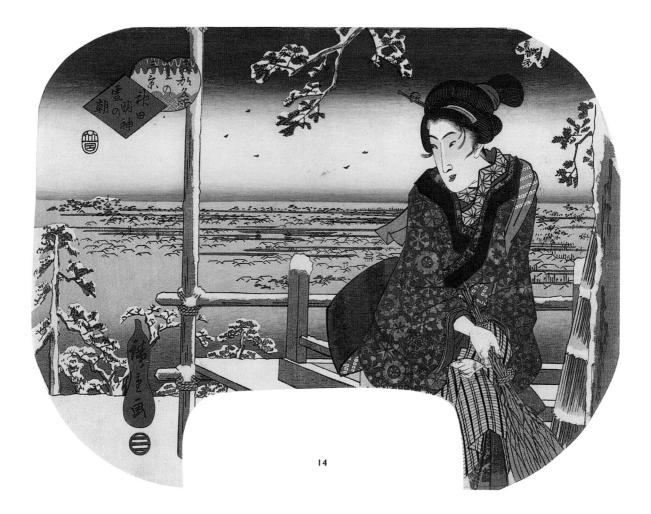

14

Plate 14
Snowy Morning at the Kanda Myōjin Shrine
(*Kanda Myōjin Yuki no Asa*)

Plate 15
Clear Skies after Snow – Ryōgoku in Moonlight
(*Ryōgoku Yukibare no Tsuki*)

Two designs from the series *Three Views of Snow at Famous Places in the Eastern Capital* (*Tōto Meisho Yuki no Sankei*)
Signed *Hiroshige ga*
Published by Ibaya Senzaburō
Censor's seal *Fu*
1843–7
V&A: E.2916-1913, E.2917-1913

The designs in this series are remarkable for their pervasive and almost palpable sense of stillness, and for the more than usually close-up renderings of their female subjects. In the third design of the series, entitled *First Snow on the Sumida River*, a hooded woman is shown on the left-hand side of a bridge with a receding expanse of water and grey sky behind her (Sakai 1996, nos 1402–3).

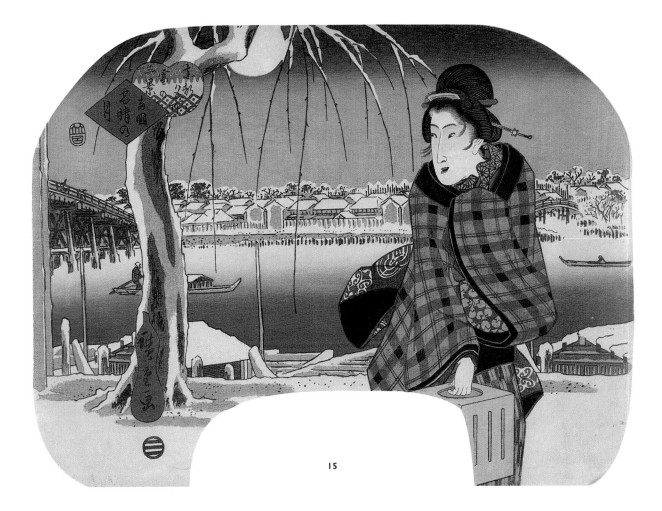

15

The Kanda Myōjin Shrine of plate 14 was situated in the Hongō district to the south of the Shinobazu Pond [Shiraishi 1993, 9B9]. It was moved from an earlier location to its position on the Yushima bluff in 1616, from which it enjoyed a commanding view to the east, shown here with the sky turning pink just before sunrise. Along with the Hie Sannō Shrine in the north of the city, the Kanda Myōjin Shrine was one of Edo's two most important Shintō establishments. They were the centres of major summer and autumn celebrations (the Sannō and Kanda Myōjin festivals) that took place in alternate years and featured grand processions of floats that passed through the grounds of Edo Castle.

The moonlit scene in plate 15 shows a woman on the western side of the Sumida river, just downstream from the Ryōgoku Bridge, in the Northern Nihonbashi district.

Quiet in this winter view – in contrast to the festive buzz of the summer scene depicted in plate 5, for example – the Ryōgoku Bridge was built shortly after the Meireki fire of 1657 to facilitate the development of the area to the east of the Sumida river. The willow tree in the foreground marks the location as the northern end of the Motoyanagi Bridge [Shiraishi 1993, 8I3]. The bridge behind the woman to the right spans the entrance to the Tatekawa Canal, the dividing line between the Honjo and Honjo Fukagawa districts.

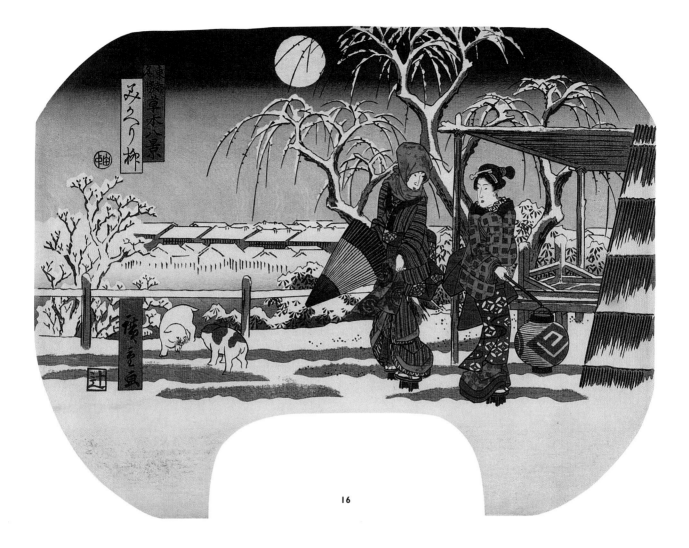

16

Four designs from the series *Eight Famous Views of Plants and Trees in the Eastern Capital* (*Tōto Meisho Sōmoku Hakkei*)
Signed *Hiroshige ga*
Published by Tsujiya Yasubei
Censor's seal *Tanaka*
1843–7
V&A: E.547-1911, E.2911-1913, E.548-1911 & E.4825-1919, E.2910-1913

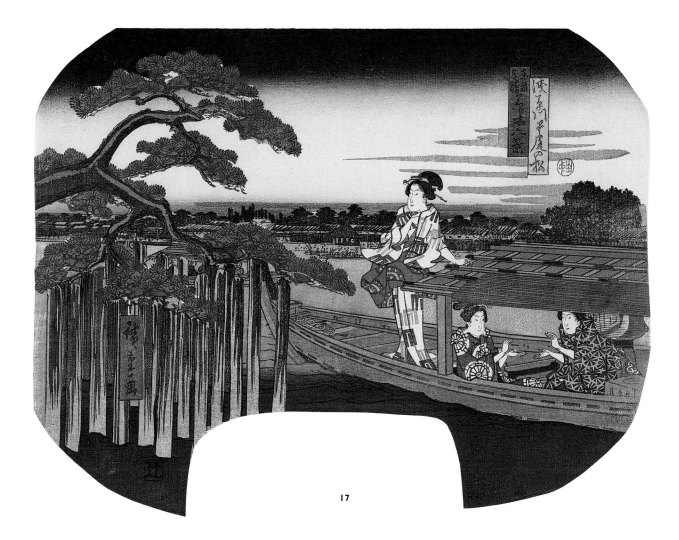

17

From the willow tree by Motoyanagi Bridge in plate 15, we move in plate 16 to the famous 'Looking Back' Willow that stood just outside the Ōmon or Great Gate, the sole point of entry and departure for visitors to the Yoshiwara licensed pleasure quarter in the Imado Asakusa district [Shiraishi 1993, 17F6]. The last object to remain in view as departing clients looked back on their early morning journey along the Nihon Embankment, it symbolised the pathos of separating lovers. The scene here is set in the dead of night rather than at dawn, however, and it is a courtesan rather than a man whom the servant with the lantern is seeing off. The lantern is marked with the katakana characters for *hi* and *ro*, the first two syllables of Hiroshige's name.

In plate 17 we are party to the sense of anticipation accompanying a journey to, rather than from, the Yoshiwara. The Shubi Pine Tree was a famous landmark that hung out over the Sumida river from the central pier of the Asakusa rice granary, a large complex of buildings that visitors travelling upstream by boat passed on their left between the Ryōgoku and Azuma bridges [Shiraishi 1993, 18D8]. *Shubi* means 'results', which in the context of visiting the Yoshiwara meant getting good value for money.

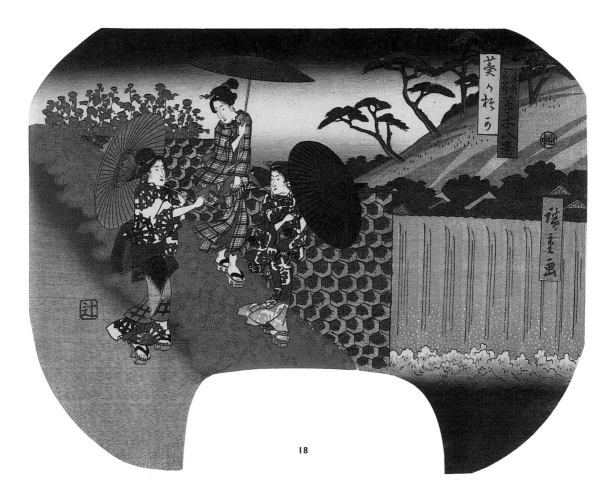

18

The locations in plates 18–20 are of sites unrelated to the Yoshiwara that were also associated with particular varieties of plants. Aoigasaka, depicted in two impressions of the same design in plates 18–19, took its name from the hollyhocks (*aoi*) that can be seen blooming at the top of the hill. It was situated in the northwestern corner of the Atagoshita district, where water from the Tameike Pond flowed over a small dam into the Sotobori Outer Moat [Shiraishi 1993, 22B2/29H2]. A comparison of the two impressions shows that plate 19 is a later printing (*atozuri*) that has suffered light damage, probably, in view of the ribmarks, while mounted up as a fan. The effects of fading aside, it is clear that much less care was taken over the use and application of colours than with the impression in plate 18. An additional block appears to have been used to provide the yellow shading on the roadway to the left.

Plate 20 uses a rich palette of blues, greens, yellows and purples in its depiction of women, whose clothes and hairstyles identify them as *goten jochū* or servants from a samurai household, viewing the irises for which Kinegawa was famous. Kinegawa was located in the central eastern part of the Mukōjima district [Shiraishi 1993, 19C4], a swampy area that was ideal for the cultivation of bog plants. The low-lying nature of the land is skilfully suggested by the tiny figures and farmhouse on the left that drop out of view behind the yellow horizon.

One other design from the series is known. It is a view of women with umbrellas admiring bushclover in the grounds of the Hagidera Temple (Matsuki 1924, no.61).

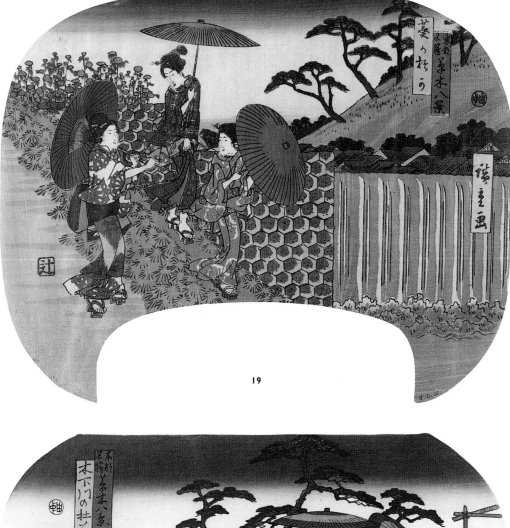

19

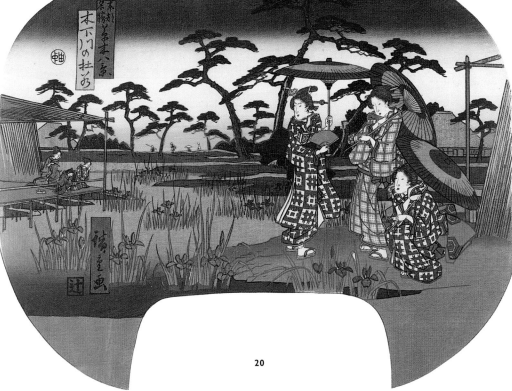

20

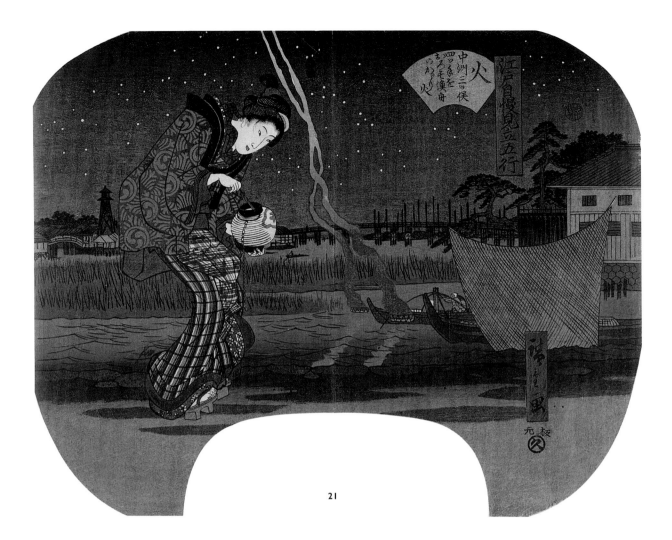

21

Plate 21
Fire (*Hi*)

Plate 22
Water (*Mizu*)

Two designs from the series *The Pride of Edo Compared
to the Five Elements* (*Edo Jiman Mitate Gogyō*)
Signed *Hiroshige ga*
Published by Ibaya Kyūbei
Censor's seal *Muramatsu*
1843–7
V&A: E.543-1911, E.4857-1919

The text in the fan-shaped cartouche on plate 21 reads
Hi – Nakasu Mitsumata yotsude o orosu gyōshu no kagaribi,
meaning 'Fire – the burning lights on the fishing boats as
they lower their four-armed scoop nets where the river
forks (*mitsumata*) at Nakasu'. The location of this star-lit
scene is the reedy strand in the stretch of river just south
of the Shin-Ōhashi Bridge in the Northern Nihonbashi
district [Shiraishi 1993, 8J6]. For a short period during the
1770s and '80s this had been the site of an eight-acre
island that had thrived as a pleasure quarter in
competition with the Ryōgoku area. In 1789, however, as
part of the crackdown on morality that accompanied the
Kansei Reforms, the island was destroyed, leaving

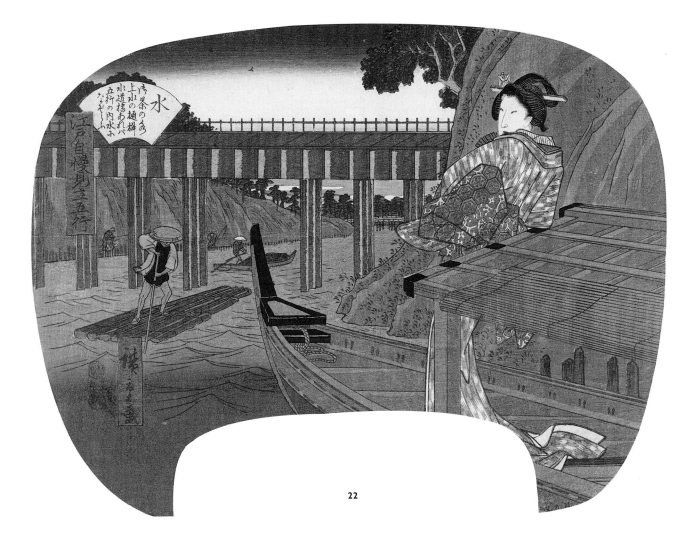

22

nothing but an expanse of reedy shallows. Here we are looking southwards over these shallows from the western side of the Sumida river. The Eitai Bridge is visible in the distance and beyond it, on the horizon, a group of masted cargo ships. The bridge behind the woman on the far left spans the entrance to one of the canals that criss-crossed the Honjo Fukagawa district.

The caption to plate 22 reads *Mizu – Ochanomizu jōsui no himasu Suidōbashi areba gogyō no uchi mizu ni nazorau*, meaning 'Water – the square aqueduct that crosses by Suidō Bridge suggests the comparison of Ochanomizu to water'. Here we are looking westwards along the Kanda river from just downstream of the aqueduct that carried

water from the Kanda Water Supply to Edo Castle and the central parts of the city to the east [Shiraishi 1993, 3F10]. Suidō Bridge itself is visible in the distance between the right-hand arches of the aqueduct. The ribmarks faintly visible towards the top of the print are evidence that it was salvaged from a made-up fan.

Two other designs from the series are also known. They are for the elements wood and earth, the latter existing only in the form of a preliminary sketch (*shita-e*) (see plates Ia, Ib and IV on pages 17 and 20).

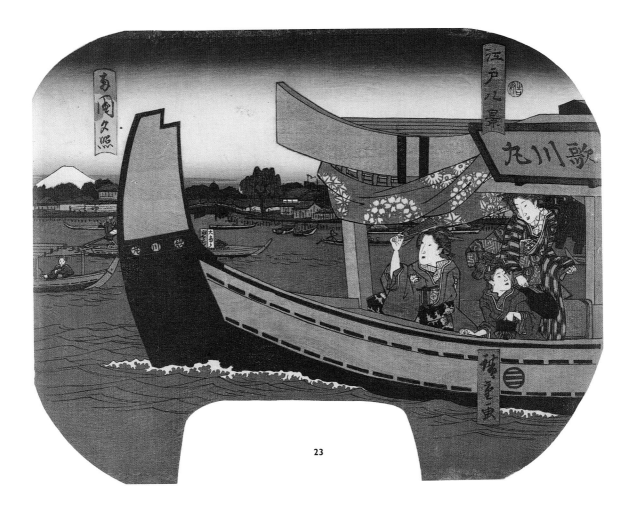

23

Plate 23
Evening Glow at Ryōgoku (*Ryōgoku Sekishō*)

Plate 24
Autumn Moon at Matsuchiyama (*Matsuchiyama no Shūgetsu*)

Plate 25
Clearing Skies at Ochanomizu (*Ochanomizu no Seiran*)

Plate 26
Night Rain on the Sumida River (*Sumidagawa no Ya-u*)

Plate 27
Evening Snow at Asakusa (*Asakusa Bosetsu*)

Plate 28
Descending Geese at Nippori (*Nippori no Rakugan*)

Plate 29
Returning Sails at Tsukuda (*Tsukuda Kihan*)

Plate 30
Evening Bell at Ueno (*Ueno no Banshō*)

Complete set of eight designs from the series *Eight Views of Edo* (*Edo Hakkei*)
Signed *Hiroshige ga*
Published by Ibaya Senzaburō
Censor's seal *Yoshimura*
1843–7
V&A: E.531-1911, E.536-1911, E.534-1911, E.529-1911, E.530-1911, E.533-1911, E.532-1911, E.535-1911

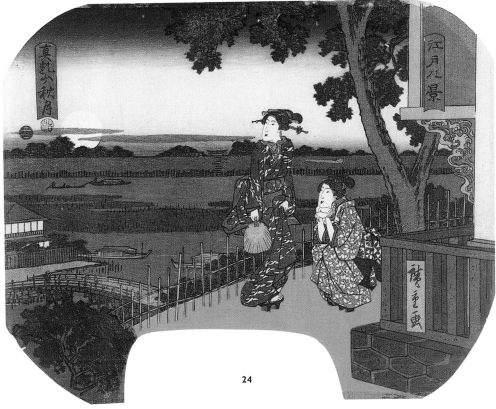

24

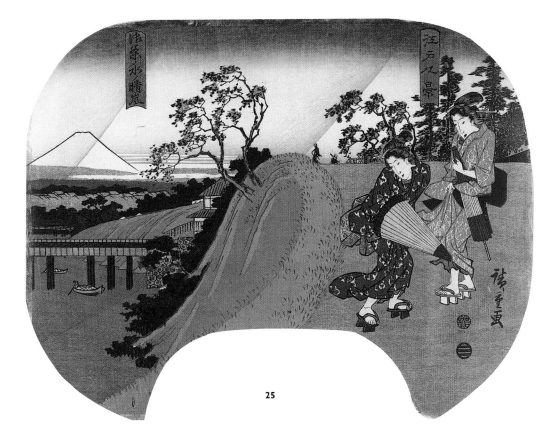

25

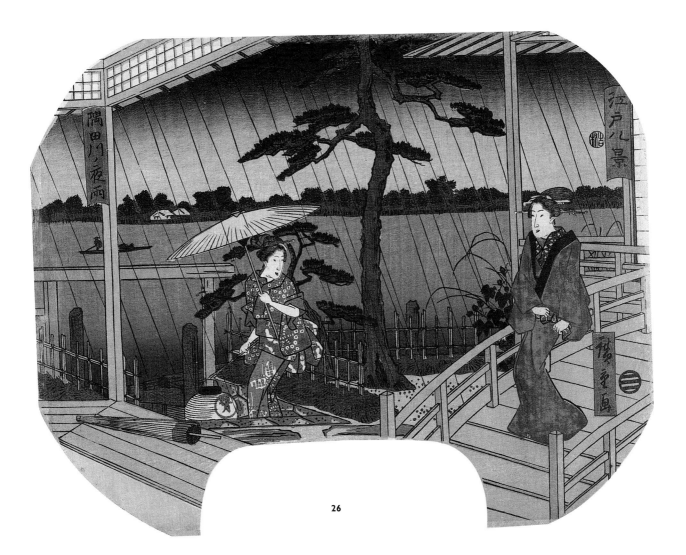

26

This set of eight designs is the largest of the four complete series of Hiroshige *uchiwa-e* in the V&A's collection. The *Hakkei* or 'Eight Views' formula was a popular one, having its ultimate source in Chinese paintings of the Xiao and Xiang rivers and originally used in Japan in the form of poetic and painterly references to eight famous sites around Lake Biwa in Ōmi Province (modern Shiga Prefecture). We have seen it used in plates 16–20, and it appears again in plates 59 and 107–8.

The presence of Mount Fuji in the left-hand corner of plate 23 indicates that we are looking southwestwards across the span of the Sumida river. On the far shore, framed between the prow and the roof of the pleasure boat in the foreground, is the Motoyanagi Bridge and the willow tree growing at its northern end [Shiraishi 1993, 8I3]. The view is almost the exact opposite of that in plate 15, where Ryōgoku Bridge, under which the pleasure boat in this print has just passed, is upstream to the left of the woman standing at the foot of the willow tree. The name of the boat, the *Utagawa-maru*, that appears on both the plaque and the prow is written with the same characters as the *Utagawa* of Utagawa Hiroshige – a contrivance similar to the use of the katakana characters for *hiro* on the paper lanterns in plates 6 and 16. The small characters on the boat in the middle of the river read *ōatari / mizugashi*, meaning 'highly acclaimed / fruit for sale'.

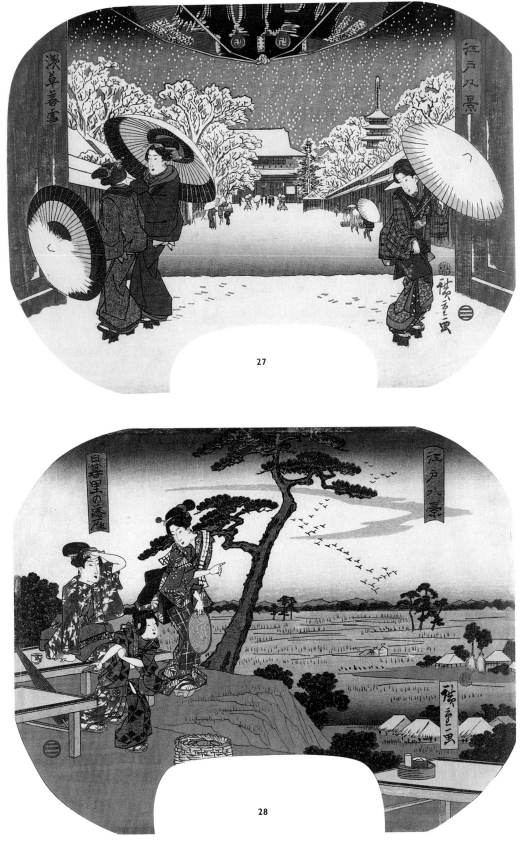

27

28

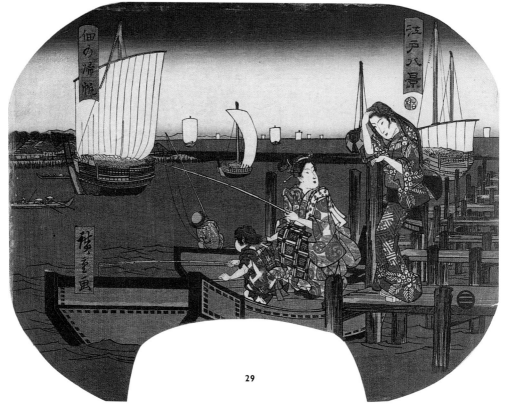

29

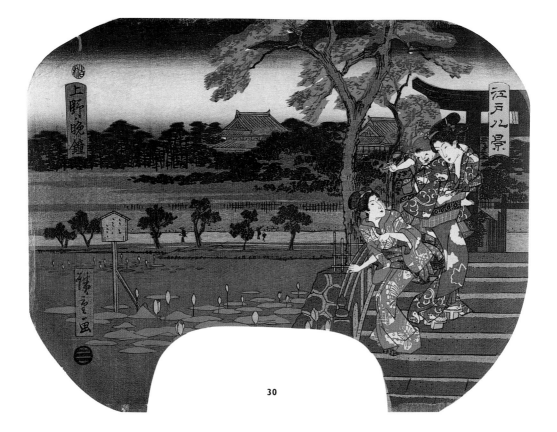

30

In plate 24 the autumn moon can be seen rising over the Mukōjima district across the Sumida river to the northeast. The top of the torii gate just visible on the skyline in the centre of the print is the entrance to the Mimeguri Shrine. We are looking across from the top of a small hill to the immediate south of the Imado Bridge, visible here on the lower left, which crossed the San'yabori Canal where it joined the Sumida river on the eastern edge of the Imado Asakusa district [Shiraishi 1993, 17F10]. Known as Matsuchiyama, this hill was and still is home to the Shōten Shrine, a popular place of pilgrimage for courtesans and others in the entertainment business. Not uncoincidentally, the Imado Bridge was the point at which travellers to the Yoshiwara licensed pleasure quarter would alight from the boats on which they had travelled up the Sumida river and begin the final part of their journey by foot along the Nihon Embankment.

The blustery scene in plate 25 is set on the high ground immediately to the north of the Kanda river on the southwestern edge of the Hongō district [Shiraishi 1993, 9A5]. The aqueduct on the lower left is the same as the one we saw from a lower vantage point in plate 22. The geometry of Mount Fuji, visible on the horizon to the southwest, is echoed in the slant of the lines that mark the boundaries of the passing storm.

The scene in plate 26 is set in a restaurant or similar establishment on the upper reaches of the Sumida river. The absence of light on most of the opposite bank tells us that we are looking at the Mukōjima district from the vicinity of the Massaki Shrine in the northern part of the Imado Asakusa district [Shiraishi 1993, 17J7]. The woman with the lantern and umbrella is in the process of escorting the female guest on the bridge down a flight of steps to a boat waiting at the water's edge. The design derives its particular appeal from the way in which the night view is framed within the geometry of an architectural structure partially cut off by the rounded corners of the fan.

In plate 27 rain has turned to snow as we stand under the huge paper lantern of the Kaminarimon or Thunder Gate, the entrance to the Asakusa Kannon Temple in the heart of the Imado Asakusa district [Shiraishi 1993, 17D8]. Officially known as the Kinryūzan Sensōji, this was and still is the city's oldest and best-known

Buddhist establishment. The building in the centre is the Niōmon or Gate of the Two Guardian Kings and that to the right a five-storey pagoda. Behind them, hidden from view, is the main compound of the temple. This design would have been much brighter when it was first printed, the red lead (*tan*) that was used on the gates to left and right having tarnished over time to its present dull brown.

Plate 28 takes us to the Nippori district in the northern part of the city. The view of geese descending over an expanse of rice paddies is taken from the eastern edge of the high ground extending from the Suwa Bluff to Mount Dōkan [Shiraishi 1993, 12F6]. The latter takes its name from Ōta Dōkan (1432-86), the medieval warlord who established an outpost here to protect the fortress he had built on what subsequently became the site of Edo Castle. Farmhouses and haystacks can be seen in the middle distance, while the mountains silhouetted on the horizon are those of the Nikkō range some 200 kilometres to the north. The basket visible in the immediate foreground is filled with small earthenware plates like the one that the girl rolling up her sleeve can be seen to be about to throw off the edge of the bluff. Known as *kawarake-nage*, literally 'earthenware-throwing', this was a popular pastime that still survives in parts of Japan today.

With plate 29 we move southwards to the island of Tsukudajima and its long row of fishing-boat moorings [Shiraishi 1993, 5J2]. Women and children chat and fish against a backdrop of boats sailing across the expanse of Edo Bay. The southwestern corner of the Honjo Fukagawa district is visible behind the cargo ship to the left, while far away on the horizon we can glimpse the profile of the Bōsō Peninsular.

The view in plate 30 is taken from the western end of the bridge that connects the island in the middle of the Shinobazu Pond to the mainland on the southeastern edge of the Hongō district [Shiraishi 1993, 9E10]. We have seen this bridge from the southwest in plate 13, as we have the temple buildings – part of the Kan'eiji Temple complex – in the background. Shades of grey and a hint of purple in the lower sky provide a tranquil backdrop to the scene of two women and a small boy out on an evening stroll.

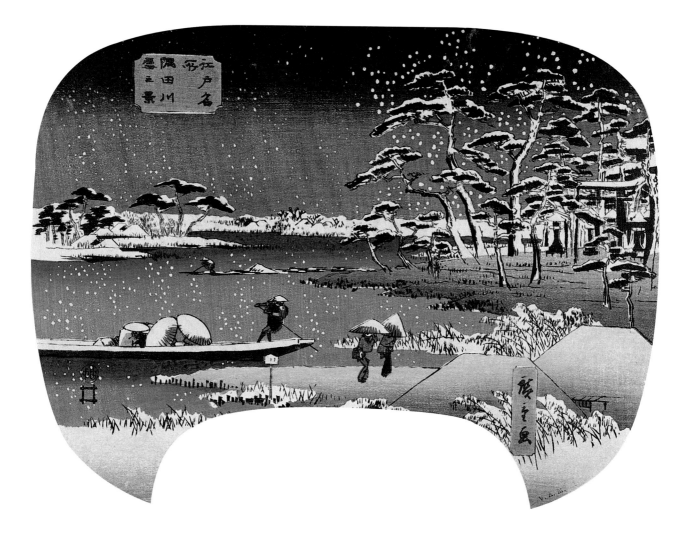

Plate 31

View of the Sumida River in the Snow (*Sumidagawa Yuki no Kei*), from the series *Famous Places in Edo* (*Edo Meisho*)
Signed *Hiroshige ga*
Published by Sanoya Kihei
Censor's seal *Tanaka*
1843–7
V&A: E.4872-1919

A later printing (*atozuri*) of a mid-1840s design, the colouring and register of this wintry view of the upper reaches of the Sumida river are still relatively good. We are looking upstream from the Mukōjima side of the Hashiba ferry crossing [Shiraishi 1993, 19J8]. The houses across the river mark the northern extremity of the Massaki area, while the stone lanterns and torii gate among the snow-laden pine trees to the right are the entrance to the Suijin Shrine. This was dedicated to the spirit of the Sumida river and was believed to give protection to boatmen and others who depended on it for their livelihood. No other designs from the series are known.

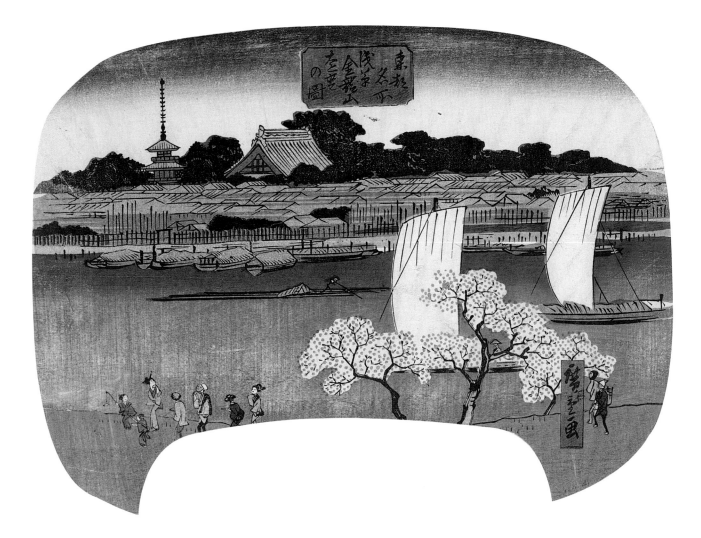

Plate 32

Distant View of the Kinryūzan Temple at Asakusa
(*Asakusa Kinryūzan Enbō no Zu*), from the series *Famous*
Places in the Eastern Capital (*Tōto Meisho*)
Signed *Hiroshige ga*
Published anonymously
About 1844–8
V&A: E.4882-1919

This view of the Asakusa Kannon Temple is taken from
across the Sumida river at a point somewhere along the
bank between the Azuma Bridge and the Mimeguri
Shrine in the southwestern corner of the Mukōjima
district [Shiraishi 1993, 1914]. The pagoda is the same as
the one we saw from underneath the Thunder Gate in
plate 27. The building to its right is the Hondō or Main
Hall, the largest and most important building of the
temple complex. The ribmarks visible at the top of the
print indicate that it was salvaged from a made-up fan,
while the less than perfect registering of colours suggests
that it was made from partially worn blocks. No other
designs from the series are known.

Plate 33
Sunrise at Shibaura (*Shibaura Hinode no Zu*), from the series *Famous Views in the Eastern Capital* (*Tōto Meisho*)
Signed *Hiroshige hitsu*
Published by Enshūya Matabei
About 1845–50
V&A: E.4862-1919

This spare but compelling design derives much of its effect from the ribmarks that radiate from its centre. As well as suggesting the rays of the sun as it rises over Edo Bay at dawn, they also draw the composition together into an integrated whole. It is as if Hiroshige had anticipated the lines that would result from the print being mounted up as a fan and had incorporated them into the design. The tripod structure in the centre of the print is an *otomegui*, a form of gauge by which sailors could judge the depth of the sea. They were a particular feature of the Shibaura coast, this view being taken from in front of or near the extensive area of reclaimed land on the eastern shore of the Atagoshita district occupied by the Hama Detached Villa [Shiraishi 1993, 22I4]. No other designs from the series are known.

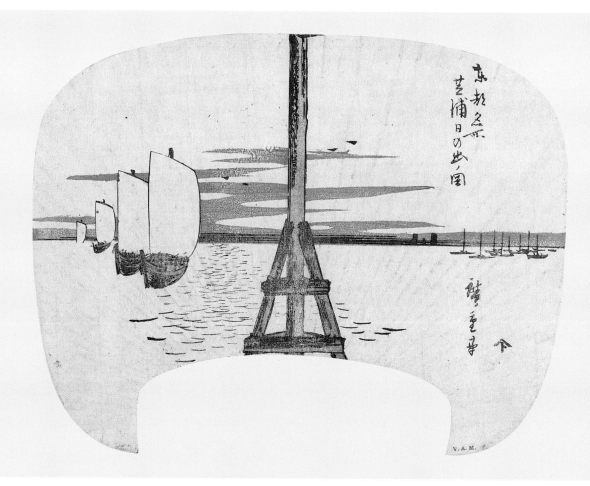

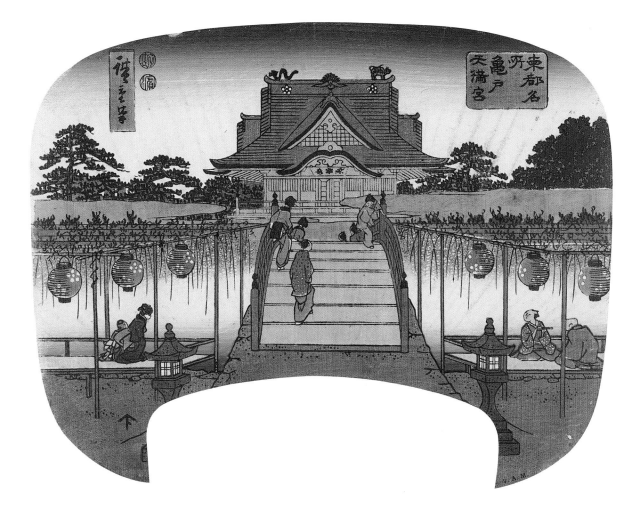

Plate 34

The Kameido Tenmangu Shrine (*Kameido Tenmangu*),
from the series *Famous Places in the Eastern Capital*
(*Tōto Meisho*)
Signed *Hiroshige hitsu*
Published by Enshūya Matabei
Censors' seals *Hama* and *Kinugasa*
1847/1–1848/10

V&A: E.4856-1919

If the ribmarks in plate 33 serve to bring coherence to a
loosely conceived composition, in this print they work
more to moderate an overly strong sense of perspective.
The structure in the centre with its complex arrangement
of roofs is the main building of the Kameido Tenmangu,
or Tenjin, Shrine in the northeastern part of the Honjo
district [Shiraishi 1993, 20A6; see plate 12]. We are
looking northwards from immediately in front of the
taikobashi or drum bridge, for which, along with the
wisteria that can be seen blooming on trellises around
the lake in the middle of the grounds, the shrine was and
still is famous. Patronised by the Tokugawa shogunate,
the shrine was dedicated to the deified Sugawara
Michizane (845–903), patron saint of learning and
calligraphy (see plate 113). No other designs from the
series are known.

Plate 35
Three Women Visiting the Okina Inari Shrine
Signed *Hiroshige ga*
Publisher's mark *Sanpei*
Censors' seals *Hama* and *Kinugasa*
1847/1–1848/10
V&A: E.539-1911

The characters *Daimyōjin* and *Okina* that figure on the banner and paper lantern to the left identify the location as the Okina Inari Shrine. As we have seen in plate 11, this was situated in the heart of the busy Southern Nihonbashi district in grounds that were much more cramped than is suggested in this idealised evening view [Shiraishi 1993, 7J3]. Mount Fuji rises in the southwest above a bank of purple clouds, and to the right we catch a glimpse of crowds crossing the bridge at Nihonbashi. Further beyond, on the horizon, the roofs of the outbuildings of Edo Castle are just visible. The woman on the right is carrying an *ema* or votive picture to give as an offering to the shrine. The bundle of sticks that the courtesan on the left is holding are counters by which she can remember how many out of a pledged number of visits to the shrine she has made.

Plate 36

The Hashiba Ferry Crossing
and the Massaki Shrine
on the Sumida River
(*Sumidagawa Hashiba*
Watashi Massaki Yashiro)

Plate 37

The Shinobazu Pond at Ueno
(*Ueno Shinobazunoike*)

Plate 38

Evening Cool and the
Ryōgoku Bridge Seen from
the Shubi Pine Tree at Ōkawa
(*Ōkawa Shubi no Matsu*
Ryōgokubashi Yūsuzumi)

Three designs from an
untitled series of views of Edo
Signed *Hiroshige ga*
Published by Enshūya Matabei
Censors' seals *Magome* and *Hama*
1849 / 1–1852 / 1
V&A: E.4855-1919, E.4861-1919, E.4863-1919

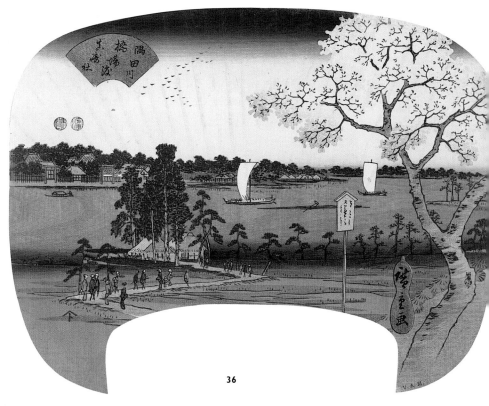

36

In plate 36 we are standing on the embankment that ran
along the western flank of the Mukōjima district. To the
left, across the Sumida river, is the Massaki Shrine, while
on the near bank groups of travellers can be seen making
their way to and from the cluster of thatched huts next to
Hashiba ferry crossing [Shiraishi 1993, 19J8]. The cherry
trees on the embankment are in bloom, and the northern
reaches of the river, which we have seen in snowy deso-
lation in plate 31, look cheerful on this bright spring day.

In plate 37 we return to the Shinobazu Pond, which we
have seen from different vantage points in plates 13 and
30 [Shiraishi 1993, 9E10]. Here we have a complete view
of the island in the middle of the pond and can see the
structure of the Benten Shrine surrounded by restaurants
and tea houses. The season being early spring, it is
cherry blossoms rather than lotus flowers that are the
main focus of attention. To the north, where the water
darkens beneath the red cartouche, we can just make out
the mouth of the watercourse that feeds into the pond.

The characters *issei ichidai* that appear to the upper right
of the artist's signature have the sense of for once and for
all or never again, suggesting that Hiroshige had run out
of ideas for depicting this popular and famous site.

In plate 38 the season has changed to summer, and we
are looking southwards down the Sumida river from
next to the Shubi Pine Tree, which we encountered from
the opposite side in plate 17 [Shiraishi 1993, 18D8]. Even-
ing revellers throng the span of the Ryōgoku Bridge,
while roof-boats and other pleasure craft gently ply the
waters of the river. The area to the left of the bridge on
the Honjo district side of the river was known as the
Ōkawabata or the Great Riverbank. The tall yellow struc-
ture at the foot of the bridge is an enclosure inside which
acrobats and other performers entertained the crowds.

As the ribmarks indicate, all three prints have been
salvaged from made-up fans. No other designs from the
series are known.

37

38

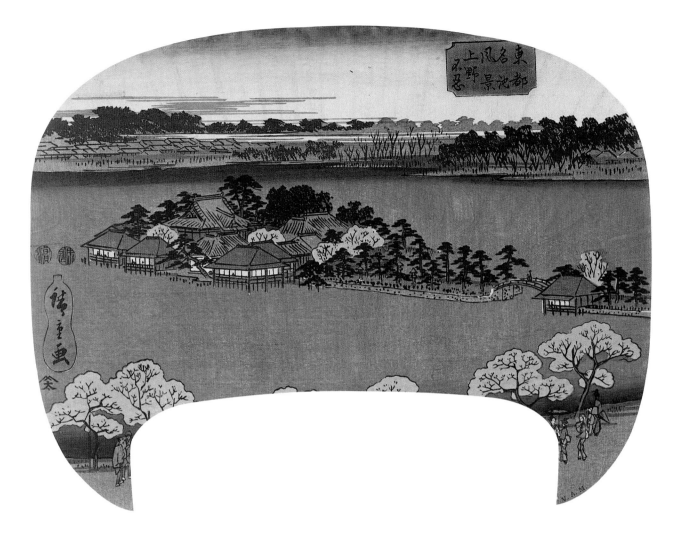

Plate 39

The Shinobazu Pond at Ueno (*Ueno Shinobazu*), from the
series *Famous Ponds in the Eastern Capital* (*Tōto Meichi
Fūkei*)
Signed *Hiroshige ga*
Unidentified publisher's mark
Censors' seals *Magome* and *Hama*
1849/1–1852/1
V&A: E.4869-1919

Like plate 37, this is a complete view of the island in the
middle of the Shinobazu Pond [Shiraishi 1993, 9E10].
From this more distant and southeasterly vantage point,
we can see the front of the Benten Shrine and the tiled
roofs of its various outbuildings. The cherry trees
blossoming on and around the island tell us it is spring.
The lack of lotuses usually found depicted on the pond
makes the island seem more isolated than in most views.
In the background, where the water darkens beneath the
red-streaked sky, the mouth of the watercourse that feeds
into the pond can be seen. The ribmarks visible towards
the top of the print indicate that it was salvaged from a
made-up fan. No other designs from the series are
known.

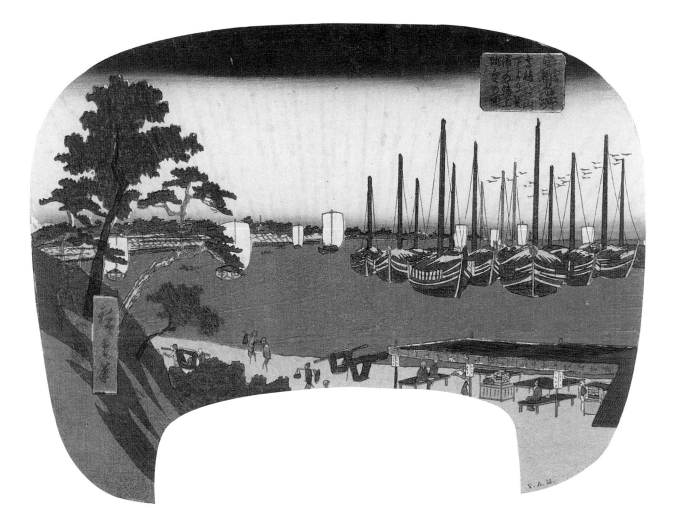

Plate 40

Scenic View of the Sea at Shibaura from the Foot of Mount Yatsu at Takanawa (*Takanawa Yatsuzan Shita yori Shibaura no Kaijō Chōbō no Zu*), from the series *Famous Places in the Eastern Capital* (*Tōto Meisho*)

Signed *Hiroshige hitsu*

Published anonymously

About 1850

V&A: E.4858-1919

In this example of a later printing (*atozuri*) salvaged from a made-up fan, we are looking out over Edo Bay from the foot of Mount Yatsu, a small hill in the southern (Shinagawa) part of the Takanawa district [Shiraishi 1993, 23C6]. The Takanawa shoreline sweeps around on the left, while in the far distance, behind the masts of the moored cargo ships, the dark outline of the Honjo Fukagawa district can be seen. The tea stalls in the foreground, a typical feature of depictions of the Takanawa coast, offered sustenance to travellers on this northernmost stretch of the Tōkaidō Highway. The figures here can be seen journeying either on foot or by palanquin. No other designs from the series are known.

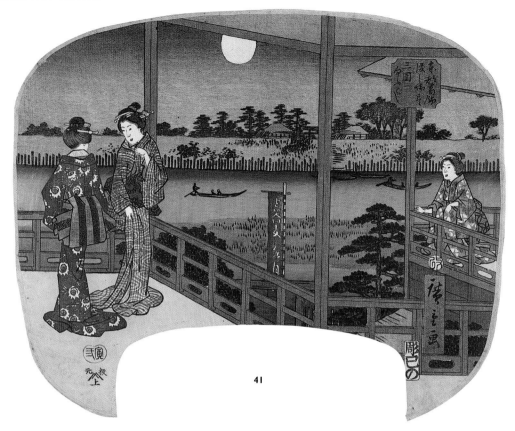

41

Plate 41
*The Mimeguri Shrine from the Opposite Side of the
Crossing* (*Mimeguri Mukōgoshi*)

Plate 42
The Niijuku Crossing (*Niijuku no Watashi*)

Plate 43
The Hashiba Crossing (*Hashiba no Watashi*)

Plate 44
The Nakagawa Crossing (*Nakagawa no Watashi*)

Four designs from the series *Ferry Crossings in Katsushika
in the Eastern Capital* (*Tōto Katsushika Watashiba Tsukushi*)
Signed *Hiroshige ga*
Published by Iseya Sōemon
Censorship seal *aratame*; date seal *Tiger 2* (1854/2)
Engraver's seal *Hori Mino* (plates 41–2)
1854/2
V&A: E.12072-1886, E.12073-1886, E.12074-1886, E.12075-1886

The *Katsushika* of the title series is used here in a generic
sense to indicate the area of the city to the east of the
Sumida river. A view of the Ichikawa ferry crossing
(Matsuki 1924, no.114) is also known, making a currently
identified total of five designs. Ribmarks visible on the
prints in plates 42–4 are evidence that they were salvaged
from made-up fans.

The night view in plate 41 is taken from the western
side of the Sumida river from the upper floor of one of the
restaurants to the north of the Imado Bridge in the Imado
Asakusa district [Shiraishi 1993, 17F10]. The vertical blue
banner tells us that the speciality of the restaurant is *soba*
or buckwheat noodles. The torii gate of the Mimeguri
Shrine can be seen across the river, partially cut off by the
wooden pillar in the foreground. Steps marking the start
of the Takeya ferry crossing lead up to the shrine from a
break in the row of stakes protecting the riverbank
[Shiraishi 1993, 19I4].

In plate 42 we have left the city and travelled north-
eastwards to the Niijuku ferry crossing, the point at which
the Mito Highway met the Naka river [Hori 1996, p.154].

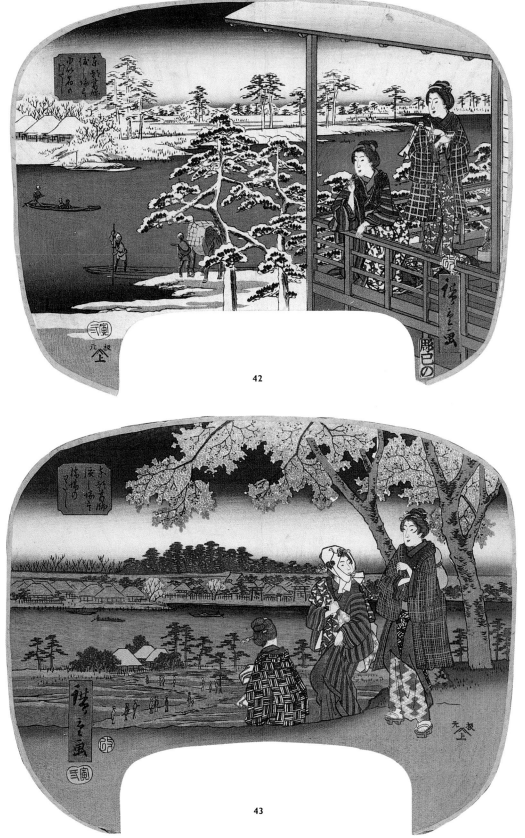

42

43

It is not clear whether we are looking eastwards from the Kameari (Edo) side of the river or westwards from Niijuku, the village from which the crossing took its name. Smith and Poster, commenting on a similar view in the *One Hundred Famous Views of Edo*, favour the former and also note that the restaurants in this area, part of one of which is visible on the right, were well known for serving carp (1986, no.93).

The view of the Hashiba ferry crossing in plate 43 is taken from a similar point along the embankment in the Mukōjima district as in plate 36 [Shiraishi 1993, 19J8]. In the centre, across the Sumida river, is the Massaki Shrine, while on the near bank are the thatched roofs of the huts in the immediate vicinity of the crossing. It is possible to see how the tall trees among which the huts are shown

clustered in plate 36 have been dispensed with in this design in order to give prominence to the figures under the blossoming cherry trees in the foreground. This is evidence of the licence commonly exercised by Hiroshige in the interests of compositional effect.

In plate 44 we are standing on the northern bank of the Onagigawa Canal at the point at which it meets the lower reaches of the Naka river on the eastern side of the Honjo Fukagawa district [Hori 1996, p.154]. Sailing boats ply the river, which flows southwards into the middle distance. The stretch of water just visible to the rear left is the Shinkawa Canal, the eastward extension of Onagigawa Canal. These canals were dug in the early seventeenth century to create a transport link with the river systems to the east and north of Edo.

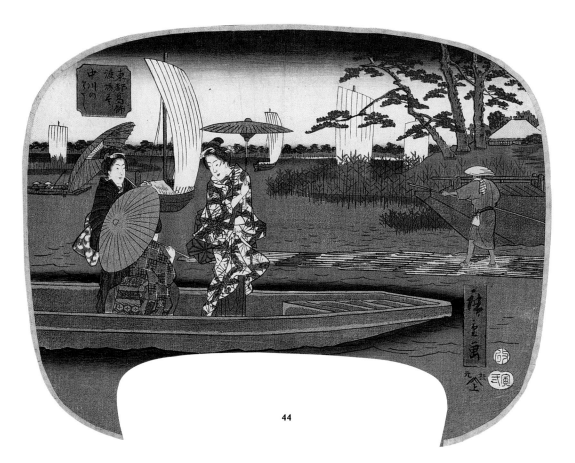

44

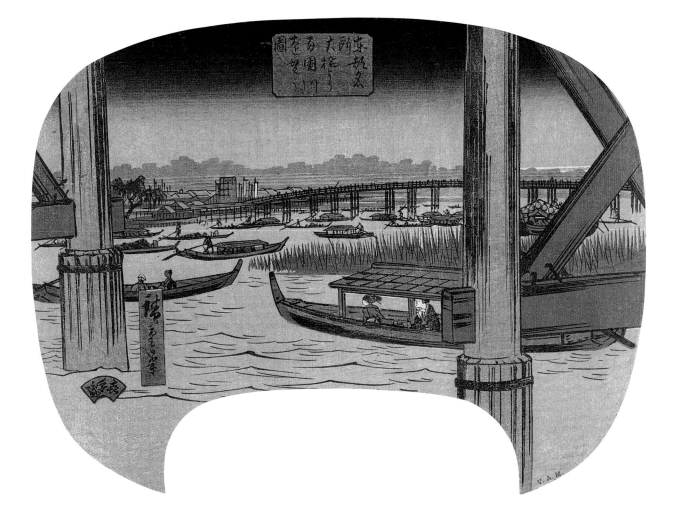

Plate 45

Distant View of Ryōgoku from the Ōhashi Bridge
(*Ōhashi yori Ryōgokugawa Enbō no Zu*), from the series
Famous Places in the Eastern Capital (*Tōto Meisho*)
Signed *Hiroshige hitsu*
Published by Kitaya Magobei
About 1855
V&A: E.4922-1919

Perhaps due to the predominant use of shades of blue, grey, orange and brown, there is an uncanny calm to this depiction of a busy summer's evening on the waters of the Sumida river south of the Ryōgoku Bridge. The view is taken from under the eastern end of the Ōhashi Bridge, more properly known as the Shin-Ōhashi Bridge, which was completed in 1693 as a link between the Northern Nihonbashi and Honjo Fukagawa districts [Shiraishi 1993, 8J6]. The grey outline on the horizon to the northwest is the high ground of the Hongō district, while the tall enclosure at the western end of Ryōgoku Bridge is similar to the one at its eastern end seen in plate 38. No other designs from the series are known.

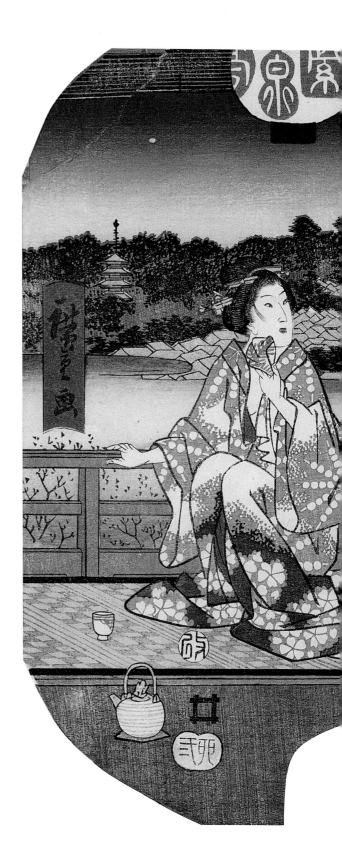

Plate 46
The Flower Pavilion at Sendagi (*Sendagi Hanayashiki*)
Signed *Hiroshige ga*
Published by Sanoya Kihei
Censorship seal *aratame*; date seal *Hare 2* (1855/2)
1855/2
V&A: E.2927-1913

As the characters on the paper lanterns indicate, the
official name of the Flower Pavilion of the title was the
Shisentei or Purple Fountain Pavilion. It was a well-
known establishment located on an escarpment at the
northeastern edge of the Hongō district [Shiraishi 1993,
9J7]. It was reached by a steep path that rose from a
valley, here filled with clouds, to the southwest. The area
below and either side of this path was planted with
flowers and trees and also had an iris pond. Beyond this,
and visible here surrounded by an extensive grove of
trees, was the Nezu Gongen Shrine, which still survives
today. The woman on the left is cooling herself after
having taken a bath. Her companion, who is holding an
identical light summer robe (*yukata*) to change into, is on
her way to the bathhouse.

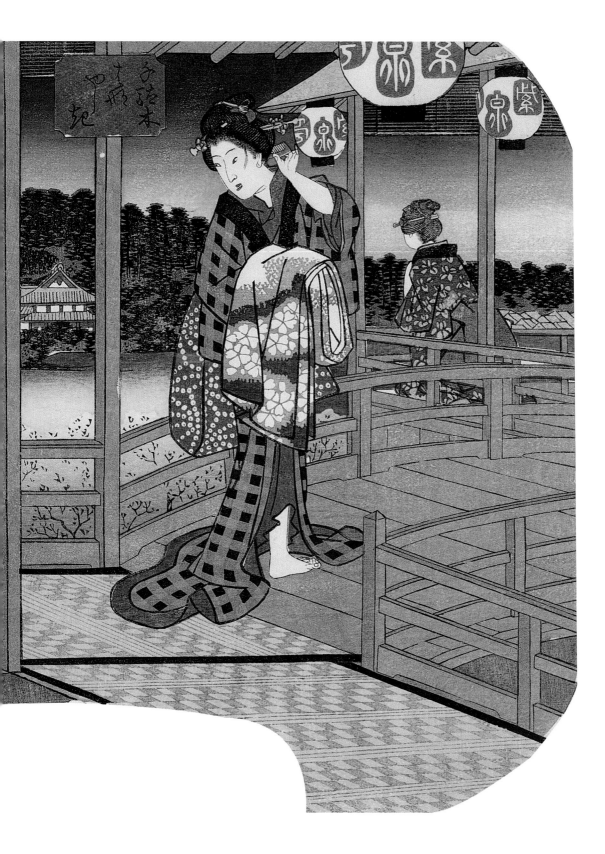

Plate 47

Sunrise at Susaki on New Year's Day (*Susaki Hatsuhi
no De*)

Plate 48

Moonlight at Ryōgoku (*Ryōgoku Tsuki no Kage*)

Plate 49

Star Festival at Yanagishima (*Yanagishima Hoshimatsuri*)

Complete set of three designs from the series *Famous
Places of Edo Compared to Sun, Moon and Stars* (*Edo Meisho
Mitate Sankō*)
Signed *Hiroshige ga*
Published by Ibaya Senzaburō
Censorship seal *aratame*; date seal *Dragon 1* (1856/1)
1856/1
V&A: E.2907-1913, E.2908-1913, E.2909-1913

This set of three designs is unusual for the way in which
the distance between viewer and subject progressively
decreases so that the focus of attention shifts from the
overall view in the first design to the stylishly clad
woman in the third. In this respect it anticipates the sort
of experimentation seen in Hiroshige's *One Hundred
Famous Views of Edo*, the first design of which appeared in
1856/2, a month after this series was published.

In plate 47 the sun is shown as a blazing globe of red
rising on New Year's Day over the spit of land (*susaki*) at
the southern (Shinagawa) end of the Takanawa district
seen from a similar vantage point in plate 9 [Shiraishi
1993, 23B8]. A considerable degree of artistic licence has

been exercised here, for we are looking northwards at a
sun that in reality would have risen in the east well off
the right-hand margin of the print. Hiroshige clearly
wanted to combine the rising sun with a view of the
buildings at the northern extremity of the spit. The two-
tiered gate in the centre is the entrance to the Susaki
Shrine, which nestles among the pine trees beyond,
while the buildings on either side are restaurants.

Plate 48 takes us up the Sumida river to the Ryōgoku
Bridge, still busy in the moonlight but not as thronged
with people as it would have been earlier in the evening.
We are looking southeastwards from the upper floor of
a restaurant in the area to the north of Yanagibashi, the
bridge that crossed the Kanda river where it flowed into
the Sumida river in the northeastern corner of the
Northern Nihonbashi district [Shiraishi 1993, 18A6].
Pleasure boats of various configurations and sizes ride
the waters of the river, which flows southwards towards
the Shin-Ōhashi Bridge on the horizon.

The woman in plate 49 is sitting in a roofed pleasure
boat at the junction of the Kitajukkengawa and
Yokojukkengawa canals in the northeastern corner of the
Honjo district [Shiraishi 1993, 20B8]. We are looking
southwards down the Yokojukkengawa Canal towards
the Yanagishima Bridge, from which the area took its
name. The lighted building on the extreme right is the
Hashimoto, a restaurant famous for its *kaiseki* cuisine.
Behind it we can see the tiled roof and red fence of the
much visited Myōken Hall, a slightly fuller view of
which we have seen in plate 11. The Star Festival of the
title is the Tanabata Festival traditionally celebrated
on the seventh day of the seventh month.

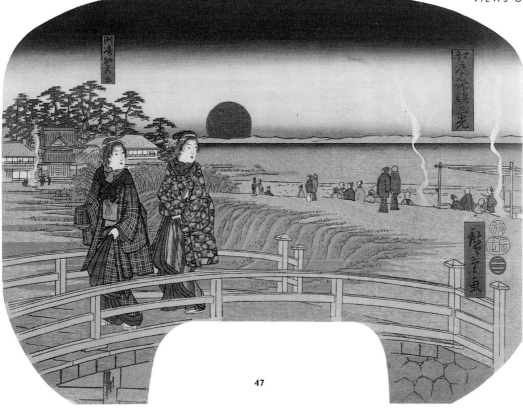

47

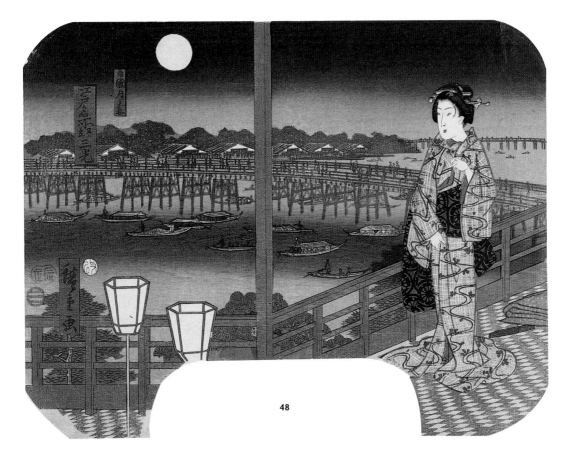

48

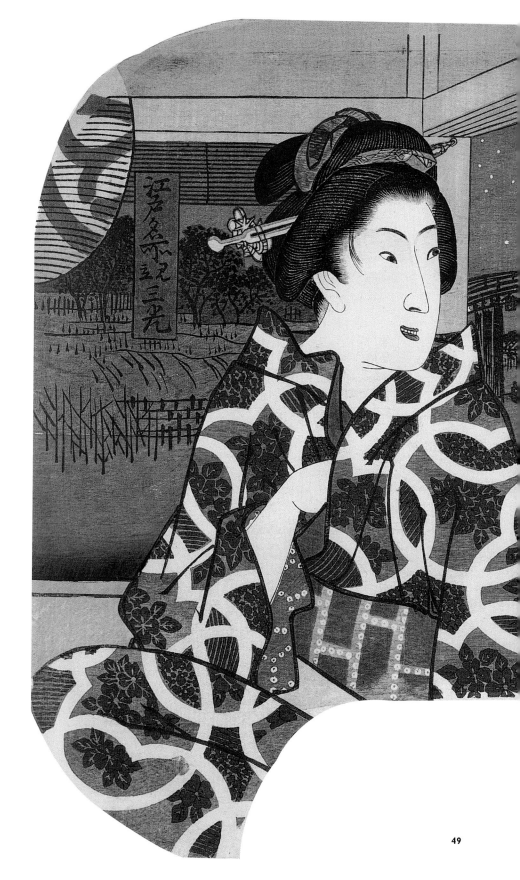

49

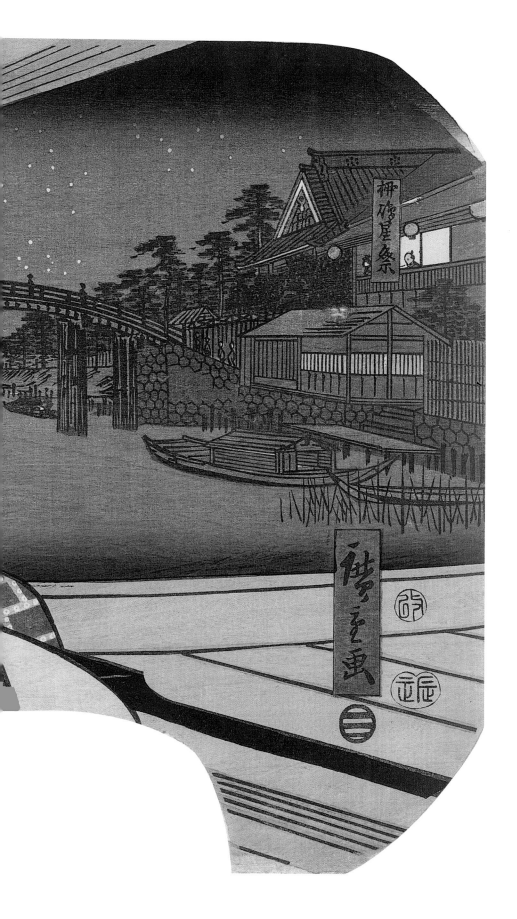

Plate 50
Cherry Trees on Mount Goten
(*Gotenyama no Sakura*)

Plate 51
The Plum Garden at Omurai
(*Omurai Baien*)

Plate 52
*Peach Blossoms at Momonoi
in Ōsawa* (*Ōsawa Momonoi*)

Three designs from the series
Flower Siblings at Famous Places
(*Meisho Hana Kyōdai*)
Signed *Hiroshige ga*
Publisher's mark *Sanpei*
Censorship seal *aratame*; date seal *Dragon 1* (1856/1)
1856/1

V&A: E.12079-1886, E.12080-1886, E.12081-1886

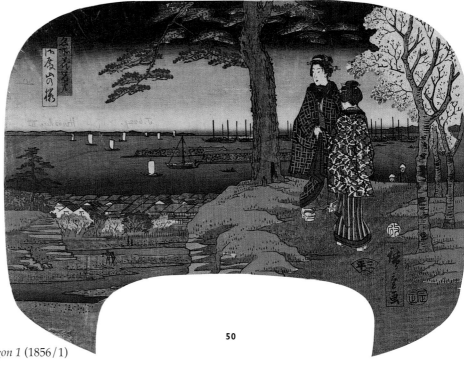

50

The commanding view of Edo Bay in plate 50 is taken from the top of Mount Goten in the southern (Shinagawa) part of the Takanawa district [Shiraishi 1993, 23B7]. When the villa that occupied the site burnt down in the late seventeenth century, it became a popular place for viewing cherry blossoms, open to the citizens of Edo at large. Like the view taken from the opposite direction in the *One Hundred Famous Views of Edo*, the focus here is less on the blooming cherry trees than on the scarred landscape that resulted from huge quantities of earth being dug away to build the cluster of island fortresses visible in the distance (Smith and Poster 1986, no.28). Known as *odaiba*, these were constructed as an emergency measure following the arrival of Commodore Perry and his American warships in 1853.

Plate 51 takes us to the Omurai plum garden behind the Azuma Shrine in the southeastern corner of the Mukōjima district [Shiraishi 1993, 19B3]. The courtesans in the foreground are well wrapped on the cold winter's day, and behind them, across a stretch of water, small figures can be seen climbing to the top of a grassy hill. This is in fact an artificial replica of Mount Fuji, one of many such constructions dotted about Edo in Hiroshige's time. The first of these was built in Takada in the western

part of the city in 1779. It was the brainchild of a follower of a popular religious cult whose worship focused on Mount Fuji and for whom the climb to its 3776-metre summit was the ultimate undertaking. This journey was more than could be managed by the young, the infirm and the elderly, and it was for their benefit that miniature versions of Mount Fuji like this were built. The slip of folded paper in the hair of the woman on the left is a talisman from the Myōgi Shrine, located in the grounds of the nearby Kameido Tenjin Shrine (see plates 12 and 34). Talismans from the Myōgi Shrine were believed to provide protection against thunder and lightning and were obtainable on the first Rabbit Day of each month.

In plate 52 we are looking southwestwards across a grove of blossoming peach trees at the real Mount Fuji, still clad in snow on this early spring day. The woman standing on the right is smoking a pipe while her seated companion sips tea. The location of this peaceful scene is to the west of Edo in what is now part of Mitaka. As in plate 54, Mount Fuji, which is geographically quite close, appears larger than in views taken from central Edo.

The ribmarks visible on all three prints are evidence that they were salvaged from made-up fans. No other designs from the series are known.

51

52

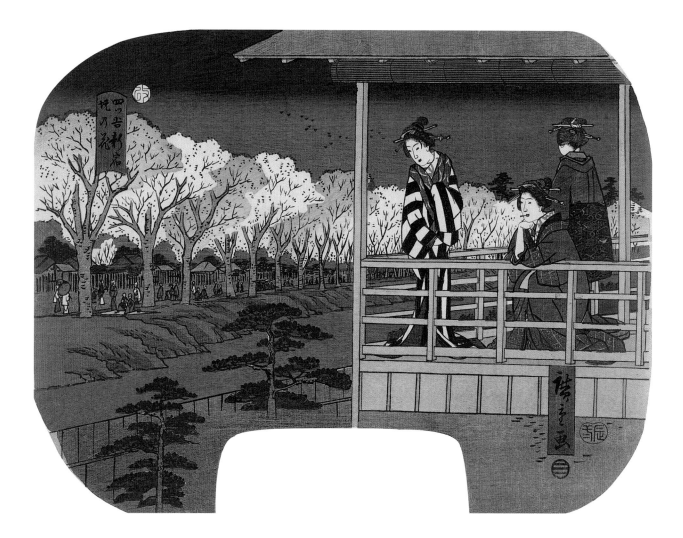

Plate 53

Cherry Blossoms on the Shinjuku Embankment at Yotsuya (*Yotsuya Shinjuku Tsutsumi no Hana*)
Signed *Hiroshige ga*
Published by Ibaya Senzaburō
Censorship seal *aratame*; date seal *Dragon 2* (1856/2)
1856/2
V&A: E.2926-1913

This evening view is taken from the upper storey of one of the brothels in the Naitō Shinjuku area in the northwestern corner of the Yotsuya district [Shiraishi 1993, 26C10]. The prostitutes on the balcony, one of them wearing an outer coat of tell-tale red, are enjoying the cherry trees blossoming along the southern bank of the Tama River Water Supply (see plate 54). This went below ground at the Yotsuya Barrier, a little way off the left-hand margin of this print, and fed into a system of channels and pipes that supplied a network of wells in the southern and western parts of the city. The cherry trees that made the embankment such a magical sight in spring were planted in the 1730s.

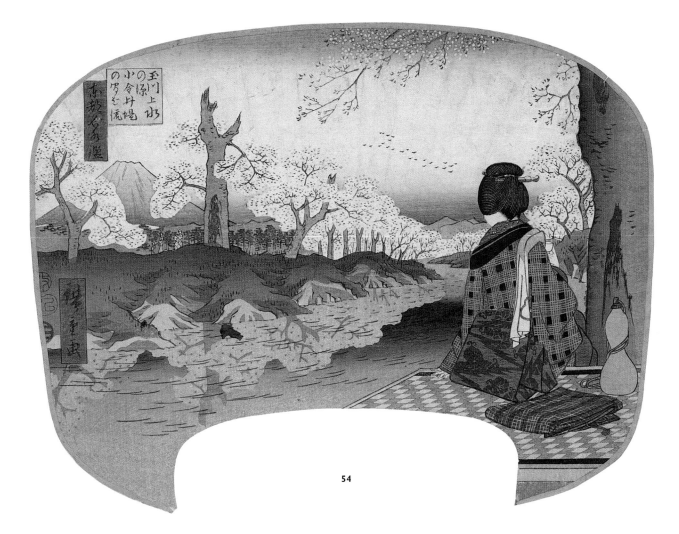

54

Plate 54
*The Upper Reaches of the Tama River Water Supply
Flowing through the Koganei Embankment* (*Tamagawa
Jōsui no Minamoto Koganeizutsumi no Aida o Naga(ruru)*)

Plate 55
*View of the Kanda Water Supply Flowing through
Yamabuki (Kerria) Village in Mejiroshita* (*Kanda Jōsui
Mejiroshita Yamabukinosato ni Nagaruru Zu*)

Plate 56
All Rivers Converge and Flow into the Sea (*Shoryū Kaigō
shite Umi ni Otsu*)

Three designs from the series *A Mirror of Famous Rivers
in the Eastern Capital* (*Tōto Meisui Kagami*)
Signed *Hiroshige ga*
Published by Ibaya Senzaburō
Censorship seal *aratame*; date seal *Snake 1* (1857/1)
1857/1
V&A: E.12082-1886, E.12083-1886, E.12084-1886

The designs in this series, published the year before
Hiroshige died, are remarkable for the quality of calm
engendered by their wide horizons and the unusual way
in which their female subjects gaze into the distance with
their backs turned to the viewer.

Plate 54 shows the upper reaches of the Tama River Water Supply at Koganei, some 20 kilometres from where, as in plate 53, it flowed through the western part of Edo and went below ground at the Yotsuya Barrier. Large and ancient cherry trees blossom along both sides of the watercourse, and Mount Fuji rises in the southwest above the reddening horizon. A woman, captivated by the evening view, sits on a bench with a towel thrown over her shoulder. The Tama River Water Supply had a total length of nearly 50 kilometres and was constructed in the mid-seventeenth century to supplement the Kanda Water Supply, depicted in plate 55, further to the north.

The night view looking westwards along the Kanda Water Supply in plate 55 is taken just upstream from where the watercourse divided into two at Sekiguchi on the southern border of the Zōshigaya district [Shiraishi 1993, 15E10]. The northern branch of the Kanda Water Supply, which was constructed in the early seventeenth century, flowed eastwards towards Suidōbashi and then turned south over the wooden acqueduct depicted in plates 22 and 25. The southern branch, effectively the overspill, flowed over a dam and joined the Sotobori Outer Moat at Iidabashi. In the middle distance we can see the Komadome Bridge and to the right the edge of the high ground occupied by the Suijin Shrine dedicated,

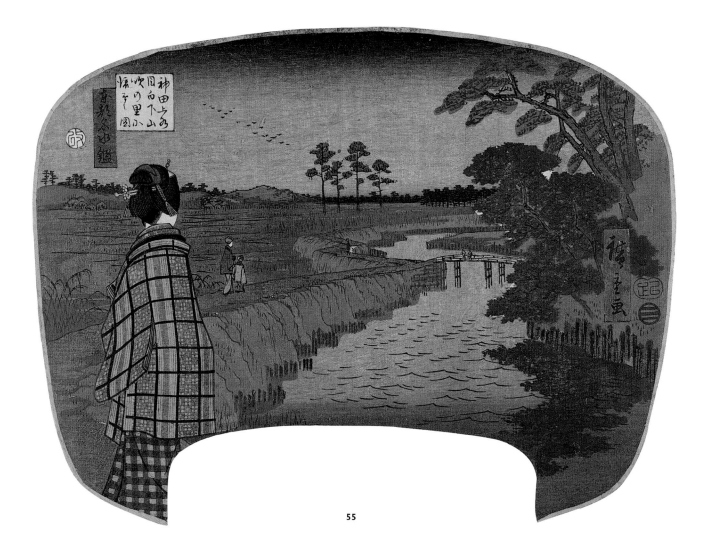

55

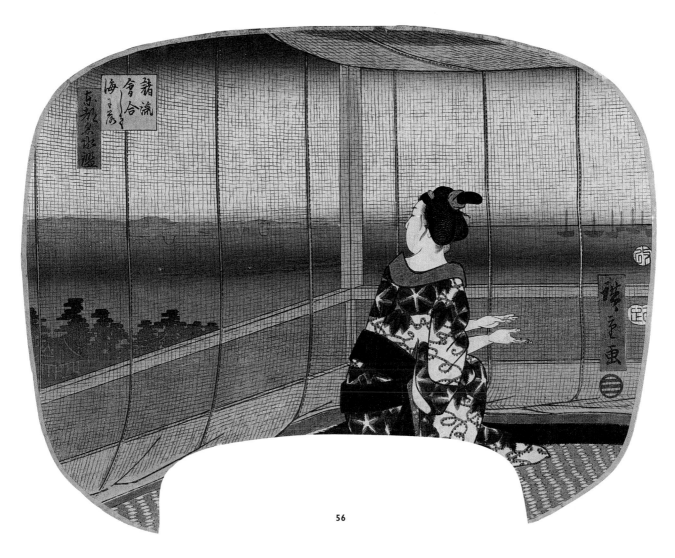

56

like its counterpart on the east bank of the Sumida river in plate 31, to the god of water. The Kerria Village of the title refers to a legend concerning the medieval warlord Ōta Dōkan (1432–86), whose aspiration to become a poet is said to have been inspired by a chance meeting with a young girl who gave him a sprig of kerria blossom.

Plate 56 takes us to the high ground at the southern (Shinagawa) end of the Takanawa district. It is early morning, and the summer sun is about to rise over Edo Bay and the Bōsō Peninsular far away to the east. A prostitute, still dishevelled from sleep, is lifting the netting that has protected her against mosquitoes through the night. Below on the left, among the pine trees, the top

of a torii gate and a small shrine can just be discerned. This is the Susaki Shrine, the approach to which we have seen in plates 9 and 47 [Shiraishi 1993, 23B8]. Not visible, like the customer with whom the woman has probably spent the night, is the mouth of the Meguro river. As suggested by the title, this flows into the sea through a channel to the immediate left of the shrine.

The ribmarks visible on the print in plate 55 are evidence that it was salvaged from a made-up fan. It can also be seen how the red lead (*tan*) used on the tree reflected in the river has turned from an original bright red to a present dull brown. No other designs from the series are known.

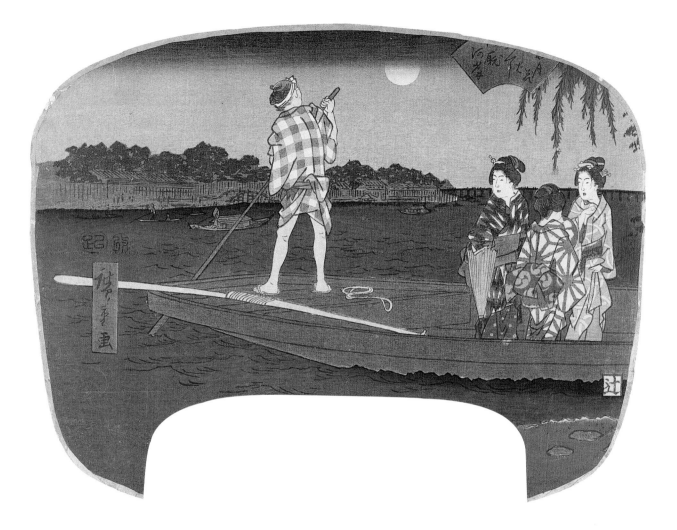

Plate 57

The Onmayagashi Crossing (*Onmayagashi*), from the
series *A Compendium of Ferry Crossings with Snow, Moon
and Flowers* (*Setsugekka Watashiba Tsukushi*)
Signed *Hiroshige ga*
Published by Tsujiya Yasubei
Censorship seal *aratame*; date seal *Snake 1* (1857/1)
1857/1
V&A: E.12088-1886

This somewhat lacklustre view of the Onmayagashi
ferry crossing in moonlight shows the landing point on
the western bank of the Sumida river just north of the
shogunate's rice granary in the Asakusa district
[Shiraishi 1993, 18F9]. Three courtesans in summer attire,
one of them holding an umbrella and another a fan, are
about to alight from the boat. Behind them, just visible
on the horizon, is Ryōgoku Bridge and to the left the
Ōkawabata or Great Riverbank area. No other designs
from the series are known.

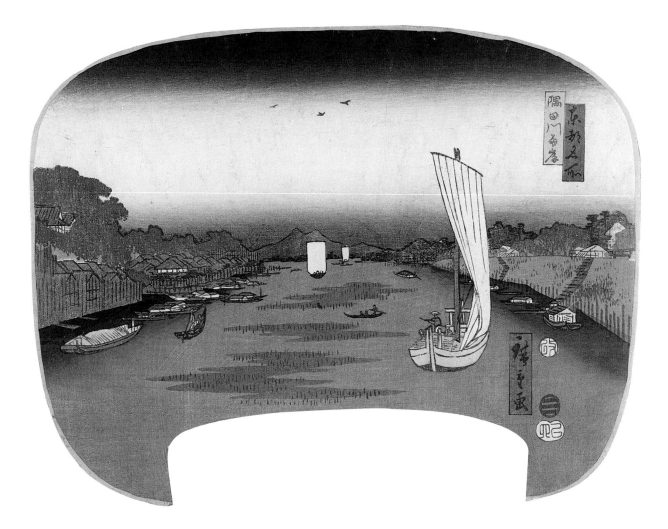

Plate 58

The Banks of the Sumida River (*Sumida Ryōgan*),
from the series *Famous Places in the Eastern Capital*
(*Tōto Meisho*)
Signed *Hiroshige ga*
Published by Ibaya Senzaburō
Censorship seal *aratame*; date seal *Snake 4* (1857/4)
1857/4
V&A: E.12087-1886

The ribmarks faintly visible in the sky add a certain
drama to this strongly receding view of the upper reaches
of the Sumida river. To the northeast, some 65 kilometres
away, the distinctive shape of Mount Tsukuba rises on
the darkening horizon. From our position in the middle

of the Azuma Bridge [Shiraishi 1993, 19J1] we can see
among the trees to the left the roof of the Shōten Shrine
at Matsuchiyama (see plate 24). Just beyond lies the
entrance to the San'yabori Canal, the point at which
travellers to the Yoshiwara licensed pleasure quarter
would alight from their boats to make the final part of
their journey by foot along the Nihon Embankment.
On the right we can see the more open space of the
Mukōjima district. Two sets of steps lead down to the
river, the nearer being those of the Takeya ferry crossing,
behind which, over the top of the embankment, the torii
gate of the Mimeguri Shrine is just visible. The reedy
strands in the middle of the river force even the smallest
of sculls to steer a careful course across the waters.
No other designs from the series are known.

2 | Views of the
Provinces

碓
井
峠
之
圖

熊
谷
堤
之
景

Plate 59
Views of the Usui Pass and the Kumagaya Embankment
(*Usui Tōge no Zu Kumagaya Tsutsumi no Kei*), from the
series *Eight Views of the Back and Front Highways* (*Ura
Omote Ekiro Hakkei*)
Signed *Hiroshige ga*
Published by Ibaya Senzaburō
Censorship seal *kiwame*
1839
V&A: E.4877-1919

This is one of three known designs depicting pairs of
views along the Kisokaidō Highway, the ancient inland
route that connected eastern Japan with the imperial
capital of Kyoto. Another series entitled the *Eight Views of
the Front and Back Highways* (*Omote Ura Ekiro Hakkei*),
datable to the mid-1830s, depicts single views along the
Tōkaidō Highway (Suzuki 1970, nos 46–9). The similarity
of their titles and the closeness of their dates of
production suggest that the two series were designed to
complement one another, the simple colouring of the
former balancing the rich polychrome of the latter. The
Usui Pass is on the border between Gunma and Nagano
prefectures just to the east of the nineteenth post-station
at Karuizawa. Kumagaya, the ninth post-station, is
situated in the north of Saitama Prefecture about halfway
between Edo and the Usui Pass. The descending geese
visible in the middle distance appear to be associated
with the Kumagaya Embankment. It is not clear what
association Hiroshige intended for the Usui Pass.

The ribmarks visible on the print are evidence that it
was salvaged from a made-up fan. The two other designs
from this series, both of which bear cyclical date seals
corresponding to 1839, are of the Wada Pass and Mount
Asama (Narasaki 1973, no.75) and of the Jūsan Pass and
the Tsumago ferry crossing (Suzuki 1970, no.155).

Plate 60
Autumn Leaves and the Togetsu Bridge at Arashiyama in Kyoto (*Kyō Arashiyama Kōyō Togetsukyō*)
Signed *Hiroshige ga*
Published by Enshūya Matabei
About 1840–2
V&A: E.4871-1919

Arashiyama is a well-known beauty spot in the north-western part of Kyoto that takes its name from the small mountain we see here from the northern bank of the Hozu river. Boatmen pole rafts of logs towards the Togetsu Bridge on the horizon to the east. Being only a short distance from the centre of Kyoto, Arashiyama was, as it is today, much visited all year round. It was particularly busy during the cherry-blossom season and, as here, at maple-viewing time. The ribmarks visible towards the top of this later printing (*atozuri*) indicate that it was salvaged from a made-up fan.

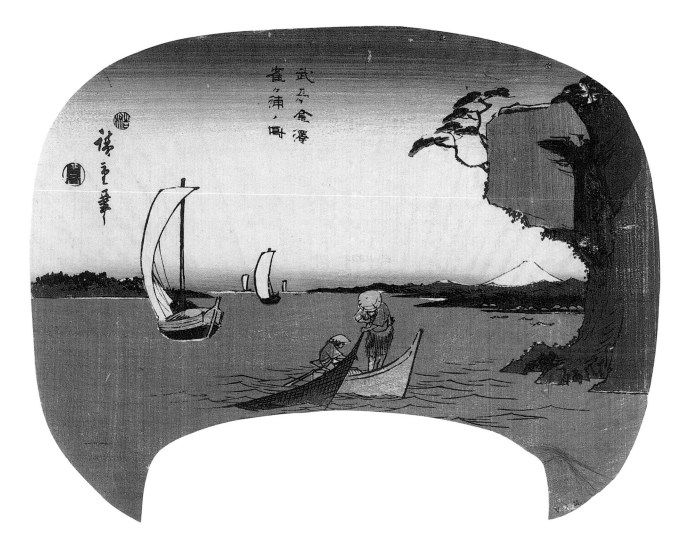

Plate 61
View of Suzume Bay at Kanazawa in Musashi Province
(*Bushū Kanazawa Suzumegaura no Zu*)
Signed *Hiroshige hitsu*
Unidentified publisher's mark
Censor's seal *Yoshimura*
1843–7
V&A: E.4832-1919

This later printing (*atozuri*) salvaged, as the ribmarks indicate, from a made-up fan shows Mount Fuji in the distance across the expanse of *Suzumegaura*, literally 'Swallow Bay'. This was one of numerous beauty spots in the Kanazawa area to the southwest of Hodogaya, the fourth post-station on the Tōkaidō Highway, in Kanagawa Prefecture. The *Kanazawa Hakkei* or Eight Views of Kanazawa had been celebrated since the early seventeenth century and were popular with travellers from Edo making the journey to Enoshima (see plates 77 and 90) further to the west.

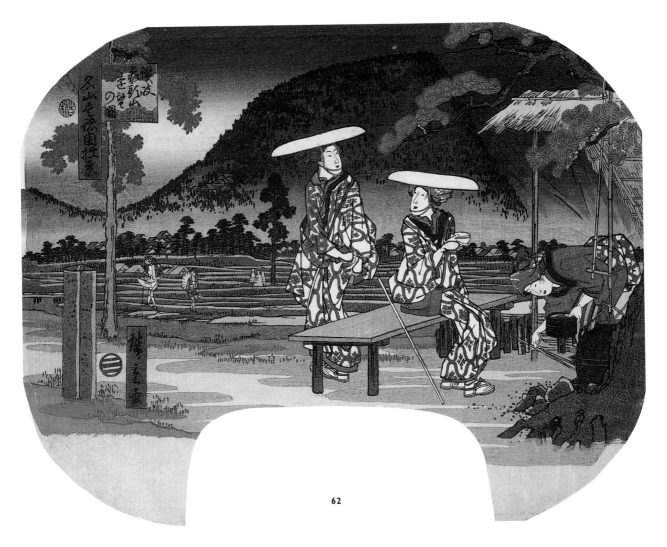

62

Plate 62

Distant View of Mount Zōzu in Sanuki Province
(*Sanuki Zōzusan Enbō no Zu*)

Plate 63

View of Autumn Maples at Ishiyama Temple in Ōmi
Province (*Ōmi Ishiyamadera Momiji no Zu*)

Two designs from the series *Ten Views of Famous*
Mountains in the Provinces (*Meizan Tsukushi Shokoku Jukkei*)
Signed *Hiroshige ga*
Published by Ibaya Senzaburō
Censor's seal *Yoshimura*
1843–7
V&A: E.2912-1913, E.2924-1913

Plate 62 shows two women in travelling garb resting on
their way to the Kotohira (Konpira) Shrine in the eastern
part of Kagawa Prefecture on the island of Shikoku.
Zōzusan, literally 'Mount Elephant Head', was the
popular name for the heavily wooded southeastern end
of Mount Ōsa, on the lower slope of which, a little to the
right of the reddening sky, some of the shrine buildings
can just be made out. Founded in the eleventh century,
the Kotohira Shrine was dedicated to the guardian deity
of fishermen and sailors. During the Edo period it
became, as it still is today, the destination of large
numbers of pilgrims from all over the country.

The autumn scene in plate 63 is set in the grounds of
the Ishiyama Temple at the southern end of Lake Biwa in
Shiga Prefecture. This is where the Heian period court

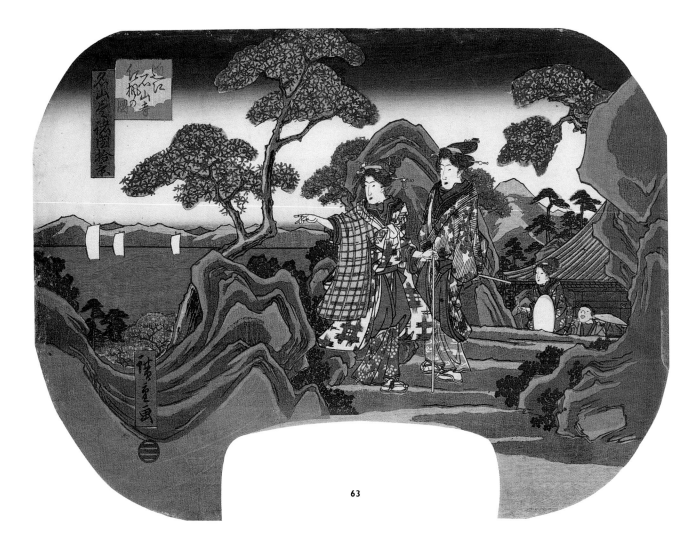

63

lady Murasaki Shikibu is reputed to have written her great novel *The Tale of Genji* at the beginning of the eleventh century. Lake Biwa and its eastern shore are visible on the left, while on the right, behind the partially visible temple building, one of the peaks in the mountainous area to the east of the Seta river can be seen. The intense red of the maple leaves has been achieved through the use of red lead (*tan*). This has begun to tarnish, particularly towards the right of the print.

Seven other designs from the series are known. They are a view of Osaka Bay from Mount Tenpō (collection of the Japan Ukiyo-e Museum), mushroom gatherers in the Kitayama mountains north of Kyoto (collection of the Japan Ukiyo-e Museum), a view of the sea from Mount Kanō in Chiba Prefecture (Matsuki 1924, no.26), Mount Fuji seen from across the sea at Miho Bay (Matsuki 1924, no.27), melting snow in the Kiso mountains in Nagano Prefecture (Matsuki 1924, no.28), Mount Dōkan in Edo (Sakai 1996, no.1405) and a distant view of Mount Mikasa to the east of Nara (Ōta Memorial Museum 1998, no.263).

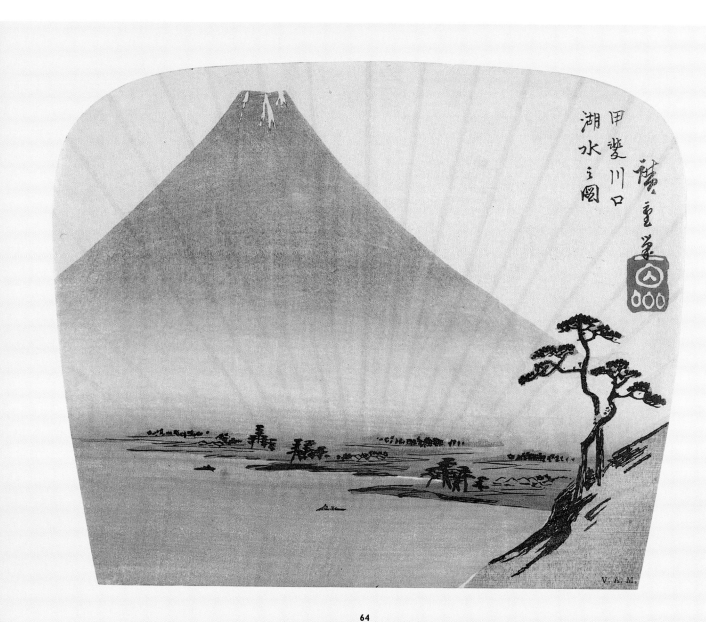

64

Plate 64
View of Lake Kawaguchi in Kai Province (*Kai Kawaguchi Kosui no Zu*)

Plate 65
View of the Sea at Kisarazu in Kazusa Province (*Kazusa Kisarazu Kaijō no Zu*)

Two designs from an untitled series of views of Mount Fuji
Signed *Hiroshige ga*, with seal *Ichiryūsai*
Published anonymously
About 1844–5
226 × 182mm (plate 64), 240 × 184mm (plate 65)
V&A: E.4893-1919, E.4894-1919

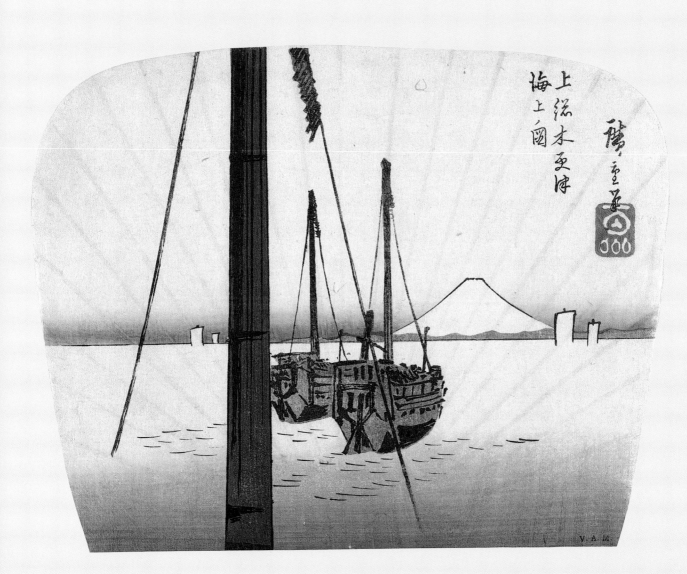

65

The wash-like use of a simple palette of colours adds to the compositional power of these two designs, one dominated by the towering mass of Mount Fuji and the other by the strong vertical of a ship's mast. Lake Kawaguchi, across whose waters we are looking in plate 64, is one of five lakes that lie to the north of Mount Fuji in southern Yamanashi Prefecture. Kisarazu, off whose coast the cargo ships in plate 65 are moored, is a port on the western side of the Bōsō Peninsular in Chiba Prefecture. The view is westwards across Edo Bay towards Mount Fuji. The designs are unusual for their small size, square format and lack of cut-away lower section. No other designs from the series are known.

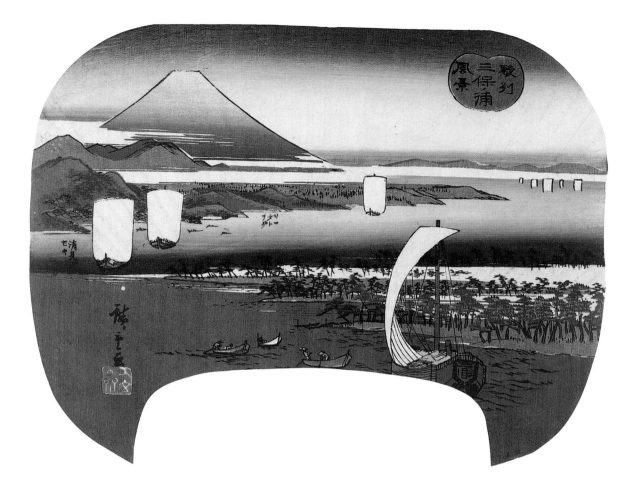

Plate 66

View of Miho Bay in Suruga Province (*Suruga Mihonoura Fūkei*)

Signed *Hiroshige ga*, with seal *Ichiryūsai*

Published anonymously

About 1845–6

V&A: E.4918-1919

This expansive panorama across and beyond Miho Bay is taken from what has for long been considered one of the prime locations from which to view Mount Fuji, which rises in an almost uninterrupted sweep to the northeast. Miho Bay lies on the coast of Shizuoka Prefecture near Ejiri, the eighteenth post-station of the Tōkaidō Highway. It was famous for its pine beach, depicted here across the centre of the design, which jutted out on the seaward side. The two sets of characters below the coastline in the middle distance identify the Kiyomigaseki Barrier (left, see plate 83) and the Satta Pass (middle), two well-known sites along the coast of Suruga Bay. The ribmarks visible towards the top of the print indicate that it was salvaged from a made-up fan. The broken outlines and less than perfect registering of the colours suggest that it was taken from partially worn blocks.

Plate 67
*Dōgashima and the Indoor
Hot Spring Waterfall
at Sokokura*
(*Dōgashima – Sokokura
Uchitaki(no)yu no Zu*)

Plate 68
Yumoto (*Yumoto*)

Plate 69
Tōnosawa (*Tōnosawa*)

Plate 70
Miyanoshita (*Miyanoshita*)

Plate 71
Kiga (*Kiga*)

Plate 72
Ashinoyu (*Ashinoyu*)

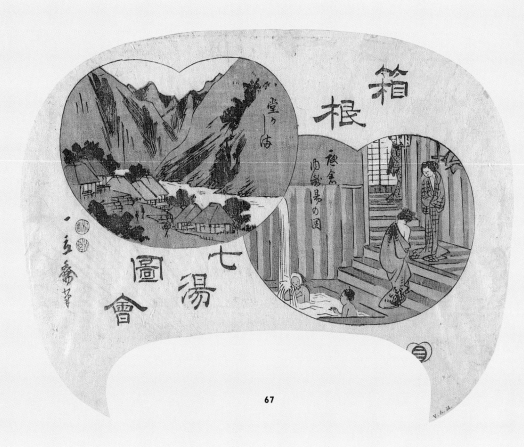

67

Complete set of six designs from the series *Depictions of the Seven Hot Springs of Hakone* (*Hakone Shichitō Zue*)
Signed *Ichiryūsai hitsu* (plate 67) and *Hiroshige ga* (plates 68–72)
Published by Ibaya Senzaburō
Censors' seals *Mera* and *Murata*
1847/2–1850/11
V&A: E.4843-1919, E.4844-1919, E.4847-1919, E.4846-1919, E.4848-1919, E.4845-1919

This delightful and complete set of six designs shows the seven hot springs of Hakone, historically and still today one of the most frequently visited resorts in Japan. It is situated in the southwestern corner of Kanagawa Prefecture about 40 kilometres from Mount Fuji, on to which it offers, from certain vantage points, spectacular views (see plate 76). Hakone was the tenth post-station along the Tōkaidō Highway and relatively accessible to city dwellers wanting to escape the noise and bustle of Edo. Its seven hot springs, around which many of its inns were built, were a popular subject for *ukiyo-e* artists. An early series by Torii Kiyonaga (1752–1815) concentrates almost exclusively on the depiction of women (*MSU*, vol.2, nos 28–33). With the subsequent rise of the landscape print, however, greater attention was paid to the topographical features of the area. This can be seen both in this series and in the designs in plates 78–80 and 91. The ribmarks visible on the prints in plates 67, 69 and 70 indicate that they were salvaged from made-up fans.

Plate 67, with its contrasting exterior and interior views of Dōgashima and Sokokura, is interesting for the way in which it has clearly been designed as a frontispiece to the series. It is possible to speculate that

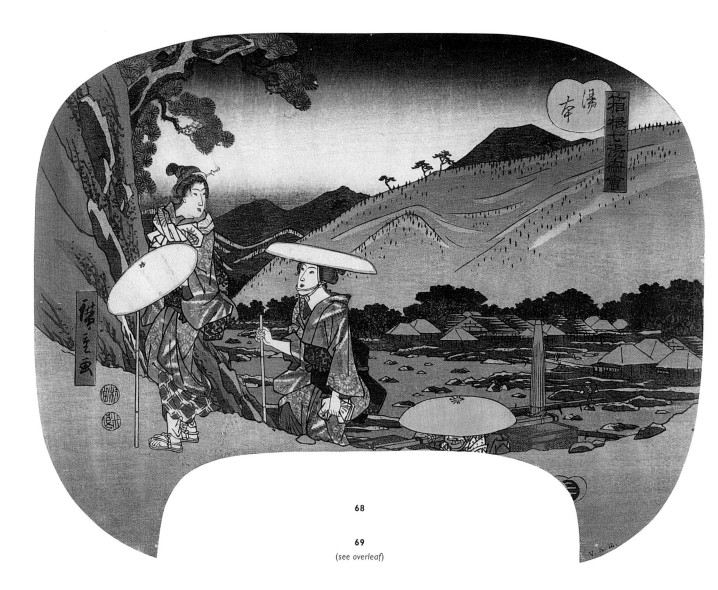

68

69
(see *overleaf*)

the six prints would have been sold as a set, with the relative simplicity of the first design acting as a foil for the richness of colour and detail of the others. For travellers from Edo the first hot spring they would have come to would not have been Dōgashima or Sokokura, however, but Yumoto, which we see to the north in plate 68. Yumoto lies next to the confluence, visible above the porter's straw hat, of the Sukumo and Haya rivers. The former, whose southern flank the Tōkaidō Highway followed, is the one we see flowing from the left. The Haya river is the one just visible as it flows towards us through the middle of Yumoto.

Following the course of the Haya river upstream to the northwest, travellers would next have come to Tōnosawa, depicted in plate 69 (*overleaf*). The speed of the river is evident, as is the mood of relaxation of the female guests about to be served a meal. Further up the Haya river travellers would have come to Dōgashima. Surrounded by the steep cliffs we see in plate 67, it was known for its air of remoteness and tranquility.

Miyanoshita, depicted in plate 70, lies on the southern side of the Jakkō river, a tributary that flows into the Haya just upstream of Dōgashima. It was the favoured resort of wealthy merchants and high-ranking samurai.

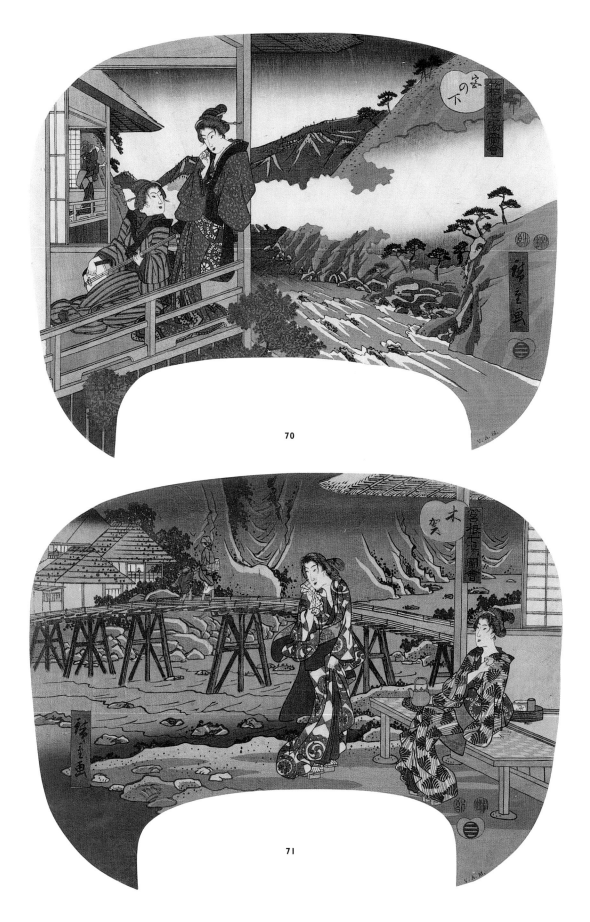

70

71

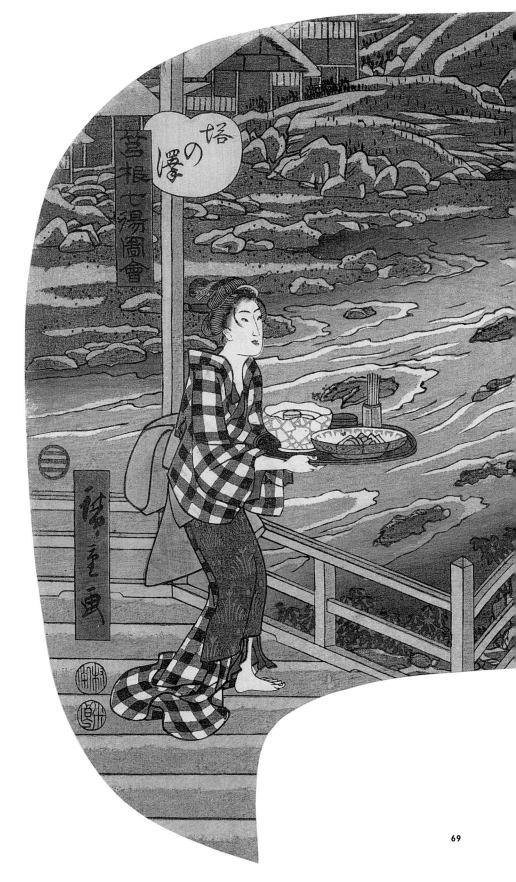

69

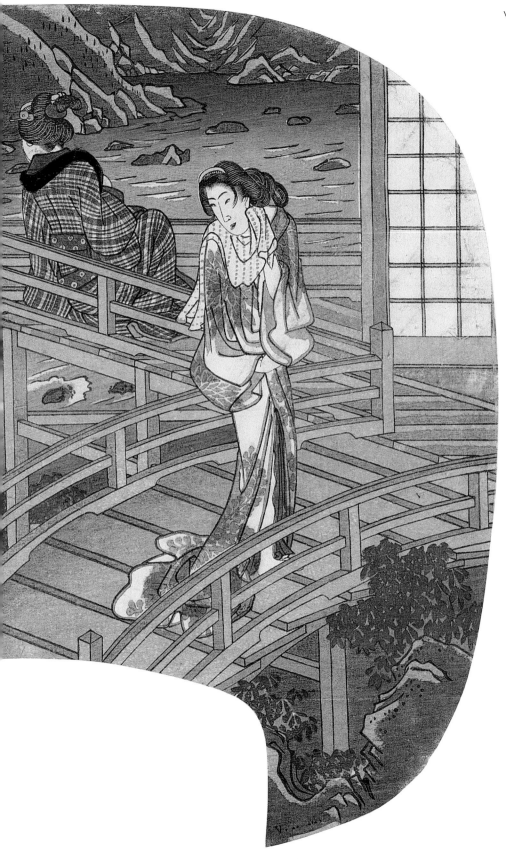

Above Miyanoshita, further up the Haya river, lie Sokokura, whose indoor facilities are shown in plate 67, and Kiga, depicted in plate 71.

Plate 72 shows the bathhouse and surrounding complex of guestrooms of the Matsuzakaya Inn at Ashinoyu, the last of the seven hot springs. The name of the inn, which still exists today, appears on the paper lantern in the foreground. Ashinoyu lies separated a few kilometres to the southwest of the Yumoto to Kiga sequence of resorts. It is situated on the eastern flank of Mount Komagatake immediately to the north of Lake Ashi. It was and still is much visited for the remedial power of its waters, believed to be particularly efficacious for high blood pressure, women's illnesses and skin problems.

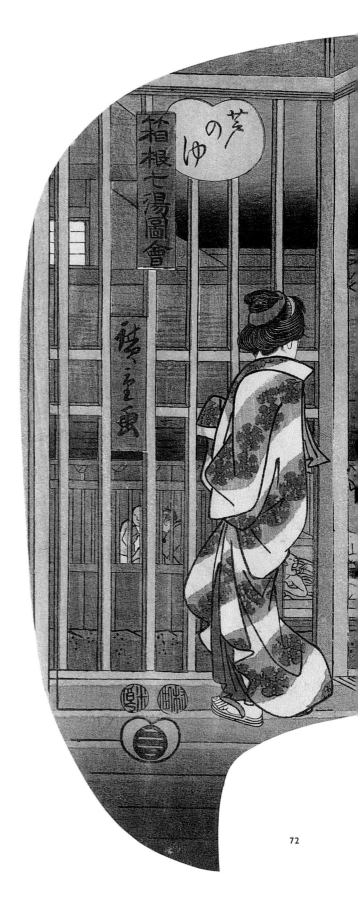

72

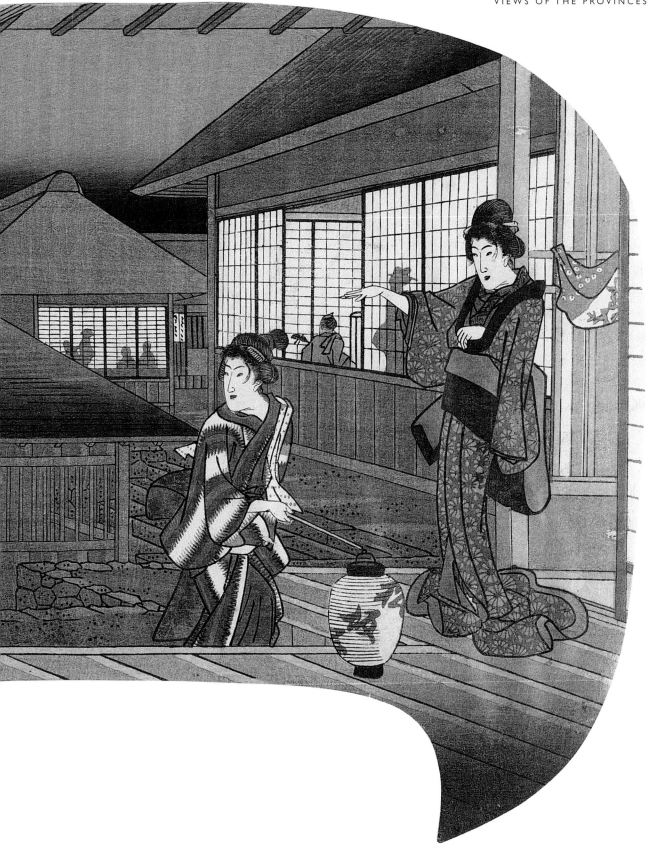

Plate 73
The Kegon Waterfall at Nikkō (*Nikkōsan Kegon no Taki*)
Signed *Hiroshige ga*
Unidentified publisher's mark
About 1848–50
V&A: E.4833-1919

The Kegon Waterfall plunges for the best part of 100 metres to the immediate east of Lake Chūzenji in what is now the Nikkō National Park in northwestern Tochigi Prefecture. Long known as a religious centre, Nikkō became a major focus of pilgrimage following the completion of the Tōshōgū Shrine in 1636. The Tōshōgū Shrine contained the mausoleum of Tokugawa Ieyasu (1543–1616), the founder of the Tokugawa shogunate, and was a key symbol of the authority of the country's military leadership. Nikkō was reached by the Nikkō Kaidō, which, like the Tōkaidō and Kisokaidō Highways, was officially administered and had a series of post-stations along its length. The abstraction of Hiroshige's composition adds to the sense of spectacle of one of Japan's most famous waterfalls. Being a later printing (*atozuri*), however, this impression fails to do full justice to the quality of the design. This is not helped by the fading of the colours, resulting from the fact, evident from the ribmarks, that it is was once mounted up as a fan.

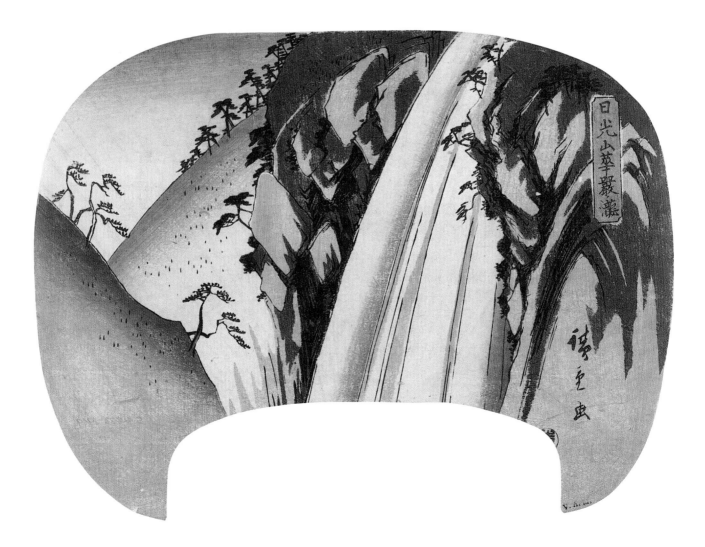

Plate 74

View of Kada Bay (*Kada(no)ura no Zu*)
Signed *Hiroshige ga*
Published by Kawaguchiya Uhei
About 1848–50
V&A: E.4895-1919

This tranquil view of women and children collecting shellfish is set on the coast northwest of Wakayama, the castle town of the Kii branch of the Tokugawa family. The torii gate and buildings on the left are those of the Awashima Shrine, while on the horizon the coastline of Awaji Island ten kilometres to the west across the Tomogashima Straits can just be made out. Kada Bay and the Awashima Shrine, whose deity was reputed to have curative powers against female ailments and made it a focus of pilgrimage in its own right, lay on the route between the great religious centres of Mount Kōya in eastern Wakayama Prefecture and the Kotohira Shrine on the island of Shikoku (see plates 62 and 94). The rib-marks visible across the print are evidence that it was salvaged from a made-up fan.

Plate 75

*A Compendium of Famous Products along the Tōkaidō
Road* (*Tōkaidō Meibutsu Tsukushi*)
Signed *Ichiryūsai hitsu*
Published by Enshūya Matabei
About 1848–50
V&A: E.4919-1919

This well-used and somewhat worn monochrome print
is interesting for what it relates about the growing
fascination with food and other regional products that
accompanied the increase in travel during the Edo
period. Like the six gardens of Edo represented in plate 3
by the plants for which they were famous, here we have

depictions of seven kinds of foodstuff associated with
particular locations along the Tōkaidō Highway.
Clockwise from top right they are: *Seto no Someii*, yellow-
dyed rice from Seto (near Fujieda, the twenty-second
post-station); *Abekawamochi*, rice cakes from Abekawa
(near Fuchū, the nineteenth post-station); *Kuwana no
Yakihamaguri*, baked clams from Kuwana (forty-second
post-station); *Kusatsu Ubagamochi*, rice cakes from
Kusatsu (fifty-second post-station); *Ōmi Gengorōbuna*,
carp from Ōmi (Ōtsu, the fifty-third post-station);
Koyoshida no Sushi, sushi from Koyoshida (Yoshida, the
thirty-fourth post-station); and *Mariko no Tororojiru*,
grated yam soup from Mariko (twentieth post-station).

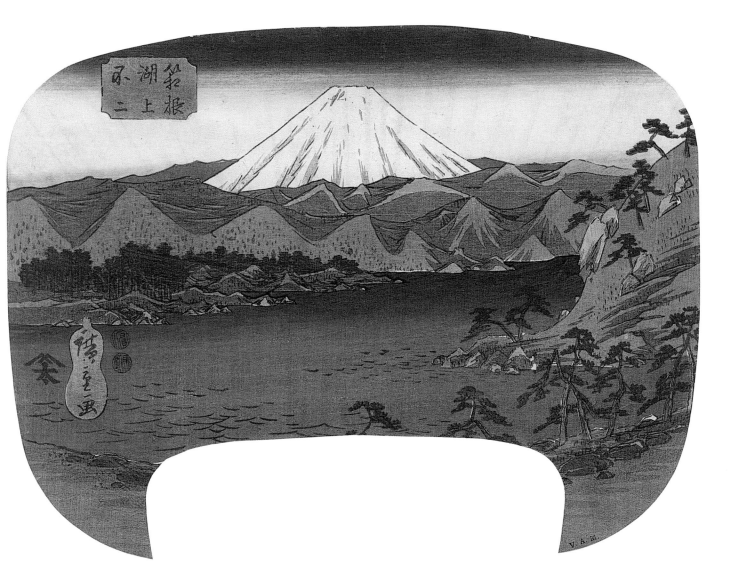

Plate 76

Mount Fuji from across the Lake at Hakone

(*Hakone Kojō Fuji*)

Signed *Hiroshige ga*

Unidentified publisher's mark

Censors' seals *Magome* and *Hama*

1849/1–1852/1

V&A: E.4849-1919

In spite of its somewhat pedestrian composition, this depiction of Mount Fuji across Lake Ashi and the mountains of Hakone captures some of the drama that has attracted so many travellers to the area over the centuries. The light is fading in the west, casting the lake and its surroundings into a shadowy darkness that renders the perfect snow-clad form of Mount Fuji all the more spectacular. Ribmarks visible towards the top of the print are evidence that it was salvaged from a made-up fan. The less than perfect registering of the colours suggests that it was taken from partially worn blocks.

106

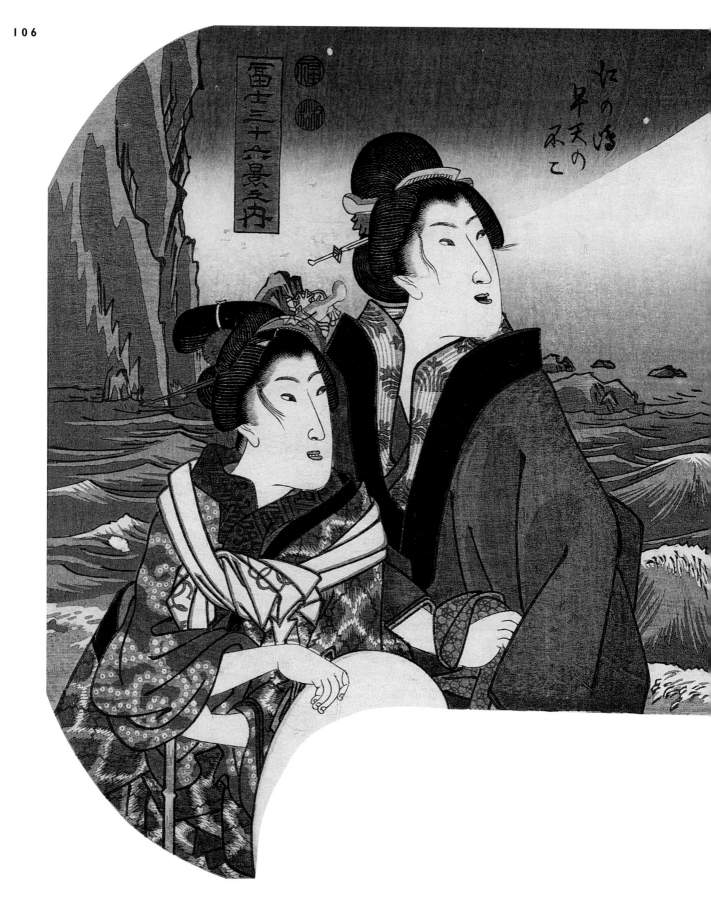

Plate 77

Mount Fuji at Dawn from the Island of Enoshima
(*Enoshima Sōten no Fuji*), from the series *Thirty-six Views of Mount Fuji* (*Fuji Sanjūrokkei no Uchi*)
Signed *Hiroshige ga*
Published by Ibaya Senzaburō
Censors' seals *Muramatsu* and *Fukushima*
1849/3–1852/2
V&A: E.575-1913

This breathtaking view of Mount Fuji shows it rising in the west over the waters of Sagami Bay in Kanagawa Prefecture. The skilful use of tonal grading (*bokashi*) combined with the deliberate omission of a black outline gives the mountain an almost unearthly radiance. The two women appear to be standing on the sandbar that at low tide allows visitors to make the short crossing to the island of Enoshima, the rocky cliffs of which are visible on the upper left. Enoshima was dedicated to the goddess Benten in the late twelfth century and has been a popular place of worship ever since. During the Edo period it was particularly frequented by merchants, actors and entertainers in search of the improved commercial and artistic prospects that prayers and offerings to the deity were believed to bring.

Two other designs from the series are known. They are an early spring view from the Rokugō ferry crossing in Kawasaki (Matsuki 1924, no.81) and a view on a summer's evening from below the Ryōgoku Bridge in Edo (Matsuki 1924, no.82).

Plate 78
A Hot Spring Inn at Yumoto (*Yumoto Yutei*)

Plate 79
View of Tōnosawa (*Tōnosawa Fōkei*)

Plate 80
Kiga Spring (*Kiga Onsen*)

Three designs from the series *A Tour of the Seven Hot Springs of Hakone* (*Hakone Shichitō Meguri*)
Signed *Hiroshige ga*, with seals *Hiro* (plate 78) and *Ichiryūsai* (plate 79)
Published by Ibaya Senzaburō
Censors' seals *Kinugasa* and *Murata*
1851/2–1851/9
V&A: E.2915-1913, E.12065-1886, E.12066-1886

These three designs offer alternative views of the hot-spring resorts depicted in plates 68, 69 and 71. They are unusual for their square format and lack of cut-away lower sections, and also for the variation in palette from one design to the next. A fourth design from the series shows an interior sequence of four baths at Ashinoyu (collection of the Kanagawa Prefectural Museum of Cultural History).

 Plate 78 shows a woman dancing to the accompaniment of a *shamisen* in an upstairs room at Yumoto. The characters on the lower right read *yukyaku shukyō no tai*, meaning 'guests merrymaking with sake'. Considerable care has been taken over the depiction of the porcelain drinking vessels in the middle of the room and the porcelain and lacquer food containers on the tray to the left.

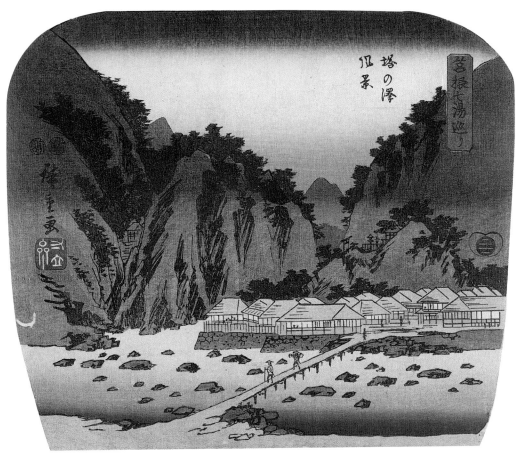

79

The subdued tones of blue, grey and purple in plate 79 show Tōnosawa at dusk. The view is from across the Haya river, which flows more gently than it does, for example, in plate 69.

Plate 80 is an *aizuri* or monochrome blue rendering of Kiga. The high vantage point offers a sweeping view over the enclosing cliffs and the distant mountains of Hakone. The characters in the red cartouches read, from left to right, *Ashisokokuraya, yushuku, Sugawa, Hayakawa* and, once again, *yushuku*. *Yushuku* means 'hot spring inn', while *Ashisokokuraya* appears to be a place name. *Hayakawa* or Haya river is the name of the river downstream of the bridge, and *Sugawa* that of its upper reaches.

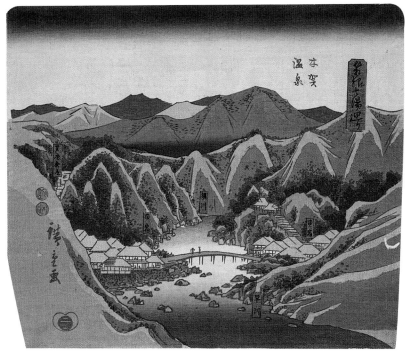

80

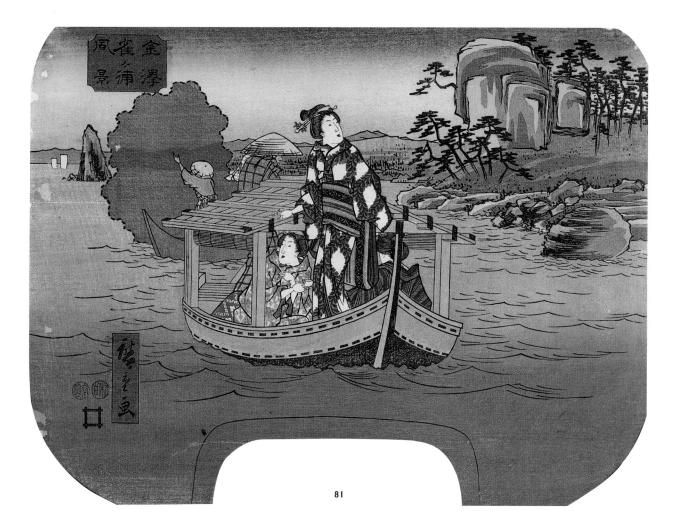

81

Plate 81
View of Suzume Bay at Kanazawa (*Kanazawa Suzumegaura Fūkei*)

Plate 82
The Plum Garden at Sugita (*Sugita no Baien*)

Two designs from an untitled series of views of
famous places in the provinces
Signed *Hiroshige ga*
Published by Sanoya Kihei
Censors' seals *Kinugasa* and *Murata*
1851/2–1851/9
V&A: E.2921-1913, E.2928-1913

The scenes in plates 81 and 82 are both set in Kanagawa
Prefecture (former Musashi Province). It is possible that
the series, no other designs from which have been
identified, is exclusively of views in this part of Japan.
The compositional balance of the designs infuses them
with a particular sense of calm, while the extensive use
of pinks and purples gives them a somewhat other-
worldly quality.

Plate 81 is a close-up depiction of Suzume Bay, which
we have seen from further out to sea in plate 61. A com-
parison of the views suggests that Mount Fuji lies just
around the corner behind the rocky outcrop on the right.
The roof-boat in which the three women are riding is
similar to those we have seen depicted on the rivers and
canals of Edo. What looks like a puff of smoke behind
them is a net that the fisherman is casting into the sea.

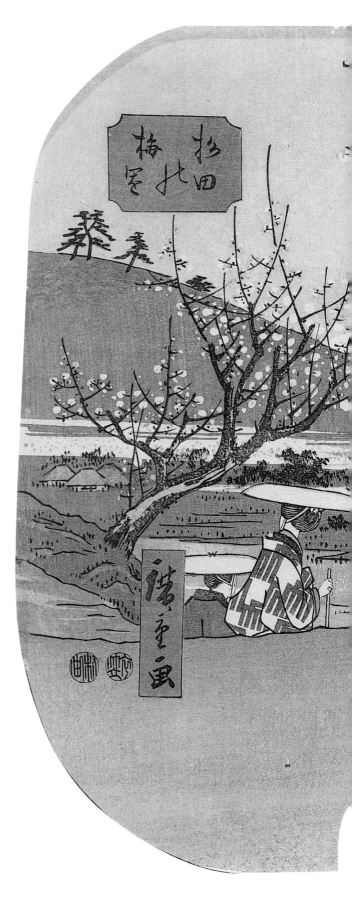

Plate 82 is set in the famous plum garden that used to
exist in what is now part of the grounds of the Myōhōji
Temple in the Isogo district of Yokohama. Mount Fuji
rises in the west behind the gnarled form of a plum tree.
A woman leans against a palanquin while her seated
companion lights a pipe from a small brazier. The charac-
ters on the sign above them read *senjicha / oyasumidokoro*,
meaning 'tea / resting place'.

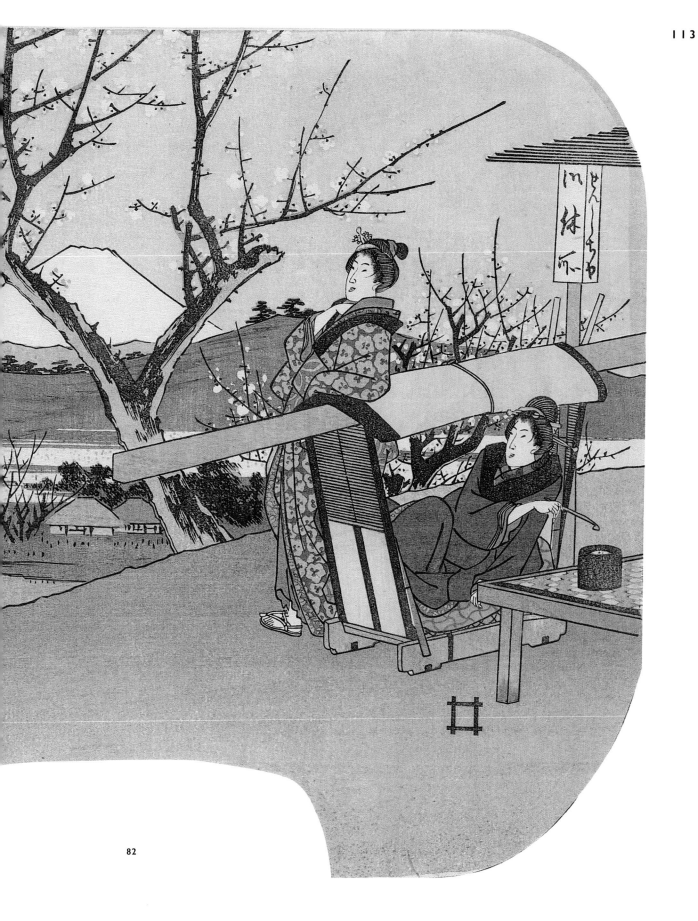

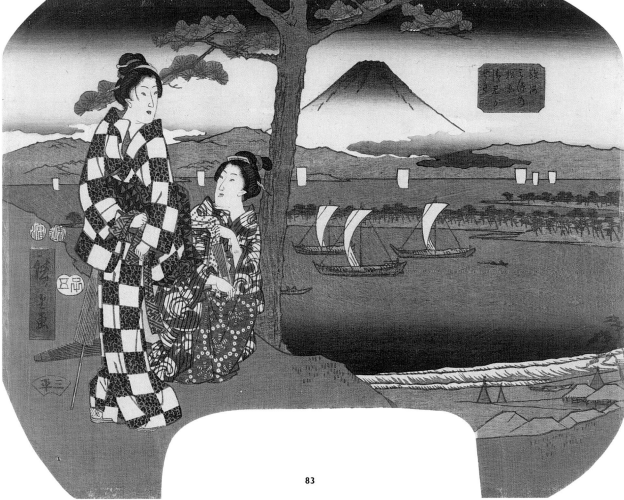

83

Plate 83
The Pine Grove at Miho in Suruga Province and the
Kiyomigaseki Barrier Station (*Suruga Miho no Matsubara*
Kiyomigaseki)

Plate 84
The Shichiri Ferry Crossing at Atsuta in Owari Province
(*Owari Atsuta Shichiri no Watashi*)

Two designs from an untitled series of views of famous
places in the provinces
Signed *Hiroshige ga*
Publisher's mark *Sanpei*
Censors' seals *Magome* and *Hama*; date seal *Rat 5* (1852/5)
1852/5
V&A: E.2919-1913, E.2920-1913

The scenes in plates 83 and 84 are set along the Tōkaidō
Highway, the first in the area of the seventeenth and
eighteenth post-stations of Okitsu and Ejiri in Shizuoka
Prefecture and the second near the forty-first post-station
of Miya (also called Atsuta) in Aichi Prefecture. No other
designs from the series are known.

The view in plate 83 of Mount Fuji seen across Miho
Bay and its famous grove of pine trees is similar to that
in plate 66 but taken from further round the coast near
the Kiyomigaseki Barrier. This was an old *sekisho* or
barrier station, set up as part of the provisions of the
seventh-century Taika Reforms. It subsequently fell into
disuse and was absorbed into the grounds of the nearby
Seikenji Temple. Due to its proximity to the Miho pine
grove, however, and the poetic associations that literary
convention ascribed to it, its name survived its physical

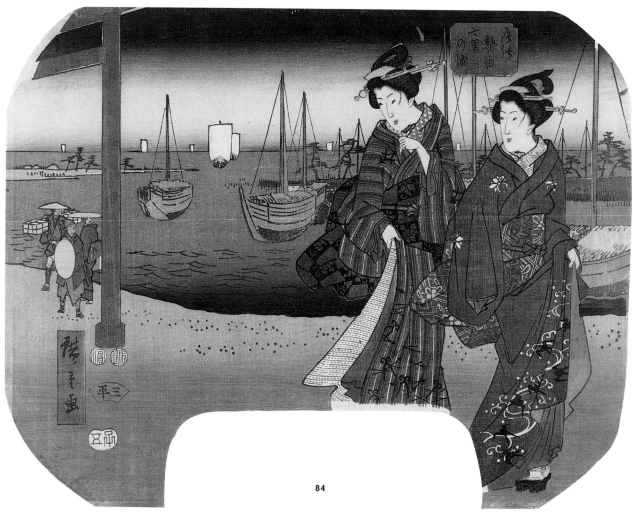

84

demise. Hiroshige's composition depends on a considerable skewing, not without precedent in depictions of this area, of the topography. Were we really to be standing at the site of the Kiyomigaseki Barrier looking towards Mount Fuji, the Miho pine grove would be well out of sight to the right.

Plate 84 is set on what used to be the coast but is now a river in an area of reclaimed land in the southern part of Nagoya. The torii gate visible to the left of the two rather statuesque courtesans marks the beginning of the approach to the Atsuta Jingū Shrine, which lies a little less than a kilometre to the northeast. This major Shintō shrine, which enjoyed the official patronage of the Tokugawa shogunate, is reputed to enshrine the sacred sword, the *Kusanagi no Tsurugi*, that forms part of the imperial regalia. The Shichiri of the title means 'seven

leagues', the distance by sea from the point of embarkation depicted here to the next post-station on the Tōkaidō Highway at Kuwana. This was shorter than the more circuitous overland route, which involved a journey inland followed by a boat trip down the Kiso river.

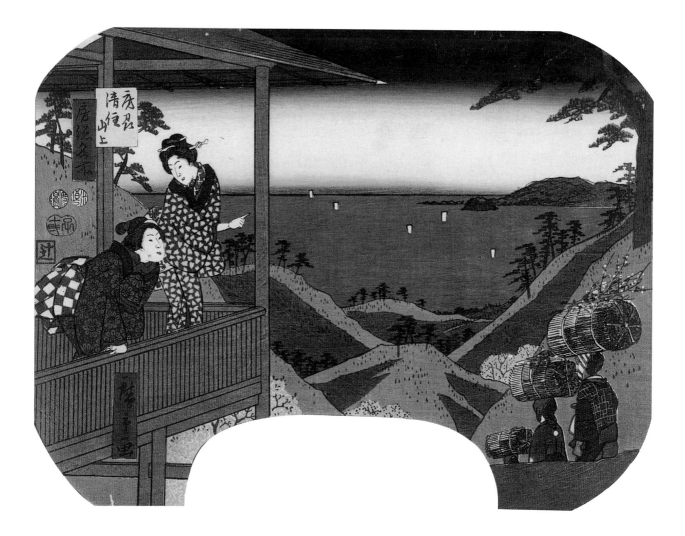

Plate 85

View from Mount Kiyosumi in Awa Province (*Bōshū Kiyosumi Sanjō*), from the series *Famous Places in Bōsō (Awa, Kazusa and Shimōsa Provinces)* (*Bōsō Meisho*)
Signed *Hiroshige ga*
Published by Tsujiya Yasubei
Censors' seals *Mera* and *Watanabe*; date seal *Rat 12* (1852/12)
1852/12
V&A: E.2925-1913

This fine southwestward view over the Pacific Ocean from the slopes of Mount Kiyosumi in Chiba Prefecture was published in the same year as Hiroshige made what is thought to have been at least his second journey to the

Bōsō Peninsular (Suzuki and Ōkubo 1996, p.190). Mount Kiyosumi lies to the north of the port of Kominato, down the steep road to which the porters on the right with their flower-strewn loads of charcoal are making their way. The area was famous on account of the fact that Nichiren (1222–82), the founder of the Nichiren sect of Buddhism, was born in Kominato and underwent his early religious training at the Seichō Temple on the summit of Mount Kiyosumi.

Four other designs from the series are known. They are a view of Kominato (Matsuki 1924, no.97) and views of Mount Fuji from Kisarazu (Matsuki 1924, no.98), from the rocky coast at Hota (Matsuki 1924, no.100) and from Mount Kanō (collection of the Ōta Memorial Museum of Art).

Plate 86

The Whirlpools in Awa Province (*Awa no Naruto*)

Plate 87

Tago Bay in Suruga Province (*Suruga Tago(no)ura*)

Plate 88

Chōshi Bay in Shimōsa Province (*Shimōsa Chōshi(no)ura*)

Three designs from the series *Famous Places in the Provinces* (*Shokoku Meisho*)
Signed *Hiroshige ga*
Published by Iseya Sōemon
Censorship seal *aratame*
1854/1–1858/1
V&A: E.12076-1886, E.12077-1886, E.12078-1886

These three richly coloured designs, the second of which has been salvaged from a made-up fan, are fine examples of Hiroshige's late work. They are unusual in bearing only an *aratame* censorship seal when normally this would appear in conjunction with a date seal. Ribmarks visible on the print in plate 87 indicate that it was salvaged from a made-up fan. No other designs from the series are known.

Plate 86 shows the famous whirlpools caused by the rushing of the tide through the Naruto Straits between Awaji Island and the northwestern corner of Tokushima Prefecture on the island of Shikoku. During his last years Hiroshige depicted these whirlpools in a variety of formats, inspired in part, it has been suggested, by the renderings of waves and eddying currents for which Katsushika Hokusai (1760–1849) was so well known (Suzuki and Ōkubo 1996, p.232).

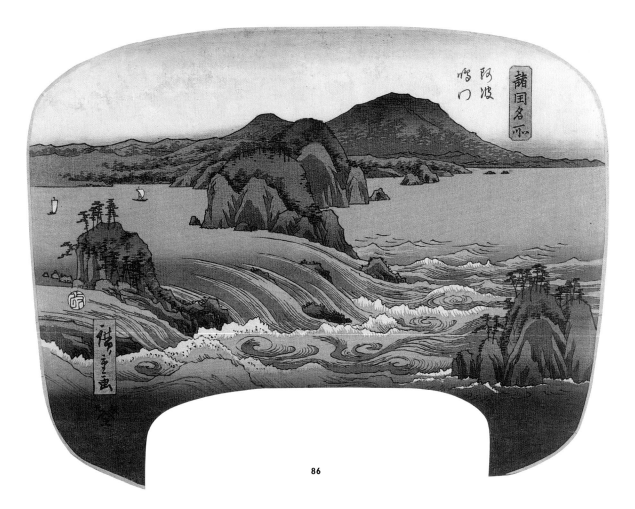

86

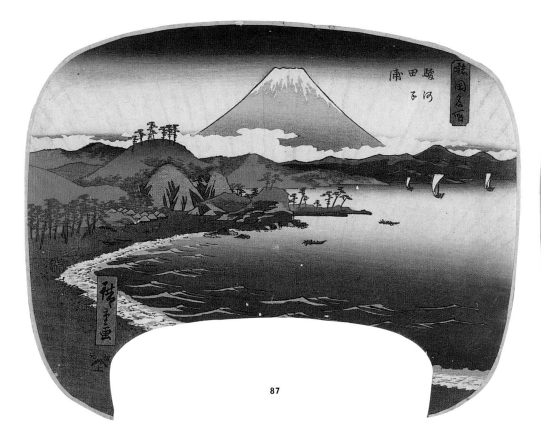

87

Plate 87 takes us eastwards to the coast of Shizuoka Prefecture. Tago Bay, immortalised in a famous poem by the eighth-century court poet Yamabe no Akahito, lies almost due south of Mount Fuji in the vicinity of Yoshiwara, the fourteenth post-station on the Tōkaidō Highway. Like Miho Bay a little to the southwest (see plates 66 and 83), it is renowned for the dramatic view it has of Japan's highest and most sacred peak.

With plate 88 we have moved even further eastwards to Chōshi Bay. This is situated on the southern side of the promontory that juts into the Pacific Ocean in the northeastern corner of Chiba Prefecture. It was and still is known for its scarred and craggy coastline, best enjoyed by boat, and for its fine if distant view towards Mount Fuji in the southwest.

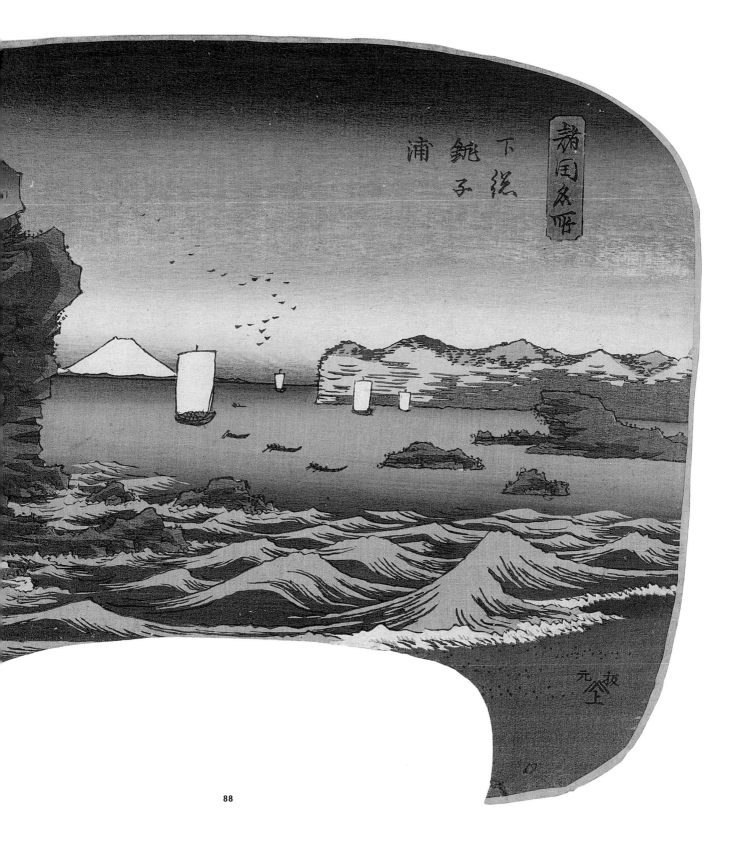

諸国名所
下総
銚子
浦

元〜仝上

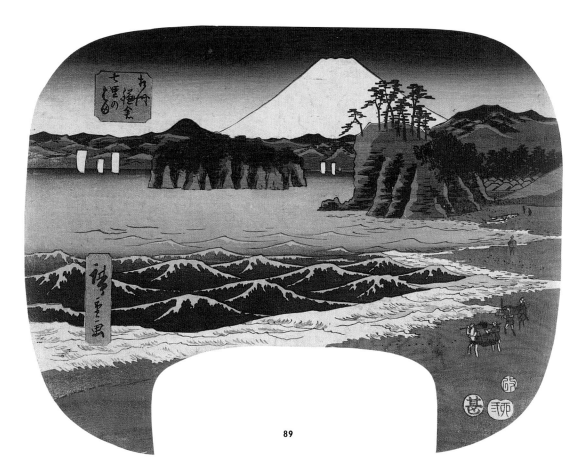

89

Plate 89

Shichiri Beach at Kamakura in Sagami Province
(*Sōshū Kamakura Shichiri no Hama*)

Plate 90

Kinkizan on Enoshima Island in Sagami Province
(*Sōshū Enoshima Kinkizan*)

Plate 91

The Hot Springs of Tōnosawa at Hakone
(*Hakone Tōnosawa Yuba*)

Plate 92

The Great Waterfall at Ōyama in Sagami Province
(*Sōshū Ōyama Ōdaki*)

Plate 93

View of the Port of Uraga in Sagami Province
(*Sōshū Uraga no Minato Fūkei*)

Five designs from an untitled series of views of famous places in Sagami Province
Signed *Hiroshige ga*
Published by Maruya Jinpachi
Censorship seal *aratame*; date seal *Hare 2* (1855/2)
1855/2
V&A: E.12067-1886, E.12068-1886, E.12069-1886, E.12070-1886, E.12071-1886

This splendid series of *aizuri* or monochrome blue depictions of famous places in Sagami Province, the former name of the western part of modern Kanagawa Prefecture, is one of the glories of the V&A's collection of Hiroshige *uchiwa-e*. The range and intensity of the shades of blue could only have been achieved by the most experienced of printers. No other designs from the series are known.

Plates 89 and 90 are set on the coast of Suruga Bay to the west of Kamakura, Japan's military capital from the

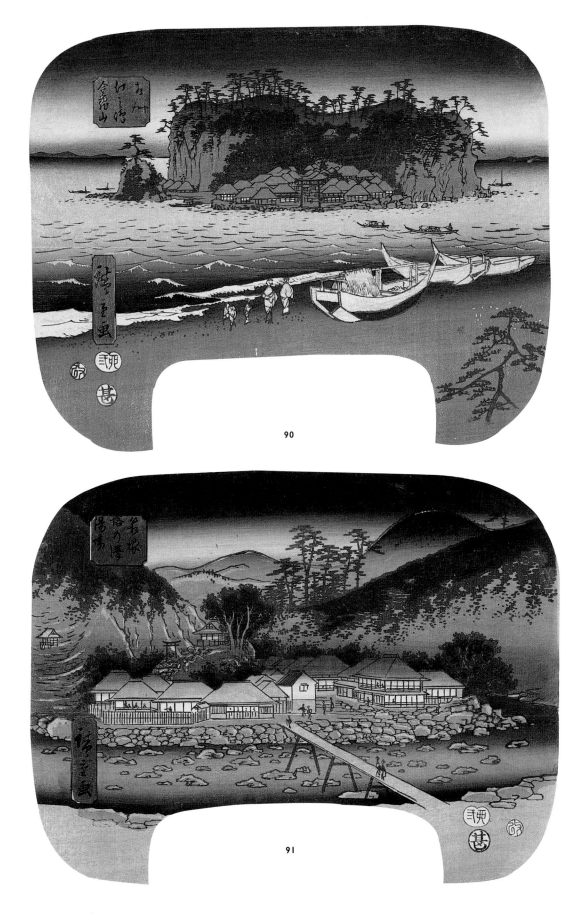

90

91

late twelfth to early fourteenth century. The island of Enoshima that features in both designs is the one whose cliffs we saw in the upper left-hand corner of plate 77. The Shichiri, literally 'Seven League', Beach of plate 89 stretches for about four kilometres from the southwest of Kamakura to the cliffs facing Enoshima. It enjoys, as here, a commanding view towards Mount Fuji in the west. The smallness of the figures making their way along the shore adds to the majesty of the scene. With plate 90 we move closer to Enoshima. The torii gate across the water marks the beginning of the approach to the shrine buildings just visible among the trees in the upper part of the island. The Kinkizan of the title is part of the Buddhist name of what was, until the Meiji government's forced separation of religious institutions in the late nineteenth century, a combined Buddhist and Shintō establishment.

The view in plate 91 of the hot-spring resort of Tōnosawa in Hakone is similar to that in plate 79. It is taken from a slightly closer vantage point a little further downstream the Haya river. A comparison of the two designs, which were produced within four years of one another, shows that topographic accuracy was less of a concern to Hiroshige than compositional and atmospheric effect. With the design in plate 91 there is a warmth and intimacy about the lit-up buildings under the protective watch of the small shrine on the rocky outcrop behind. This is quite different from the sense of remoteness of the cluster of roofs huddling among craggy cliffs in plate 79.

Plate 92 shows the Great Waterfall, also known as the Rōben Waterfall, at Ōyama, a 1250-metre peak in the Tanzawa mountains in western Kanagawa Prefecture. Its summit is occupied by the Afuri Shrine, dedicated to the god of rain. Ōyama was an important religious centre visited by large numbers of pilgrims during the summer months. As the small figure on the left is doing, pilgrims would wash themselves in the waters of the waterfall, cleansing themselves in body and spirit before offering prayers at the shrine. Ōyama was reached from Fujisawa, the sixth post-station on the Tōkaidō Highway. Fujisawa was also the nearest post-station to Enoshima. For pilgrims from Edo, it was common to make a combined visit to the two sites, the whole journey taking about three days.

Plate 93 takes us to the port of Uraga on the eastern coast of the Miura Peninsular. This juts southeastwards towards the Bōsō Peninsular of Chiba Peninsular, narrowing the mouth of Edo Bay to a distance of 10 kilometres before it opens into Sagami Bay and the Pacific Ocean. During the Edo period Uraga was presided over by a shogunal commissioner charged with inspecting and taxing all shipping entering Edo Bay. It was here that Commodore Perry and his American warships dropped anchor in July 1853, precipitating the series of events that resulted in the ending of the policy of national seclusion instituted by the Tokugawa shogunate in 1639. Hiroshige's depiction of Uraga, which was published less than two years after Perry's arrival in Japan, ignores the ructions of history and shows it in a state of almost sublime tranquillity.

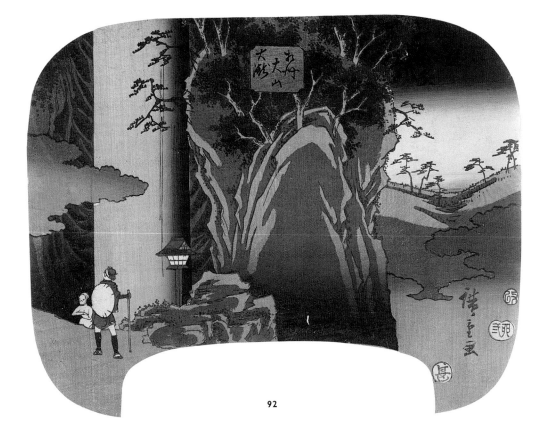

92

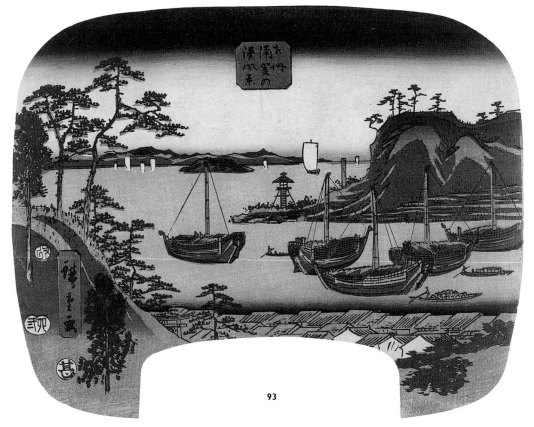

93

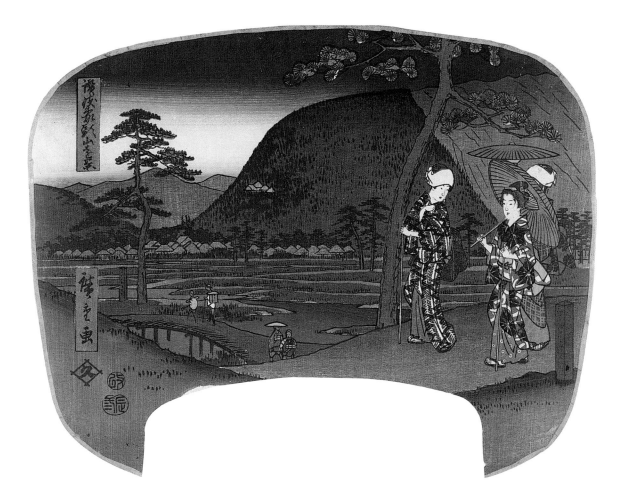

Plate 94

Distant View of Mount Zōzu in Sanuki Province

(*Sanuki Zōzusan Enkei*)

Signed *Hiroshige ga*

Unidentified publisher's seal

Censorship seal *aratame*; date seal *Dragon 3* (1856/3)

1856/3

V&A: E.12089-1886

This depiction of Mount Zōzu in Kagawa Prefecture is similar in general terms to the view in plate 62. The higher vantage point and greater foreshortening of the middle ground give added prominence to the mountain, however, and the women in the foreground are kept out of the line of vision to the right. The mountain itself is higher, more rounded and even more obviously shaped like an elephant's head. The buildings of the Kotohira Shrine glow red like an eye, while the dip and rise of the trunk seem even more convincingly alive against the distant grey hills that do not appear in the earlier design. Hiroshige's most successful rendering of Mount Zōzu is the one that appears in his *Famous Views in the Sixty-odd Provinces*, whereby the vertical format allows the mountain to be completely separated from the foreground elements and shown floating on a bank of clouds (Suzuki and Ōkubo 1996, no.56).

Plate 95

Sumiyoshi Bay at Naniwa (*Naniwa Sumiyoshinoura*)

Plate 96

The Togetsu Bridge at Arashiyama in Kyoto (*Kyō Arashiyama Togetsukyō*)

Plate 97

Kanazawa in Musashi Province (*Musashi Kanazawa*)

Three designs from the series *Depictions of Famous Places in the Provinces* (*Shokoku Meisho Zue*)
Signed *Hiroshige ga*
Published by Iseya Sōemon
Censorship seal *aratame*; date seal *Dragon 5* (1856/5)
(*aratame* seal only on plates 96–7)
1856/5
V&A: E.12086-1886, E.12085-1886, E.544-1911

Plate 95 shows three women in a pleasure boat on a canal running parallel to the Idemi Beach near the Sumiyoshi Shrine in southern Osaka. The expanse of Osaka Bay can be seen below the reddening sky beyond the beach and its row of thatched houses. Land-reclamation projects have since moved the coastline far out to the west, diminishing the once strong connection between the sea and the Sumiyoshi Shrine, whose four deities were believed to protect and bring prosperity to sailors and fishermen. The spiritual efficacy of the Sumiyoshi Shrine was complemented by the provision of tall lanterns, like the one visible here, to guide ships back to shore. These were something of a tourist attraction in their day and regularly feature in depictions of this much visited quarter of Japan's second largest city.

Plate 96 portrays a group of women crossing the Togetsu Bridge in Arashiyama in northwestern Kyoto. This is the bridge we saw on the horizon from a westerly

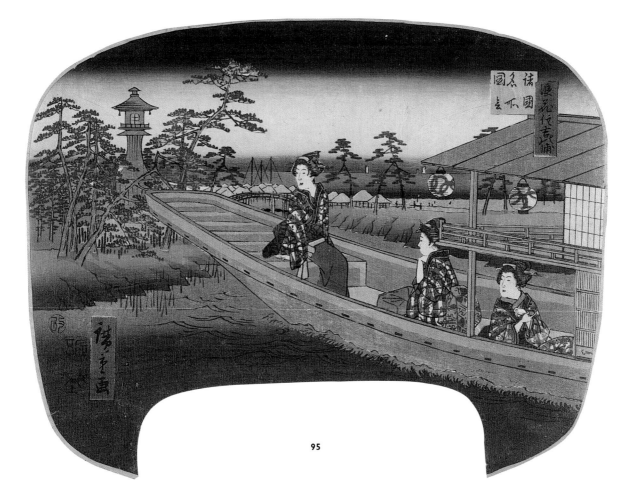

95

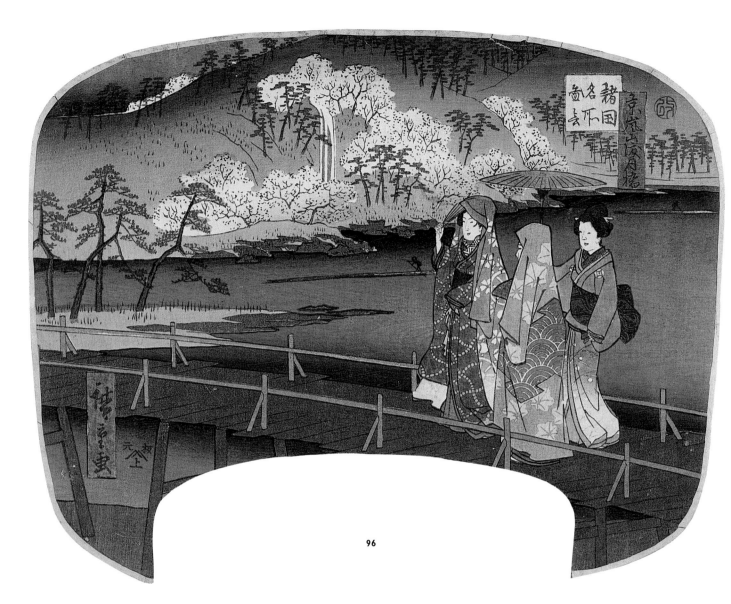

96

vantage point further up the Hozu river in plate 60.
Here we are looking southwestwards from just down-
stream of the bridge. The cherry trees for which the area
is famous are in full boom, and among them we can see
the small but picturesque Tonase Waterfall. The spit of
land protruding from the left is the northern end of
Nakanoshima, a narrow island that divides the river just
before it turns to the south and changes its name to the
Katsura river.

Plate 97 takes us back to the area in Kanazawa in
Kanagawa Prefecture that we have seen in plates 61 and
81. Female guests at a seaside inn are enjoying the
tranquillity of a scene in which the only movement is
that of two small boats crossing the sea in the distance.
The dark form visible above the head of the kneeling
woman is the island of Nojima, one of the celebrated
Eight Views of Kanazawa, while on the right, at the top
of an almost vertical cliff, a commandingly positioned
viewing pavilion can be seen.

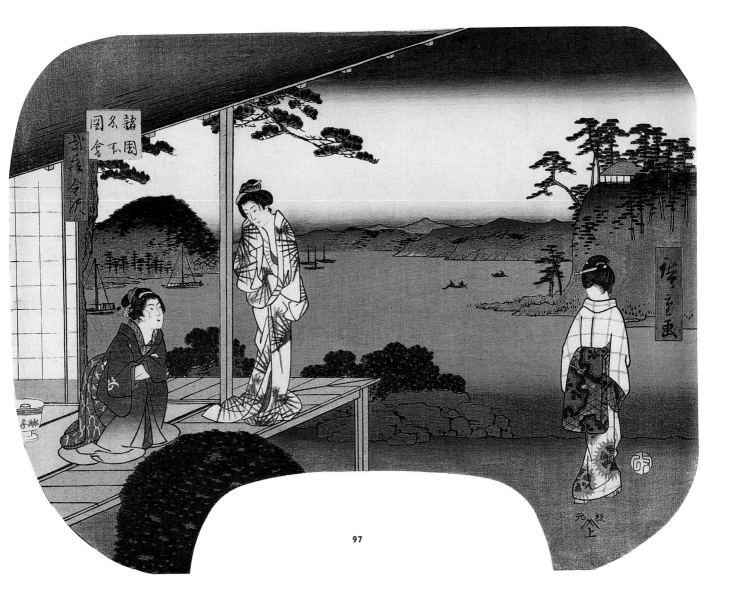

97

One other design from the series is known. It is a
depiction of the 'Wedded Rocks' at Futamigaura in Ise
Bay (collection of the Japan Ukiyo-e Museum). Like the
designs in plates 96 and 97, this has an *aratame*
censorship seal but no date seal. We have already seen
this unusual arrangement in plates 86–8, another series
of famous views of the provinces issued by the same
publisher.

3 | Literature, Legend, History and Theatre

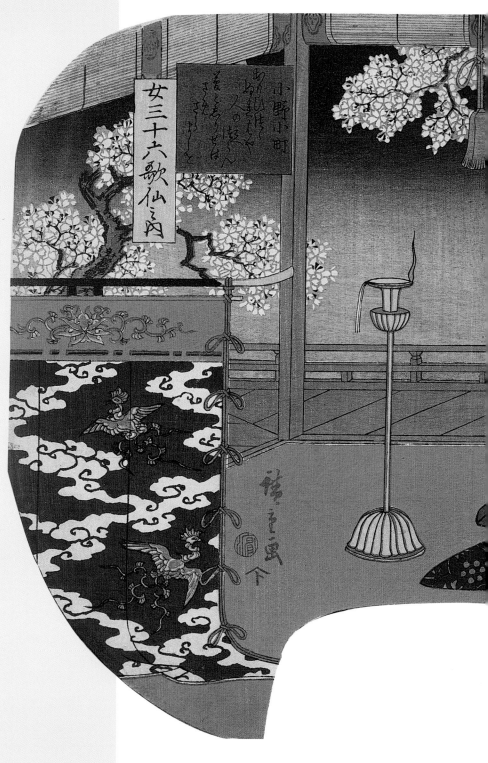

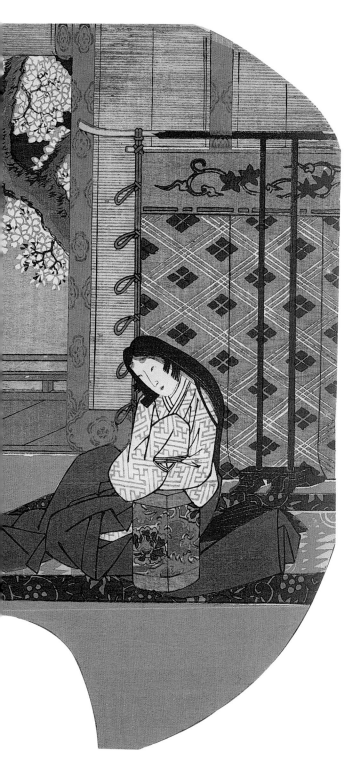

Plate 98
Ono no Komachi (*Ono no Komachi*), from the series
The Thirty-six Women Poets (*Onna Sanjūrokkasen no Uchi*)
Signed *Hiroshige ga*
Published by Enshūya Matabei
Censor's seal *Hama*
1843–7
V&A: E.2933-1913

This elegant scene shows the ninth-century poetess Ono
no Komachi awake in her room at night. The *waka* (31-
syllable) poem in the red cartouche reads: *Omoitsutsu/
Nureba ya hito no/Mietsuran/Yume to shiriseba/
Samezaramashi o*, meaning: 'It must have been because I
fell asleep tormented by longing that my lover appeared
to me/Had I known it was a dream, I should never have
awakened.' Ono no Komachi has been described as the
first Japanese to have recreated in poetry the experience
of what it is like to have the feverish urges to passion
denied (Miner 1968, p.80). Her renown was such that she
was included both among the tenth-century *Rokkasen* or
Six Poetic Geniuses and the eleventh-century *Sanjūrokkasen*
or Thirty-six Poetic Geniuses. These formulae, like the
Hakkei or Eight Views, were extensively used in later
centuries, in this case in specific relation to women poets.

One other design from the series is known. It is a
depiction of the sisters Matsukaze and Murasame with
a poem by the tenth-century poetess Saigū no Nyōgo
(Matsuki 1924, no.31).

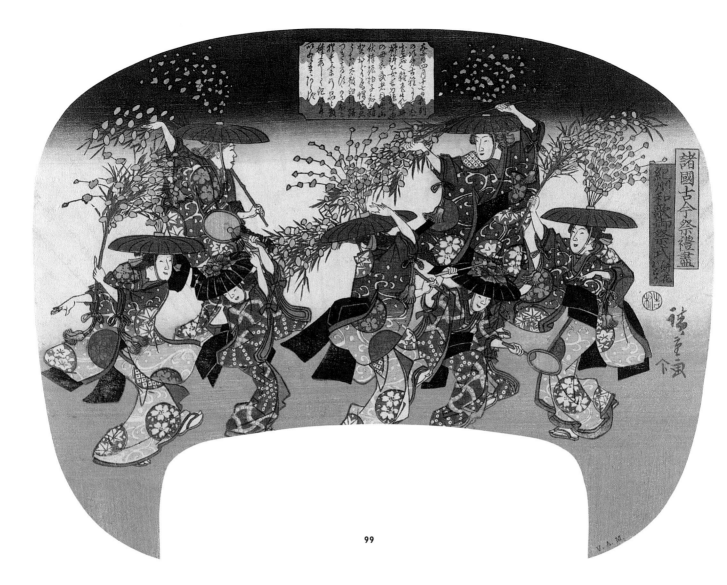

99

Plates 99 and 100

Two impressions of *The Mochibana Dance at the Wakanoura Festival in Kii Province* (*Kishū Waka Gosaishiki Mochibana Odori*), from the series *Old and New Festivals in the Provinces* (*Shokoku Kokon Sairei Tsukushi*)

Signed *Hiroshige ga*

Published by Enshūya Matabei

Censor's seal *Yoshimura*

1843–7

V&A: E.4867-1919 & E.4926-1919

These two impressions are of the only known design of a series of *uchiwa-e* depicting folk festivals (*matsuri*) in the provinces. Wakanoura or Waka Bay lies on the coast to the south of Wakayama in the northwestern corner of Wakayama Prefecture. It is home to the Tamatsushima Shrine, at which, according to the inscription in the central cartouche, a festival was held each year on the seventeenth day of the fourth month. Like most spring festivals in the regions, its primary purpose would have been to invoke a rich harvest. It would also have served to strengthen bonds between members of the local

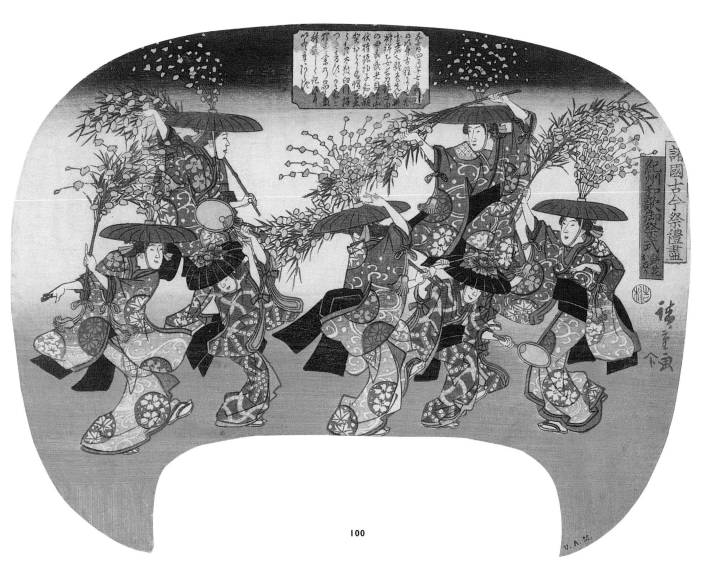

100

community. Central to the festival was a procession involving people dressed in various guises dancing, singing and making music. One component of this was the Mochibana Dance depicted here. Mochibana, meaning 'rice cake flower', refers to the sprigs of artificial pink and yellow flowers attached to the hats of, and held by, the five taller dancers. The rhythm of the dance, which would have been accompanied by chanting in a high nasal voice, is beaten out on the fans carried by the two smaller women wearing black hats decorated with peonies.

A comparison of the two impressions suggests they were printed contemporaneously. The only significant difference is in the application of the band of black across the top. Despite the fact that the print in plate 99 has been salvaged from a made-up fan, its colours are the better preserved. This is particularly noticeable on the taller women's robes, the lower parts of which have turned from an original purple in plate 99 to a faded blue in plate 100.

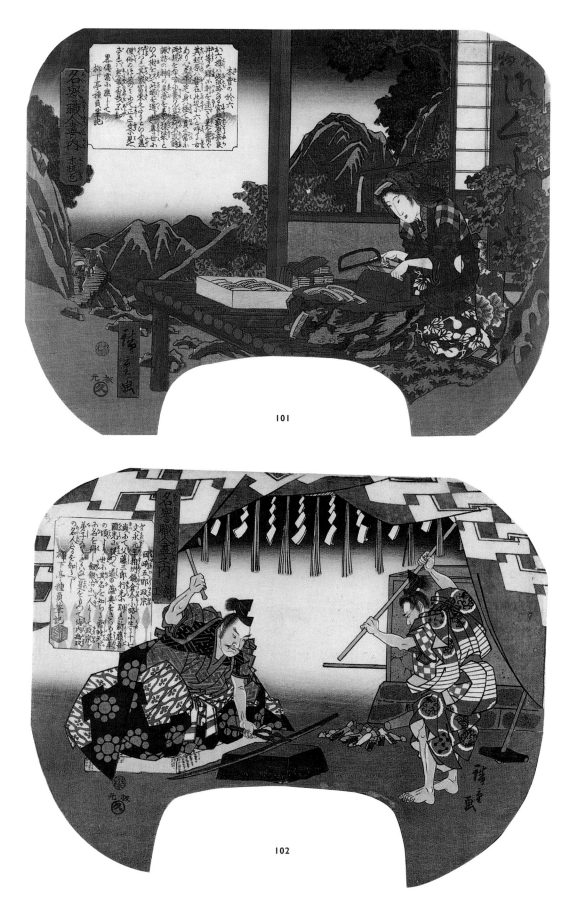

101

102

Plate 101
Kiso no Oroku Combs
(*Kushihiki Kiso no Oroku*)

Plate 102
The Swordsmith Okazaki
Gorō Masamune (*Katana Kaji*
Okazaki Gorō Masamune)

Plate 103
The Sculptor Hidari Jingorō
(*Horimono Hidari Jingorō*)

Three designs from the series
A Compendium of Famous Artisans
(*Meiyo Shokunin Tsukushi no Uchi*)
Signed *Hiroshige ga*
Published by Ibaya Kyūbei
Censor's seal *Muramatsu*
1843–7
V&A: E.2918-1913, E.2931-1913, E.2932-1913

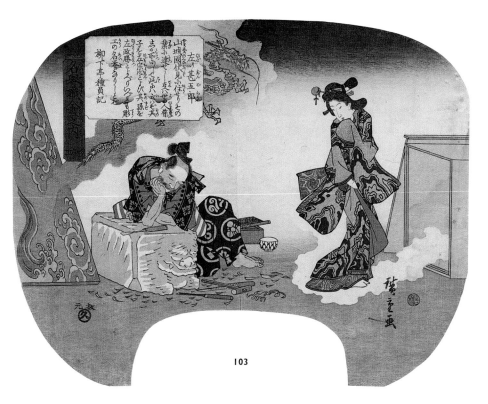

103

These three designs combine depictions of legendary craftsmen and craftswomen with text incriptions by Ryūkatei Tanekazu. Tanekazu was a student of Ryūtei Tanehiko (1783–1842), a leading exponent of early nineteenth-century illustrated popular fiction (*gōkan*). No other designs from the series are known.

Plate 101 portrays Roku, the girl accredited with starting the comb-making industry in the mountainous Kiso region of southern Nagano Prefecture. The text explains how Roku, after whom the combs made in the area were named, was deeply loyal to her poverty-stricken parents and prayed regularly for improvement to their lot. One night the god of Suwa visited her in a dream and told her to find a particular kind of wood from which to fashion combs. The combs she made proved so popular that her family became rich and prosperous. The text on the shop sign behind her reads *Meibutsu/Onkushidokoro*, meaning 'Famous Product/ Comb-maker'.

Plate 102 shows the great Kamakura period swordsmith Masamune forging a sword with the help of an assistant. The formal attire in which he is dressed and the hangings across the doorway are indicative of the ritualistic conditions maintained during the making of swords. The text relates that Masamune was born in Kamakura in Sagami Province (modern Kanagawa Prefecture) in the first year of the Bun'ei era (1264), and that at the age of 17 he left the workshop of his father, Yukimitsu, to train with Shintōgo Kunimitsu. So great were his skills that he became famous throughout the land, and there were no swordsmiths worthy of the name who had not trained with him.

Plate 103 shows the fabled Hidari Jingorō asleep in his workshop with his woodcarvings coming to life around him. Behind him a doll has come out of its box to assume the form of a young girl, and above him a dragon is breaking loose from a carved panel propped up against the wall to the left. Even the carving block on which he is leaning is starting to turn into a lion-dog. The text states that Hidari Jingorō was a native of Fushimi in Yamashiro Province (modern Kyoto Prefecture), but that he is so well known that no more needs to be said about him. It then explains that his son and grandson, both of whom were also highly skilled carvers, were called Sōshin and Hidari Masakatsu.

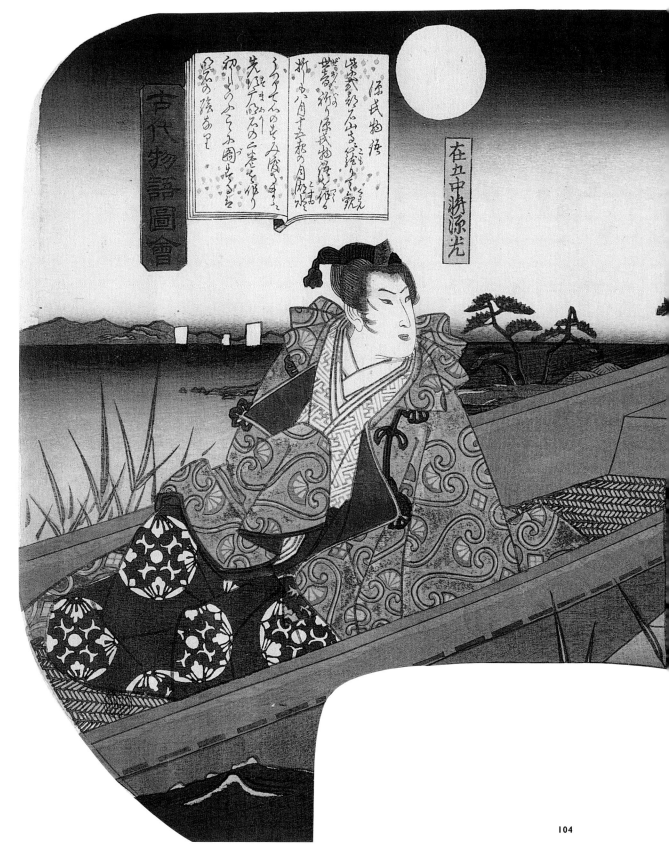

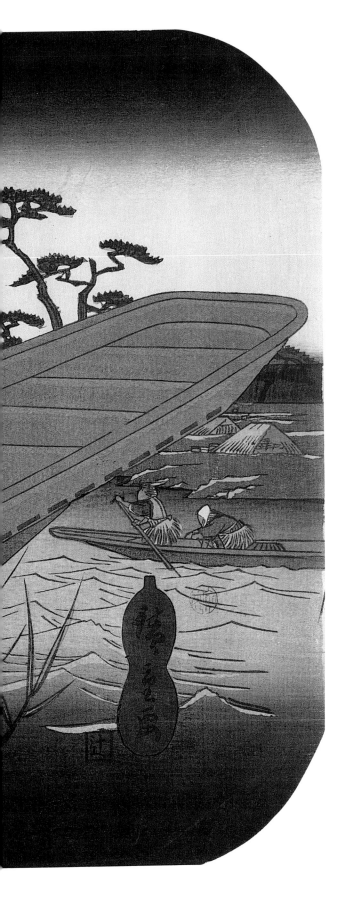

Plate 104
The Tale of Genji (*Genji Monogatari*)

Plate 105
The Tale of the Soga Brothers (*Soga Monogatari*)

Two designs from the series *Illustrations of Stories
of Ancient Times* (*Kodai Monogatari Zue*)
Signed *Hiroshige ga*
Published by Tsujiya Yasubei
Censor's seal *Kinugasa*
1843–7
V&A: E.541-1911, E.2929-1913

These two designs are from a series of contemporary
settings of scenes from classical literature. A third design
illustrating the Akutagawa chapter of the *Tales of Ise* is
also known (Ōta Memorial Museum 1998, no.252).

Plate 104 is an illustration of the Akashi chapter of *The
Tale of Genji*. The text in the cartouche explains that this
was written by Murasaki Shikibu while in seclusion at
the Ishiyama Temple, and that it was on the fifteenth day
of the eighth month, when her mind was as clear as the
August moon reflected on Lake Biwa, that she started to
write. She began, so it is said, with the Suma and Akashi
chapters, the latter of which is illustrated here. Prince
Genji is shown sitting in a boat dressed in elaborate robes
against an indeterminate but typically Hiroshige back-
ground. The way in which he is depicted with a small
peak of hair just above his forehead is similar to how he
is portrayed in the *Nise Murasaki Inaka Genji*. This
popular parody of *The Tale of Genji*, written by Ryūtei
Tanehiko (1783–1842) and illustrated by Utagawa
Kunisada I (1786–1864), was published in instalments
from 1829 to 1842 but was then suppressed as part of the
Tenpō Reforms. An interesting aspect of this print is the
idenfication of Prince Genji in the yellow cartouche. This
gives his name as Zaigo Chūjō Minamoto no Hikaru.
Minamoto no Hikaru, the 'Shining [Prince] of the
Minamoto [Family]', is appropriate for Prince Genji, but

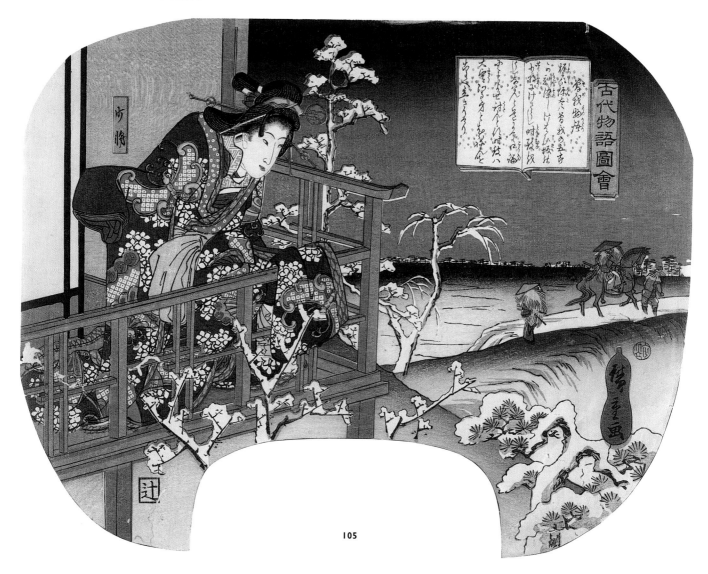

105

Zaigo Chūjo is the court title of Ariwara no Narihira, the hero of the earlier *Tales of Ise*. This confusion of names is a reflection of the conflation in the popular nineteenth-century mind of these two famous, romantic figures of the Heian period.

The episode from *The Tale of the Soga Brothers* illustrated in plate 105 is set in the contemporary surroundings of the Yoshiwara licensed pleasure quarter in Edo, the figures on the right making their way along the familiar Nihon Embankment (see plate 16). The text in the cartouche explains how Kajiwara Genda has fallen in love with the courtesan Kewaizaka no Shōshō and has just challenged her suitor Soga no Gorō Tokimune with

an insult. Tokimune, intent on avenging the death of his father, suppresses his fury and walks away without rising to the taunt. Kewaizaka no Shōshō, who is identified by name in the small pink cartouche on the upper left, is shown in gorgeous attire and with a coiffure that at the time of the print's publication would have been regarded as appropriately old fashioned for a classical story. Kajiwara Genda can be seen shouting from his horse and Tokimune walking away with his head bent low.

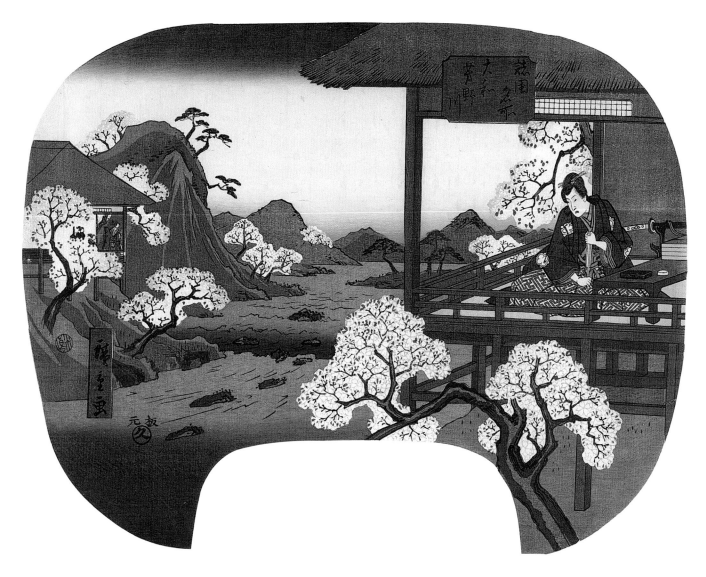

Plate 106

Yoshino River in Yamato Province (*Yamato Yoshinogawa*),
from the series *Famous Places in the Provinces* (*Shokoku
Meisho*)
Signed *Hiroshige ga*
Published by Ibaya Kyūbei
Censor's seal *Mera*
1843–7
V&A: E.545-1911

This glorious depiction of cherry trees blossoming along
the Yoshino river in southern Nara Prefecture might on
first sight, as indeed the title in the red cartouche

suggests it is, appear to be a landscape print. To a
contemporary viewer, however, it would have been
immediately recognisable as the famous scene in the play
Imoseyama Onna Teikin (*An Example of Noble Womanhood*)
when the young lovers Koganosuke and Hinadori,
deterred from meeting by the long-standing feud
between their families, look longingly at each other
across the expanse of the Yoshino river. Tragedy ensues
as they both choose death in preference to serving Soga
no Iruka, the country's scheming senior minister, who
sends orders via their parents that they should become
his retainer and concubine respectively. No other designs
from the series are known.

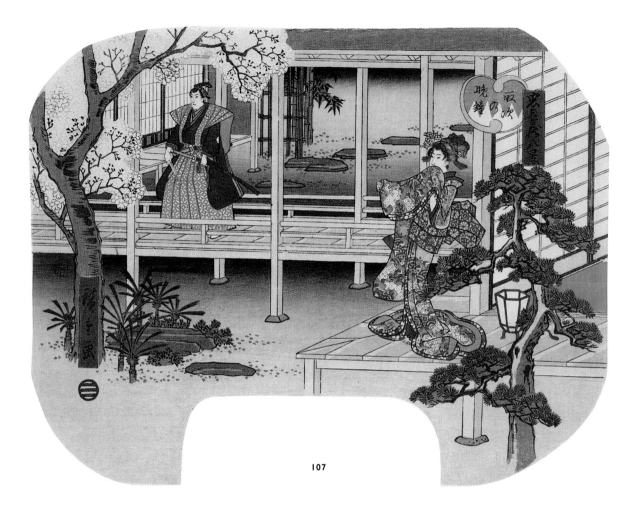

107

Plate 107
Evening Bell and the Receipt of the Message (*Toritsugi no Banshō*)

Plate 108
Night Rain on the Mountain Road (*Sandō no Ya-u*)

Two designs from the series *Eight Views from the Chūshingura* (*Chūshingura Hakkei*)
Signed *Hiroshige ga*
Published by Ibaya Senzaburō
Censor's seal *Murata*
1843–7
V&A: E.2913-1913, E.2914-1913

These two designs, the impression in plate 108 being a later printing (*atozuri*), belong to a series in which the *Hakkei* or Eight Views formula is used for the depiction of episodes from the 11-act *Kanadehon Chūshingura* (*The Treasury of Loyal Retainers*), one of the best-known plays in the Japanese theatrical repertory. It is based on the true story of the avenging of the death of their master Asano Naganori (1665–1701; En'ya Hangan Takasada in the play) by the 47 retainers of Akō, an action that led to their being sentenced by the shogunal authorities to commit suicide by seppuku. They were buried near the grave of their master in the Sengakuji Temple in Edo and were immediately hailed as paragons of the samurai principle of absolute loyalty to one's lord. The double-comma motif surrounding the picture title cartouches is the family crest of Ōishi Kuranosuke (Ōboshi Yuranosuke

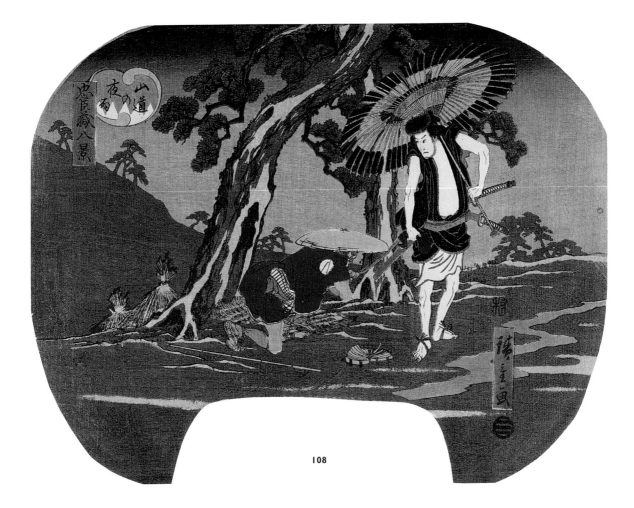

108

in the play), Asano's chief counsellor and leader of the vendetta. The tooth pattern within the cartouches is the same as that used on the robes of the 47 retainers in the final scene of the play, when they storm the mansion of Kira Yoshinaka (Kō no Moronao in the play) and put him to death.

Plate 107 records the moment in Act 2 when the young Rikiya, Yuranosuke's son, arrives at the palace of Momoi Wakanosuke to deliver a message. Rikiya is engaged to Konami, the 17-year-old daughter of Wakanosuke's chief advisor. Konami's mother knows that Rikiya is coming and sends Konami to meet him. Rikiya, surprised to be met by his beloved, blushes and turns away, while Konami hides her face with embarrassment.

Plate 108 depicts the episode in Act 5 when Yoichibei is returning home on a dark stormy night after conducting

preliminary negotiations to sell his daughter into prostitution in order to raise money for his son-in-law Kanpei, one of the 47 retainers. Tired from his journey, the old man sits down to rest. As he takes out his purse to count his money, he is attacked by the young and powerful Ono Sadakurō, who robs and murders him.

Four other designs from the series are known. They are entitled *Ochiudo no Seiran* (*Clearing Skies and the Refugee*) (collection of the Japan Ukiyo-e Museum), *Gionmachi no Aki no Tsuki* (*Autumn Moon at Gion*) (Matsuki 1924, no.91), *Sakai no Kihan* (*Returning Sails at Sakai*) (collection of the Tokyo National Museum) and *Adauchi no Bosetsu* (*Evening Snow and the Vendetta*) (Ōta Memorial Museum 1998, no.239). These correspond to episodes in Acts 3, 7, 10 and 11 respectively.

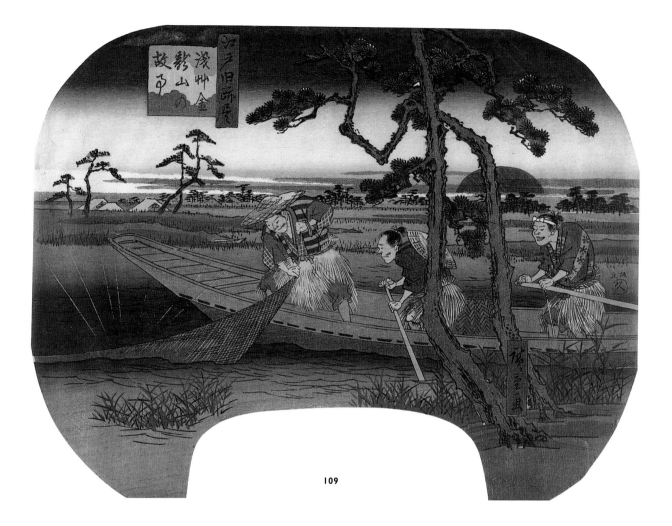

109

Plate 109

The Origins of the Kinryūzan Temple at Asakusa
(*Asakusa Kinryūzan no Koji*)

Plate 110

The Legend of the Stone Pillow of Ubagaike Pond at Asakusa (*Asakusa Ubagaike Ishimakura no Yurai*)

Two designs from the series *A Compendium of Historical Sites in Edo* (*Edo Kyūseki Tsukushi*)
Signed *Hiroshige ga*
Published by Ibaya Kyūbei
About 1845–6
V&A: E.528-1911, E.527-1911

These two designs illustrate legends associated with various locations in Edo. Four other designs from the series are known. They relate to the Otamagaike Pond in Kanda (Matsuki 1924, no.44), the Umewaka Mound in the grounds of the Mokuboji Temple on the banks of the Sumida river (Matsuki 1924, no.45), Kasumigaseki (Matsuki 1924, no.46) and Yamabuki (Kerria) Village in Takada (Matsuki 1924, no.48).

Plate 109 illustrates the legend of the fishermen who are said to have caught in their net a miniature statue of Kannon, the Buddhist Goddess of Mercy, suggested here by the rays of a halo emanating from the waters of the Sumida river. The village headman recognised the divinity of the statue and rebuilt his house as a temple

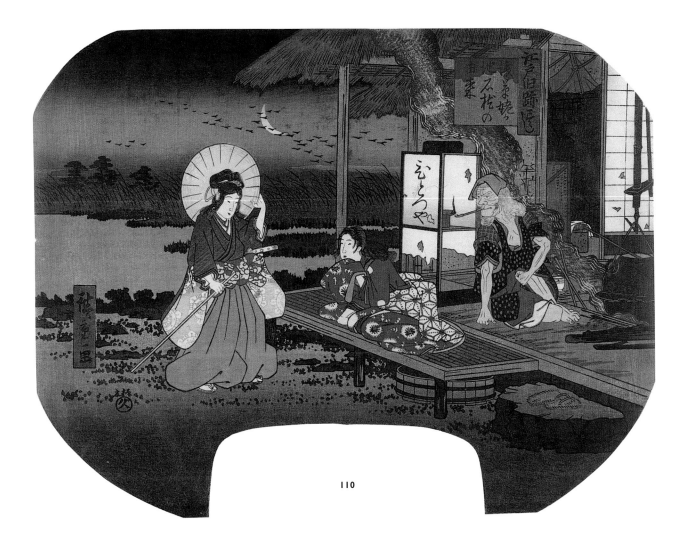

110

dedicated to it, thereby establishing what subsequently became the Asakusa Kannon or Kinryūzan Sensōji Temple (see plates 27 and 32). This is said to have happened in 628, the last year of the reign of Empress Suiko.

Plate 110 illustrates the story of the stone pillow of the Ubagaike Pond. This lay immediately to the east of the compound of the Asakusa Kannon Temple. The stone pillow legend, which is found in various parts of Japan, relates that a traveller who has been invited into a remote house and offered a bed equipped with a stone pillow is robbed and murdered during the night. In this case we see an old woman and her daughter beckoning a traveller into a dilapidated farmhouse. The characters on

the torn lantern read, somewhat ominously, *Hitotsuya*, meaning 'Lone House'. The traveller, identifiable by the resemblance of the tilted hat to a halo, is the deity Kannon in disguise.

Plate 111

**The Moon Reflected on the Water
by the Pier of a Bridge**

Signed *Ichiryūsai hitsu*, with seal *Hiroshige*

Published by Aritaya Seiemon

About 1845–50

V&A: E.4878-1919

This simple but well-balanced composition is inscribed with a *haiku* (17-syllable) poem by Sakuragaoka Toshishige, whose signature and seal appear in the centre of the design. The poem reads *Kumorinaki / Oya no megane ya / Aki no tsuki*, meaning 'Unclouded / Like a parent's understanding of its child / The autumn moon.' The ribmarks are evidence that the print was salvaged from a made-up fan.

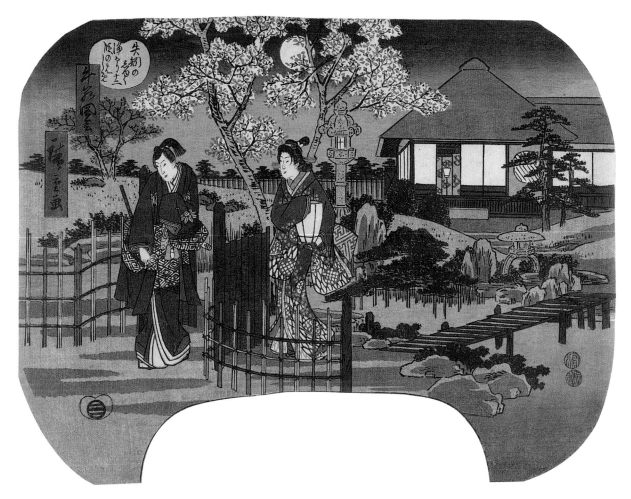

Plate 112

The Meeting at Yahagi: The Beginnings of the Jōrurijūnidan Story (*Yahagi no Shuku Jōrurijūnidan no Hajime*), from the series *Scenes from the Life of Ushiwaka(maru)* (*Ushiwaka Zue*)
Signed *Hiroshige ga*
Published by Ibaya Senzaburō
Censors' seals *Magome* and *Hama*
1849/1–1852/1
V&A: E.540-1911

This design is from a series illustrating episodes in the life of Ushiwakamaru, the youthful Minamoto no Yoshitsune (1159–89), one of Japan's best-known tragic heroes. It shows him being met by the servant of Princess Jōruri, the daughter of the wealthy landlord of Yahagi in Mikawa Province (modern Aichi Prefecture), whose attention he has attracted by playing the flute he carries

in his sash. The love affair that ensued was the subject of medieval storytelling from at least the fifteenth century. The tale survived into the Edo period under a variety of appellations, including the Jōrurijūnidan of the title of this design. The term *jōruri*, which refers to the type of narrative chanting that developed in conjunction with the Bunraku puppet theatre, is said to derive from the title of this story, which was originally recited by minstrels to the accompaniment of the *shamisen*.

Four other designs from the series are known. They depict Ushiwakamaru practising swordsmanship at Sōjōgatani (Ōta Memorial Museum 1998, no.256), the secret meeting between Ushiwakamaru and the daughter of Kiichi Hōgen (Ōta Memorial Museum 1998, no.258), Ushiwakamaru's encounter with Benkei on Gojō Bridge (Matsuki 1924, no.93) and Ise no Saburō swearing an oath of loyalty to Ushiwakamaru (collection of the Kanagawa Prefectural Museum of Cultural History).

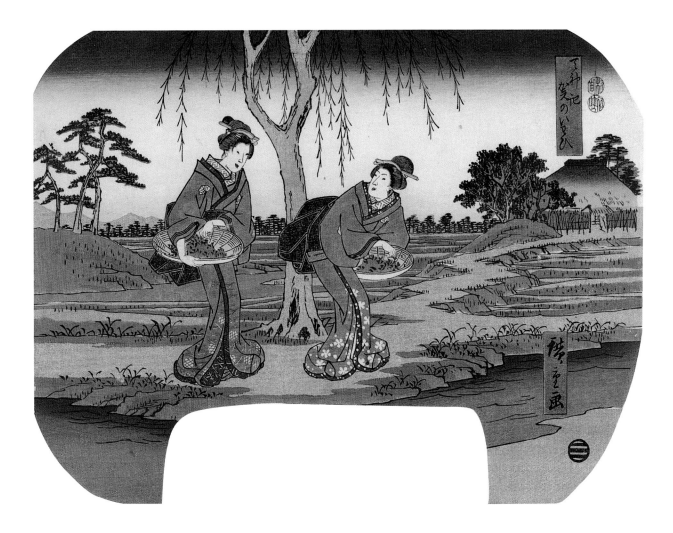

Plate 113

Seventieth Birthday Celebrations (*Ga no Iwai*), from the
series *The Chronicles of Sugawara Michizane* (*Tenjinki*)
Signed *Hiroshige ga*
Published by Ibaya Senzaburō
Censors' seals *Kinugasa* and *Murata*
1851/2–1852/9
V&A: E.2922-1913

This is one of a series of designs depicting episodes from
the popular and frequently performed *Sugawara Denju
Tenarai Kagami* (*The Secrets of Sugawara's Calligraphy*), a
play based on the life of the Heian period poet, scholar
and politician Sugawara no Michizane (845–903). A man
of great talents, Michizane was the victim of a political
conspiracy that resulted in his being banished to the
island of Kyūshū in 901. The series of disasters that befell
the imperial court after Sugawara's death in exile were
ascribed to his angry ghost. Attempts were made to
placate his spirit by posthumously pardoning him and
reinstating him in office. The *Ga no Iwai* scene illustrated
here shows the wives of two of the triplet sons of
Shiradayū, Sugawara's faithful retainer, gathering herbs
in preparation for their father-in-law's seventieth-
birthday feast.

Two other designs from the series are known. These
are illustrations to the *Kamotsutsumi* (*On the Banks of the
Kamo River*) scene (Ōta Memorial Museum 1998, no.285)
and the *Kurumabiki* (*Stopping the Carriage*) scene
(collection of the Japan Ukiyo-e Museum).

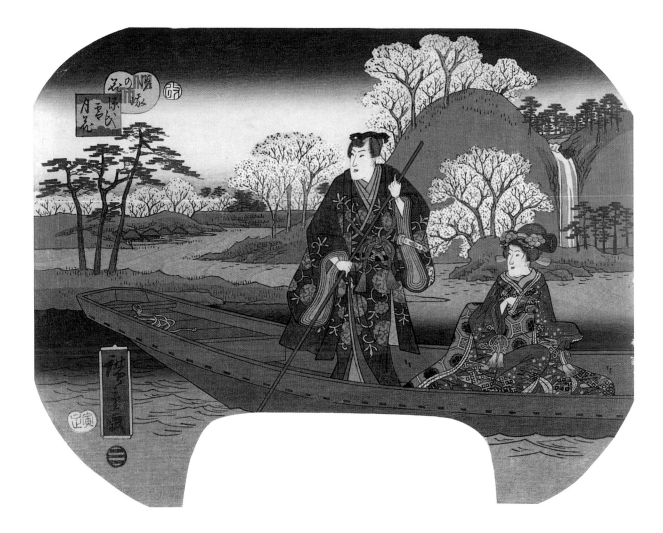

Plate 114

Cherry Blossoms at Saga (*Saga no Hana*), from the
series *Prince Genji and Scenes of Snow, Moon and Flowers*
(*Genji Setsugekka*)
Signed *Hiroshige ga*
Published by Ibaya Senzaburō
Censorship seal *aratame*; date seal *Tiger 1* (1854/1)
1854/1
V&A: E.2923-1913

As the title indicates, the setting for this spring scene is
the Saga area in the northwestern part of Kyoto. The
topographic features, stylised though they are in
comparison with the depiction in plate 96, are recognis-
able as the Hozu river with Arashiyama and the Tonase

Waterfall in the background. The spit of land immediately
behind the boat is Nakanoshima, the narrow island that
in most depictions of this locality is shown linked by the
Togetsu Bridge. Its omission here is deliberate, for this is
an allusion to a scene in the popular illustrated novel
Nise Murasaki Inaka Genji, which takes place during the
fifteenth century. As in plate 104 Prince Genji sports a
distinctively peaked forelock and is dressed in richly
ornamented robes. The so-called *Genji-kō* symbols in the
heart-shaped cartouche correspond to the Matsukaze
and Hanachirusato chapters of *The Tale of Genji*. No other
designs from the series are known.

Plate 115

Full Moon with a Cuckoo Flying above the Masts of Moored Boats

Signed *Hiroshige hitsu*

Published by Enshūya Matabei

About 1855

V&A: E.4860-1919

Like the design in plate 111 this is a simple composition inscribed with a *haiku* (17-syllable) poem. The poem reads *Hitokoe wa / Tsuki ga naita ka / Hototogisu*, meaning 'A single call / Did the moon cry out? / A passing cuckoo.' The sense is that by the time we look up the cuckoo has already flown past, making us think that it was the moon that called out. The association of the cuckoo with summer makes it a particularly appropriate subject for a design to be mounted, as the ribmarks show that this print once was, as a fan.

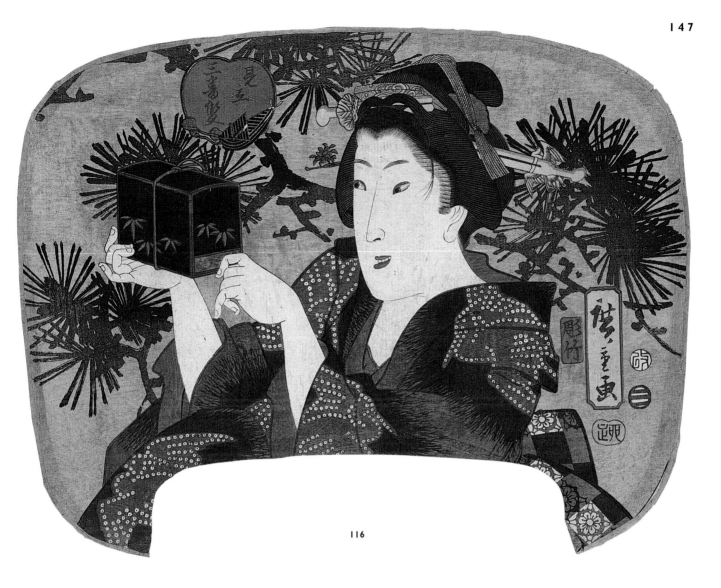

116

Plate 116
Allusion to the Character Senzai
Signed *Hiroshige ga*

Plate 117
Allusion to the Character Okina
Signed *Toyokuni ga* (Utagawa Kunisada I (1786–1864))

Plate 118
Allusion to the Character Sanbasō
Signed *Ichiyūsai Kuniyoshi ga* (Utagawa Kuniyoshi (1797–1868))

Complete set of three designs from the series *Parodies of the Sanbasō Dance* (*Mitate Sanbasō*)
Published by Ibaya Senzaburō
Censorship seal *aratame*; date seal *Hare 1* (1855/1)
Engraver's seal *Hori Take*
1855/1
V&A: E.12090-1886, E.12091-1886, E.12092-1886

This set of three designs is an interesting case of different artists working on the same series under the control of a single publisher. The quality of production, which includes the use of *nunomezuri* or textile printing in the rendering of the insect cage in plate 116, is extremely high, and the state of preservation is good. The patterning of the women's robes, the objects they are holding

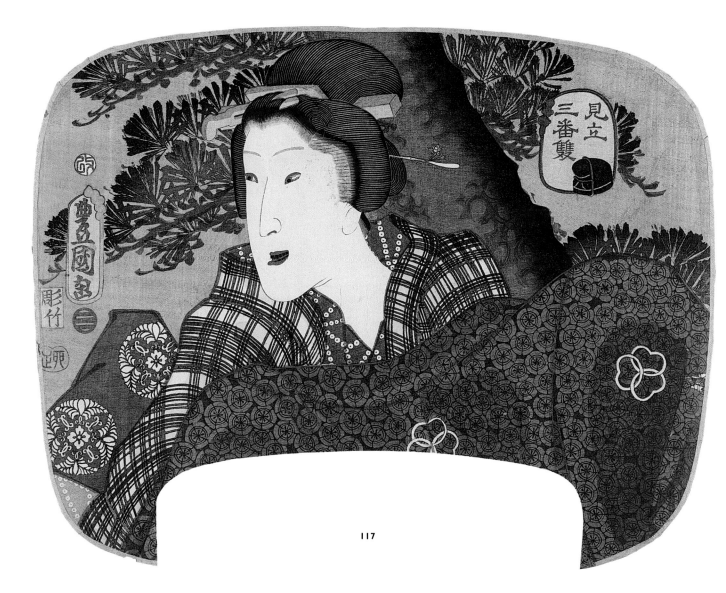

117

and the hats depicted in the lower corners of the series title cartouches make reference to the three characters in the *Sanbasō* dance sequence. This was an Edo period adaptation of *Okina*, one of the oldest works in the Nō theatrical repertory with origins in ritual dances dating back to the tenth century. In both its Bunraku puppet theatre and Kabuki versions it was performed, as in the case of the Nō theatre, on celebratory occasions and always at the beginning of a cycle of plays. The pine-tree

backdrop in each of the designs is similar to what would have been used on the stage.

The references to Senzai in plate 116 are the heron pattern on the woman's robe, the insect cage alluding to the box in which the mask presented to Okina would have been kept, and the small black cap in the cartouche. This and the hats in the cartouches of the two other designs are similar to those worn on stage by the three different characters. In plate 117 the references to Okina

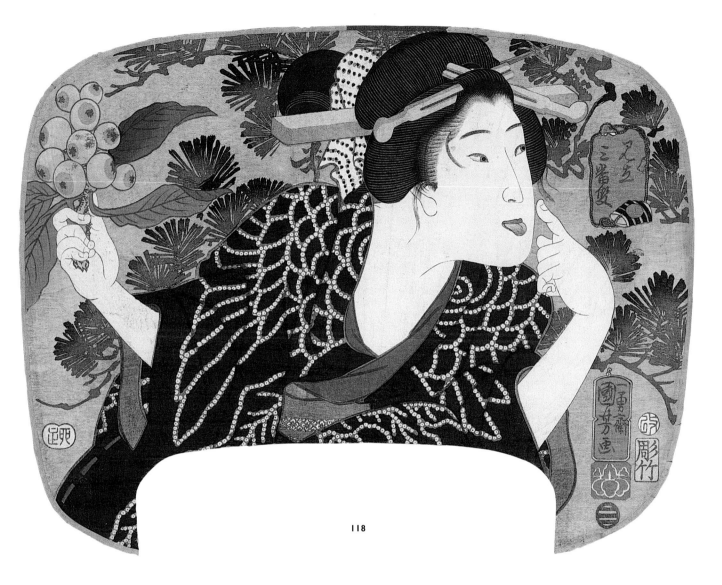

118

are, in addition to the hat in the cartouche, the *haori* coat
that the woman is holding and the so-called *okina-gōshi*
checked patterning to her robe. The references to Sanbasō
in plate 118 are the crane motif on the woman's robe and
the spray of loquats she holds. These resemble the golden
bells used in the dance. The way in which the woman is
sticking out her tongue is a reference to a popular
nineteenth-century variant of the dance called *Shitadashi
Sanbasō*, literally 'Sanbasō with his tongue sticking out'.

4 | Animals, Flowers and Still-lifes

Plate 119
Cockerel, Hen and Autumn Flowers
Signed *Hiroshige hitsu*, with seal *Ichiryūsai*
Published by Sanoya Kihei
Censorship seal *kiwame*
1837
V&A: E.4883-1919

This striking rendering of a cockerel and hen against a background of autumn flowers has survived in good condition in spite of having been salvaged, as the rib-marks indicate, from a made-up fan. The forcefulness of the composition and the intensity of the colours have something of the feel of the work of Katsushika Hokusai (1760–1849), who was well known for his representations of chickens and other fowl (see plate III on page 19). The date of the design is suggested by the style of the signature and by the fact that 1837 was the Year of the Cock.

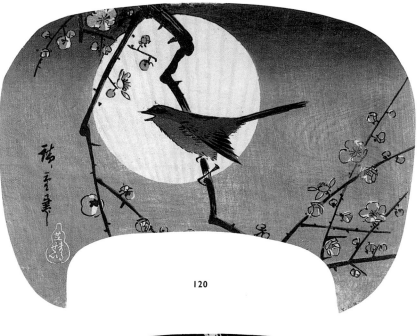

Plate 120
Bush Warbler on a Plum Tree
in Moonlight

Plate 121
Irises

Plate 122
Cranes by the Water's Edge

Plate 123
Cockerel, Hen and Basket

Four designs from an untitled
series of bird and flower studies
Signed *Hiroshige hitsu*
Published by Maruya Seijirō
About 1840–2
V&A: E.4898-1919, E.4915-1919,
E.4907-1919, E.4834-1919

As in the case of plates 78–80,
there is a more than usual degree
of variation in palette between
these designs, plate 123 being
dominated by shades of pink as
opposed to the blue of plates
120–2. The latter are not strictly
aizuri or monochrome blue prints,
although blue is the predominant
colour. The ribmarks on all four

120

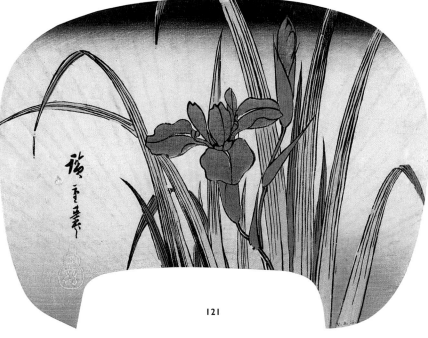

121

designs indicate that they were salvaged from made-up
fans. In terms of symbolism the *uguisu* or bush warbler
perched on a plum tree in plate 120 is a classic signaller
of early spring. Irises, as in plate 121, flower in May and
are thus suggestive of early summer. The cranes in plate
122 are indicative less of a season than of longevity, of
which, like the turtles in plate 124, they are a well-known
symbol. The significance of the chickens in plate 123 was

talismanic in that their cries were believed to bring
protection against the evil forces of darkness. The pink
body and black breast and tail feathers of this particular
cockerel are typical of the *jidori*, a primitive breed of
chicken indigenous to Japan. The ribmarks visible on all
four prints are evidence that they were salvaged from
made-up fans. No other designs from the series are
known.

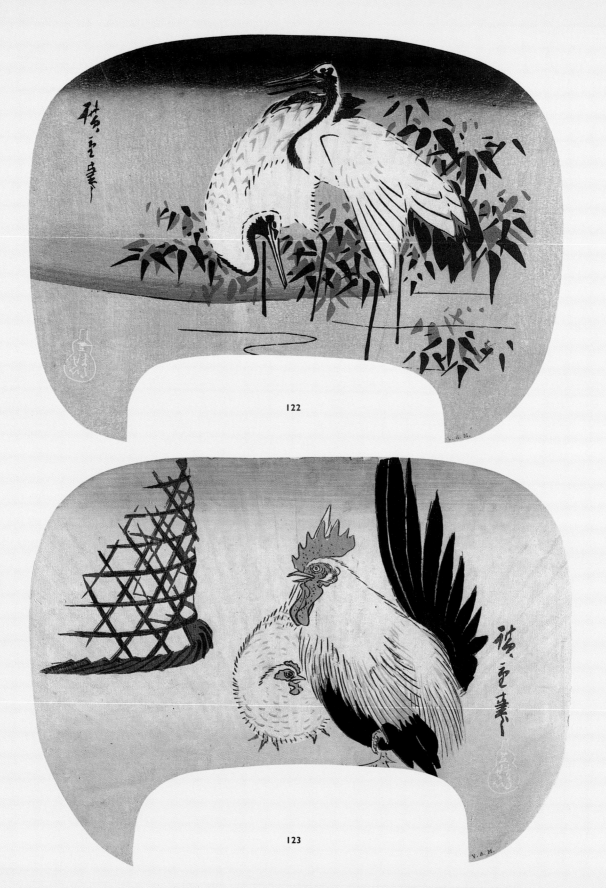

122

123

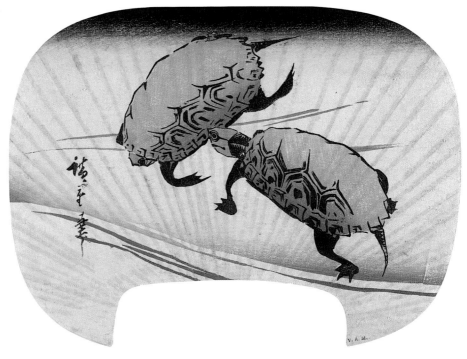

Plate 124
Swimming Turtles
Signed *Hiroshige hitsu*
Published anonymously
About 1840–2
V&A: E.4836-1919

As with many of Hiroshige's nature studies, there is a definite playfulnesss about this rendering of a pair of swimming turtles. The use of black for the outline means that this is not a true *aizuri* or monochrome blue print, though blue, appropriately cool in feel for the summer months, is the predominant colour. Turtles were believed to live for 10,000 years and were symbolic of longevity and good fortune. The ribmarks, which in this case help to unify the composition, are evidence that the print was salvaged from a made-up fan.

Plate 125
Autumn (*Aki*)

Plate 126
Winter (*Fuyu*)

Two designs from the series *Fashionable Flower Arrangements of the Four Seasons* (*Fūryū Shiki no Ikebana*)
Signed *Hiroshige hitsu*, with seal *Ichiryūsai*
Publisher's mark *Gankiken of Shiba*
Censor's seal *Fu*
1843–7
V&A: E.4828-1919, E.4829-1919

This final pair of designs, both of which have survived relatively well despite having been mounted up as fans, are the only two known from the series. They consist of close-up views of flower arrangements in front of paintings mounted as hanging scrolls (*kakemono*) such as are found in the *tokonoma* or display alcoves of Japanese rooms. In plate 125 the melancholy of autumn is suggested by a large spray of chrysanthemums set off by a painting of the moon. In plate 126 the chill of winter is portrayed by a snowy view of the torii gate of the Mimeguri Shrine, seen from the reaches of the Sumida river. The starkness of the image is relieved by the curving form of the narcissus on the right and the deep red of the camellia on the left. In both cases Hiroshige's signature appears to be attached to the painting rather than the design as a whole. This was a common contrivance in compositions of this kind.

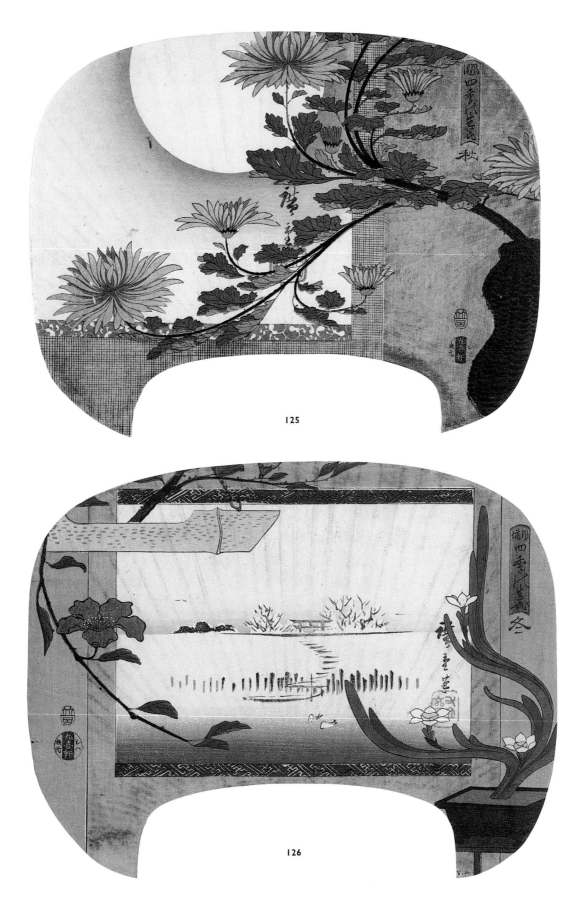

125

126

Signature *Hiroshige ga*
from plate 106

Bibliography

• Titles marked with black dots are in Japanese.

• **ASANO and YOSHIDA 1998**
Asano Shūgō and Yoshida Nobuyuki (eds), *Hiroshige*, vol.5, *Ukiyo-e o Yomu* (Reading *Ukiyo-e* series), Tokyo; Asahi Newspapers, 1998

BICKNELL 1994
Julian Bicknell, *Hiroshige in Tokyo: The Floating World of Edo*, San Francisco; Pomegranate Artbooks, 1994

BOGEL and GOLDMAN 1988
Cynthia Bogel and Israel Goldman, *Hiroshige: Birds and Flowers*, New York; George Braziller in association with The Rhode Island School of Design, 1988

EDMUNDS 1922
Will H. Edmunds, 'The Identification of Japanese Colour Prints I–IV', *Burlington*, nos 40–1, 1922

FORRER 1997
Matthi Forrer, *Hiroshige: Prints and Drawings* (exhibition catalogue), London; Royal Academy of Arts / Munich and New York; Prestel, 1997

• **FUJISAWA 1999**
Fujisawa Akane, 'Yakusha *Uchiwa-e* no Hensen' (Transitions in Actor Fan Prints), *Ukiyo-e Geijutsu* (*Ukiyo-e* Art), no.132, 1999, pp.3–15

• *GUDJ*
Genshoku Ukiyo-e Daihyakka Jiten (Colour Encyclopedia of *Ukiyo-e*), 11 vols, Tokyo; Taishūkan, 1980–2

HALFORD 1956
Aubrey and Giovanna Halford, *The Kabuki Handbook*, Rutland, Vermont and Tokyo; Charles E. Tuttle, 1956

HAMADA 1973
Hamada Giichirō, *Edo Bungaku Chimei Jiten* (Dictionary of Edo Place Names in Literary Sources), Tokyo; Tōkyōdō, 1973

HAPPER 1909
Catalogue of the Valuable Collection of Japanese Colour Prints: The Property of John Stewart Happer, Esq. (sale catalogue) 14–18 June 1909, London; Sotheby, Wilkinson & Hodge, 1909

• *HIZŌ UKIYO-E TAIKAN*
Narazaki Muneshige et al., *Hizō Ukiyo-e Taikan* (*Ukiyo-e* Masterpieces in European Collections), 13 vols, Tokyo; Kōdansha, 1987–90

• **HORI 1996**
Hori Kōmei, *Hiroshige no Ō-Edo Meisho Hyakkei Sanpo* (A Walk around Hiroshige's One Hundred Famous Views of Edo), vol.5, *Kochizu Library* (Old Map Library series), Tokyo; Jinbunsha, 1996

• **HORI 1997**
Hori Kōmei, *Hiroshige no Tōkaidō Gojūsantsugi Tabi Keshiki* (Travel Scenes along Hiroshige's Fifty-three Stations of the Tōkaidō), vol.3, *Kochizu Library* (Old Map Library series), Tokyo; Jinbunsha, 1997

HUTT and ALEXANDER 1992
Julia Hutt and Hélène Alexander, *Ōgi: A History of the Japanese Fan*, London; Dauphin, 1992

• **IIJIMA 1941**
Iijima Kyōshin, *Ukiyo-eshi Utagawa Retsuden* (Biographies of *Ukiyo-e* Artists of the Utagawa School), Tokyo; 1941 (reprinted, Chūō Kōronsha, 1993)

• **INOUE 1917**
Inoue Kazuo, '*Uchiwa-e* ni tsuite' (About Fan Prints), *Ukiyo-e*, no.27, 1917, pp.13–15

• **KOBAYASHI 1989**
Kobayashi Tadashi, 'Hiroshige no *Uchiwa-e*' (Hiroshige's Fan Prints) in *Hizō Ukiyo-e Taikan*, vol.V, 1989, pp.250–1

• **KOBAYASHI 1993**
Kobayashi Tadashi, *Senmenga (Kinseihen)* (Fan Paintings (Early Modern Period)), vol.321, *Nihon no Bijutsu* (Japanese Arts series), Tokyo; Shibundō, 1993

• **KOBIJUTSU 1983**
Hiroshige, Bessatsu Kobijutsu (*Kobijutsu*: a Quarterly Review of Fine Arts, Special Issue Number 3) (exhibition catalogue), Tokyo; Sansaishinsha, 1983

KOOP and INADA 1923
Albert Koop and Inada Hogitarō, *Meiji Benran: Japanese Names and How to Read Them*, London; Eastern Press, 1923

• **MATSUKI 1924**
Matsuki Kihachirō (ed.), *Ichiryūsai Hiroshige Uchiwa-e Tenran Zuroku* (Catalogue of an Exhibition of Fan Prints by Ichiryūsai Hiroshige) (exhibition catalogue), Kyoto; Geisōdō, 1924

MINER 1968
Earl Miner, *An Introduction to Japanese Court Poetry*, Stanford University Press, 1968

• *MSU*
Narazaki Muneshige et al., *Meihin Soroimono Ukiyo-e* (Masterpieces of *Ukiyo-e* Published in Series), 12 vols, Tokyo; Gyōsei, 1991–2

• **NARASAKI 1973**
Narazaki Muneshige (ed.), *Utagawa Hiroshige, Zaigai Hizō Ōbei Shūzō Ukiyo-e Shūsei* (*Ukiyo-e* Treasures in European

and American Collections series), Tokyo; Gakken, 1973

NEWLAND and UHLENBECK 1990
Amy Newland and Chris Uhlenbeck (eds), *Ukiyo-e to Shin Hanga: The Art of Japanese Woodblock Prints*, Wigston, Leicester; Magna, 1990

• **NISHIYAMA 1984**
Nishiyama Matsunosuke et al. (eds), *Edogaku Jiten* (Dictionary for the Study of Edo), Tokyo; Kōbundō, 1984

• **NOGUCHI 1933**
Noguchi Yonejirō, *Ichiryūsai Hiroshige*, Tokyo; Seibundō, 1933

OKA 1992
Oka Isaburō, *Hiroshige: Japan's Great Landscape Artist*, Tokyo, New York, London; Kōdansha International, 1992

• **ŌTA MEMORIAL MUSEUM 1998**
Sugimoto Ryūichi (ed.), *Kaikan 120-nen Kinen Poland Cracow Ōritsu Hakubutsukan Ukiyo-e Meihinten* (*Ukiyo-e* from Cracow Revisiting Japan: On the 120th Anniversary of the Foundation of the National Museum in Cracow) (exhibition catalogue), Tokyo; Ōta Memorial Museum of Art and Nihon Keizai Newspapers, 1998

• **SAKAI 1981**
Sakai Gankō, index of Hiroshige fan prints in Rose Hempel et al., *Museum für Ostasiatische Kunst in Berlin und Köln etc.*, pp.229–3, *Ukiyo-e Shūka* (Collected Glories of *Ukiyo-e* series), Tokyo; Shogakkan, 1981

• **SAKAI 1996**
Sakai Gankō (ed.), *Hiroshige Edo Fūkei Hanga Daishūsei* (Great Collection of Hiroshige's Woodblock Print Views of Edo), Tokyo; Shogakkan, 1996

• **SATŌ 1998**
Satō Satoru, 'Nanushi Sōin Shikō' (A Reconsideration of the Dual Censor Seal System), *Ukiyo-e Geijutsu* (*Ukiyo-e* Art), no.129, 1998, pp.3–9

• **SHIRAISHI 1993**
Shiraishi Tsutomu, *Edo Kiriezu to Tokyo Meisho-e* (Close-up Maps of Edo and Famous Places in Tokyo), Tokyo; Shogakkan, 1993

SMITH and POSTER 1986
Henry Smith and Amy Poster, *Hiroshige: One Hundred Famous Views of Edo*, New York; George Braziller in association with The Brooklyn Museum, 1986

STRANGE 1897
Edward F. Strange, *Japanese Illustration*, London; George Bell, 1897

STRANGE 1904
Edward F. Strange, *Japanese Colour Prints*, London; HMSO, 1904

STRANGE 1913
Victoria & Albert Museum Guides, Department of Engraving, Illustration and Design, *Japanese Colour Prints: Lent by R. Leicester Harmsworth, Esq., MP, November 1913 to March 1914, Illustrated*, London; HMSO, 1913

STRANGE 1925
Edward F. Strange, *The Colour Prints of Hiroshige*, London, New York, Toronto and Melbourne; Cassell, 1925

• **SUZUKI 1970**
Suzuki Jūzō, *Hiroshige*, Tokyo; Nihon Keizai Newspapers, 1970

• **SUZUKI and ŌKUBO 1996**
Suzuki Jūzō and Ōkubo Jun'ichi, *Hiroshige Rokujūyoshō Meisho Zue: Pulverer Collection* (Hiroshige's Famous Places in the Sixty-odd Provinces: The Pulverer Collection), Tokyo; Iwanami, 1996

• **TANBA 1965**
Tanba Tsuneo, *Hiroshige Ichidai* (The Great First Generation Hiroshige), Tokyo; Asahi Newspapers, 1965

• **UCHIDA 1932**
Uchida Minoru, *Hiroshige*, Tokyo; Iwanami, 1932 (reprinted 1978)

WALEY 1984
Paul Waley, *Tokyo Now and Then*, New York and Tokyo; Weatherhill, 1984

• **WATANABE 1918**
Watanabe Shōzaburō, *Catalogue of the Memorial Exhibition of Hiroshige's Works on the 60th Anniversary of His Death*, Tokyo; *Ukiyo-e* Kenkyūkai, 1918

• **YOSHIDA 1971**
Yoshida Teruji, *Ukiyo-e Jiten* (*Ukiyo-e* Dictionary), 3 vols, Tokyo; Gabundō, 1971–2

Index

Page numbers in **bold** refer to illustrations